Russian and Soviet Painting

Russian and Soviet Painting

An Exhibition from the Museums of the USSR Presented at The Metropolitan Museum of Art, New York, and The Fine Arts Museums of San Francisco

Introduction by **Dmitrii Vladimirovich Sarabianov**

Catalogue information by **E. Yu. Korotkevich and E. A. Uspenskaia**

Translation, foreword, and bibliography by **John E. Bowlt**

THE METROPOLITAN MUSEUM OF ART · 1977

Trade edition distributed by RIZZOLI INTERNATIONAL PUBLICATIONS, INC.

ON COVER: detail of *The Storming of the Snow Town,*

BY V. I. SURIKOV (1848-1916)

Color photography by Malcolm Varon, New York
Publication designed by Peter Oldenburg
Composition by Custom Composition Company, York, Pennsylvania
Printed by Eastern Press, New Haven, Connecticut

LIBRARY OF CONGRESS CATALOGING IN PUBLICATION DATA

Main entry under title:
Russian and Soviet painting.
 Bibliography: p.
 1. Painting, Russian—Exhibitions. 2. Painters—Rus-
sia—Biography. I. New York (City). Metropolitan Mu-
seum of Art. II. Fine Arts Museums of San Francisco.

ND681.R85 759.7'074'01471 77-3010
ISBN 0-87099-162-0

Trade edition distributed by *Rizzoli International Publications, Inc.*
ISBN 0-8478-0043-1

Contents

Acknowledgments

This third exhibition in the cultural exchange between the Museums of the Soviet Union and The Metropolitan Museum of Art, presented first in New York and later in San Francisco, encompasses the full range of painting in Russia from the fourteenth century to the present. The selection begins with icons in which the formal and hieratic style of the Byzantine tradition is wedded to a uniquely Russian lyricism; it continues through the eighteenth and nineteenth centuries when Russian painting was closely allied to European movements such as Romanticism and Realism, yet was invested with a distinctly national character in which religious mysticism easily coexisted with reportorial objectivity. The selection continues with the emergence of abstraction in the early years of the twentieth century and concludes with examples of Soviet Socialist realism.

An exhibition of Russian and Soviet painting of this scope and this magnitude has not heretofore been seen in the United States. For this reason alone the occasion is one of historic importance to both Russians and Americans. It becomes increasingly clear that Russia, along with her accomplishments in literature and music, produced a visual art of the highest caliber. Of course, Russian art contains its own idiosyncracies, especially in its relation to Russia's social and political history—from the princes of ancient Russia to Catherine the Great, from Alexander I to the 1917 Revolution and through to today. But beyond the specific historical and national connotations of the paintings on view, they carry a particular resonance for the American visitor. We are struck by the close and curious parallels between the development of the Russian style and our own artistic traditions, especially those of the nineteenth century. These points of convergence suggest a major field for inquiry and future research.

The exhibition is being held at the Metropolitan Museum concurrently with The Glory of Russian Costume, the second show of the cultural exchange (its counterpart from the Metropolitan to the Soviet Union is an exhibition of pre-Columbian gold). The concurrence provides a dramatic opportunity for one to gain a broader, fuller picture of Russian life and art during a period of centuries.

In exchange for this exhibition of Russian and Soviet painting the Metropolitan will be sending to museums in Leningrad, Moscow, and Minsk an exhibition of American painting entitled Representations of America, organized by the Metropolitan with the cooperation of The Fine Arts Museums of San Francisco. The planning of this exhibition has been done by Henry Geldzahler, Curator of Twentieth Century Art, with the assistance of the staff at the Metropolitan, in collaboration with Ian White, Director, The Fine Arts Museums of San Francisco, and Thomas Garver, Curator of Exhibitions, The Fine Arts Museums of San Francisco.

The success of our exchange program would have been impossible without the support of Petr Demichev, Minister of Culture of the USSR, and the cooperation of the Ministry of Culture. Vladimir Popov, Deputy Minister of the Ministry of Culture, and Alexander Khalturin, Head of the Arts Department of the Ministry of Culture, conducted negotiations with Philippe de Montebello and me. Anatoly Djuchev, Head of the Foreign Department at the Ministry of Culture, was also very helpful in the planning. James F. Pilgrim, the Metropolitan's Deputy Vice-director for Curatorial Affairs, assisted at various stages of the negotiations.

Victor Sakovich, Cultural Counselor of the Embassy of the USSR in Washington, Ivan A. Kouznetsov, Consul-Designate of the Consulate General of the USSR in New York, and Peter Solmssen of the U.S. Department of State have been very helpful.

I would like to mention in particular the generosity and cooperation of P. I. Lebedev, Director of the State Tretiakov Gallery, Moscow, Vitalii Manin, Deputy Director of the Tretiakov Gallery, and V. A. Push-kariev, Director of the Russian Museum, Leningrad.

7

Most of the paintings in the exhibition come from these two museums.

Special thanks must go to John E. Bowlt, Associate Professor at The University of Texas at Austin, who served as special consultant for the exhibition. His expertise in the history of Russian painting has been invaluable, and we are grateful to him not only for his translation of the Russian text of the catalogue but for compiling the bibliography and writing the foreword.

Coordination of the exhibition at the Metropolitan was the responsibility of Katharine Baetjer, Associate Curator of European Paintings. John Buchanan, Special Assistant to the Director, Herbert Moskowitz, Associate Registrar, Dianne Dwyer, and Alain Goldrach, Assistant Conservators, and Herbert F. Schmidt, Manager, Design Department, were all most helpful. A special note of appreciation goes to Vera K. Ostoia, recently retired from the Department of Medieval Art, and to Natalie Spassky, Associate Curator, American Paintings and Sculpture, who could be counted on for instant translations of documents submitted in Russian.

Russian and Soviet Painting at the Metropolitan Museum, as well as the exhibition of pre-Columbian Gold in the Soviet Union were made possible by a grant from the Alcoa Foundation. The Metropolitan Museum is deeply grateful to the Foundation, and especially so to its president, Arthur M. Doty, who will retire at the end of 1977 after years of leadership in advancing business support of the arts, both in this country and abroad.

THOMAS HOVING
Director
The Metropolitan Museum of Art

8

Lenders To The Exhibition

Abramtsevo Museum, Moscow Region
Andrei Rublev Museum of Ancient Art, Moscow
Central Lenin Museum, Moscow
Central Museum of the Soviet Army, Moscow
Ceramics Museum, Kuskovo Estate
Collection of A. A. Drevin, Moscow
Gorky Art Museum, Gorky
Kalinin Picture Gallery, Kalinin
Karpov Institute of Physics and Chemistry, Moscow
Konenkov Museum of Visual and Applied Arts, Smolensk
Kuibyshev City Art Museum, Kuibyshev
Ministry of Culture of the USSR, Moscow
Museum of V. A. Tropinin and His Contemporary Moscow Artists, Moscow
Russian Museum, Leningrad
Sloboda Museum, Kirov Region
Tadshik Art Museum, Dushanbe
Tretiakov Gallery, Moscow
Union of Artists of the USSR, Moscow

Foreword:
Between East and West

JOHN E. BOWLT.

The last time that the American public viewed a large exhibition of Russian art from the Soviet Union was in 1924 when the Russian Art Exhibition was mounted at the Grand Central Palace, New York. Although Igor Grabar, the artist and critic and chief curator with the exhibition, asserted that there "wasn't a single negative evaluation,"[1] the exhibition had a very mixed reception. Americans then had little idea of what to expect from Russian art and, in any case, the political overtones (the exhibition opened only seven years after the Bolshevik coup) were particularly resonant. Unfortunately, more than fifty years later, we still lack an essential understanding of the development of Russian art. True, within the last few years American galleries and museums have organized a number of exhibitions related to various aspects of Russian art, but by and large these have treated of specific periods such as the ancient Russian icon or the twentieth-century avant-garde. The current exhibition encompasses all the principal trends of Russian and Soviet painting, although the exigencies of transportation, material condition, and other factors have prevented the inclusion of certain desirable works. Repin's celebrated *Volga Boatmen* and Vrubel's *Demon Downcast* are among the works affected by the inevitable restrictions, but despite these gaps the exhibition does provide a reliable synopsis of the general evolution of Russian and Soviet art.

One of the most intriguing facts about Russian art is that, apart from the disciplines of icon painting and wood-carving, its stylistic traditions do not deviate radically from those of the European schools, at least during the eighteenth and nineteenth centuries. Furthermore, a number of close parallels exist between Russian and American art of the same period. The artistic correspondences that spring to mind—Boro-

vikovsky and Gainsborough, Venetsianov and the Barbizons, Borisov-Musatov and Maurice Denis—offer material for comparative research, but at this juncture more questions will be raised than answered.

It is curious to recall that none of the great Russian portrait-painters of the late eighteenth and early nineteenth centuries—Rokotov, Levitsky, and Borovikovsky—ever visited western Europe and that, in the case of Rokotov and Borovikovsky, their artistic training was of a rather desultory kind. Against the nondescript background of the late sixteenth and early seventeenth centuries, a time of troubles in art as much as in politics, this trio of artists appears as a sudden and brilliant constellation. As in the case of Gainsborough and Romney, so here the level of technical accomplishment was of the highest. Strange as it may seem, a measure of this bravura returned to Russian art only in the early twentieth century with the set and costume designs of Diaghilev's Ballets Russes (1909-29). It is really no great distance from Levitsky's histrionic portrait of Catherine II to Bakst's splendid occult symmetries for *Schéhérazade* and the *Firebird*.

The parallel between the Russian portrait-painters and the European tradition is not a fortuitous one. Artists from France, Italy, Germany, Austria, and Britain resided in Russia for various lengths of time during the late eighteenth and early nineteenth centuries, and the Academy of Arts in St. Petersburg was virtually controlled by foreign masters, including, for example, the versatile George Dawe, who managed to produce over four hundred portraits of Russian generals for the Winter Palace between 1819 and 1828. Throughout the nineteenth century, too, Russian artists—consciously or unconsciously—maintained a close aesthetic link with the West. It is not difficult to recognize points of re-

11

semblance between Aleksandr Ivanov and the Naza-
renes, between Briullov and Géricault, just as it is
possible to discover organic connections between Push-
kin and Lord Byron or Gogol and Dickens. It is one
thing to enumerate such stylistic convergences, another
to elucidate the reasons for them. However, careful
examination of just one concurrent development,
namely the formation and extension of the Russian and
American luminist tradition in the mid- and late nine-
teenth century, might delineate some of the common
motives responsible for the frequent coincidence of
style between East and West.

Among the most evocative paintings in this exhibi-
tion are the nineteenth-century landscapes of Kuindzhi,
Levitan, Savrasov, Shishkin, Soroka, and Vasiliev. The
viewer may well be reminded of the achievements of the
Hudson River School, although the Russians were too
elemental, perhaps too romantic, to warrant a close
proximity to Bierstadt, Church, Heade, Kensett, and
Lane. Still, there are interesting parallels: both the
Russians and the Americans were exceptionally sensi-
tive to the effects of natural light on landscape, all
shared a similar "stereoscopic" vision of reality, and all
seemed to revere the majesty and "transcendentalism"
of nature. There were also more concrete reasons why
Russian and American artists of the 1860s–70s devel-
oped in similar directions: both groups found them-
selves on the peripheries of the European Academy and,
to a considerable extent, at loggerheads with it. Inevita-
bly, they endeavored to create an alternative tradition
which, both in Russia and in America, led immediately
to the establishment of national schools of painting.
Consequently, the topographies of the respective coun-
tries, containing the broad horizons and panoramic
vistas so loved by the luminists, came to play a distinct
and national role in contradistinction to the Mediterra-
nean Arcadia repeated endlessly by their romantic
predecessors. Moreover, both the Russians and the
Americans were interested in photography and, in some
cases, they worked as retouchers; they kept abreast of
the rapid scientific progress being made in physics and
optics, and in greater or lesser degree derived part of
their inspiration from the traditions of naive painting
operative in both countries. Soroka's work, for example,
relies on a charming fusion of the Russian primitive
tradition (as seen, for example, in tray painting and the
palekh, or enameled boxes) and the Western academic

discipline. It is a fusion of styles that amazes us all the
more by its resemblance to the art of George Bingham.
Still, in the luminist achievement, pride of place must
go to the Ukrainian Kuindzhi whose *Birch Grove* is a
spectacular piece of pictorial engineering. Nineteenth-
century viewers were so affected by this painting that
some "stood open-mouthed before it, while others
wept."[2]

This East-West coincidence of artistic ideas was also
very evident in the twentieth century. The Russian
symbolist poets and painters were well versed in the
literature of the French decadents and the art of the
nabis. The influence of French cubism on the nascent
avant-garde in Russia was, of course, appreciable. Ital-
ian futurism was well known both in image and in
idea—and perhaps the poet Benedikt Livshits was not
far wrong when he asserted that "Rayonism, with which
Larionov tried to outstrip the Italians, fitted into Boc-
cioni's vest pocket."[3] But (as Livshits also said) the
Russians did retain an appreciation of material, of the
expressive qualities of the artistic medium itself, that
Western artists lacked. When Vladimir Burliuk rolled
his canvases in the soil of his garden, when Malevich
painted his clean planes of Suprematism, when Tatlin
and Rodchenko carefully assembled their reliefs and
constructions from pure textures of wood and metal,
they were extending this "culture of materials" (to use a
catchword of the early Soviet years). Only in isolated
instances, did the Western avant-garde manifest the
same serious and exclusive concern with the physiology
of art. To a considerable degree, the artists of the Rus-
sian avant-garde rediscovered material through their
deep interest in the arts and crafts of ancient Russia.
Goncharova and her colleagues were quick to "shake
the dust from [their] feet and leave the West,"[4] and to
transfer their allegiance to the systems of the Russian
icon, the peasant broadside (*lubok*), the painted sign-
board, and the like. Their popular derivation is apparent
both in their choice of theme (Goncharova's *Washing
Linen*), and in their treatment of it (inverted perspec-
tive, monoplanar imagery); it is apparent above all in
their vital response to the material of paint, its plastic-
ity, its luminosity, its textural compounds. This redis-
covery of paint, very noticeable after the drab color
scales of the Russian realists, is one of the most striking
characteristics of the Russian avant-garde. Petrov-
Vodkin's *Bathing of the Red Horse* is a superb example

of this new awareness of Russia's pre-Petrine artistic tradition: not only does it depend on the same dense body color of the old Russian icon, but also (as Dr. Sarabianov points out in his Introduction) it contains a deep mythological and philosophical value.

If color was the primary element for Goncharova, Kandinsky, Larionov, Lentulov, Malevich, and Petrov-Vodkin, then line and linear expressivity was the dominant concern of Soviet painters in the 1920s and early 1930s, whether in the documentary pictures of Brodsky or in the works by the painters of OST—one of the most original but least explored phenomena of twentieth-century Russian art. Fortunately, OST is well represented in this exhibition by its founder-members: Deineka, Goncharov, Pimenov, Shterenberg, and Vialov. Deineka and Pimenov, in particular, were influenced substantially by modern Central European art: Deineka's *Defense of Petrograd*, for example, derived its iconography from Ferdinand Hodler's *Auszug der Jenaer Studenten zum Freiheitskampf von 1813* (1908); Pimenov's skeletal pictures of athletes and industrial workers owed much to Otto Dix, whose work he saw both in reproduction and at the two exhibitions of German art in Moscow in 1924 and 1925. While supporting a figurative style, the OST artists endeavored to create a vigorous and resilient form that would express the new era of Socialist construction. Although there were lugubrious themes (Pimenov's war scenes, Goncharov's *Death of Marat*), and although elements of surrealism were not uncommon (especially in the work of Barto, Luchishkin, and Tyshler, not represented in this exhibition), the OST artists aspired toward a positive and assertive portrayal of reality. Unlike the German expressionists, they distorted form not to parody negative features, but to emphasize the impulse and potential of the new Soviet technology. Unfortunately, OST was short-lived, and while traces of its influence showed in Drevin and still show in Tyshler, it had ended its innovative period by 1930.

Curiously enough, the dynamic, early period of Socialist realism (the 1930s) is not treated extensively in this exhibition, although the large canvas *Higher, Ever Higher!* by Riangina epitomizes the grand, ambitious principles of the Socialist realist program. Perhaps more than any other movement in modern art, Socialist realism is the victim of an intricate and misleading mythology, and it is difficult now to sift artistic fact from political fiction (and vice versa). Actually, the aesthetic credo of Socialist realism, ratified in 1934, contained some very significant and innovative ideas, especially in its advocacy of the need to depict "reality in its revolutionary development," to use "labor as a central hero," to apply "typicality" as a primary principle, and so on. Whether or not we like the interpretations and extensions of this program is another matter, although, of course, there were "good" and "bad" Socialist realist paintings, just as there were "good" and "bad" social realist paintings in America during the same period. Like their predecessors in OST, Riangina and her colleagues strove to transmit the idea of the imminent fulfillment of a utopian dream through the lyrical distortion of reality. Socialist realism of the 1930s was a visual rhetoric, and its flights of fancy are rarely encountered now. Only in isolated cases, as in Pokhodaev's *First Rendezvous. "Soyuz" and "Apollo,"* do we again perceive the romance and rhapsody of early Socialist realism.

The condition of contemporary Soviet painting is self-evident and needs little commentary. After a long period of isolation, Soviet art has once again returned to the international arena, although on a level vastly different than that of the 1920s. Despite their various national derivations, the new Soviet painters favor a lyrical and contemplative style that depends very little on the original tenets of Socialist realism. They now reside in some curious twilight zone midway between Hans Makart and Norman Rockwell, and they exert a subtle attraction to many people whether in Moscow, Paris, New York, or Tokyo. *Golden Harvest, Construction Workers, Under Peaceful Skies*—this is the new international style.

Notes

1. I. Grabar in a letter dated 21 April, 1924. Quoted from O. Podobedova: *Igor Emmanuilovich Grabar*, Moscow, 1965 (?), p. 189.
2. Letter from Repin to I. Ostroukhov, 25 November, 1901. In I. Brodsky (ed.): *Repin. Pisma 1893-1930*, Moscow, 1969, Vol. 2, p. 167. Repin was referring to a copy of the original *Birch Grove*.
3. B. Livshits: *Polutoraglazyi strelets*, Leningrad, 1933, p. 239.
4. N. Goncharova: Preface to catalogue of her one-woman show, Moscow, 1913, i.e. *Vystavka kartin Natalii Sergeevny Goncharovoi 1900-1912*, Moscow, 1913, p. 1.

Russian and Soviet Painting

DMITRII VLADIMIROVICH SARABIANOV

Visitors to this exhibition will see about 150 works. Of course, this is not really enough to provide a true representation of the development of Russian painting from the Middle Ages to modern times. Nevertheless, one can gain a general idea of the processes of Russian painting, its achievements, and its distinctive national image.

Needless to say, it is very difficult to locate qualities that are germane to all—or almost all—phenomena of Russian art. At best, such qualities would prove to be too abstract to be at all meaningful. There is, however, one exception to this rule. People often speak of the anthropocentrism of Russian art and literature and, most certainly, there is some truth in this point. This is probably the only general characteristic that we could locate in most important phenomena of Russian artistic culture. Indeed, whether we turn our attention to ancient icon painting in which God or a saint appears before us in the guise of man, imbued with all our human virtues and qualities, whether we study the 18th-century portraits that penetrate so deeply to the spiritual and physical beauty of their model, whether we examine the 19th-century paintings in which the artists seek to resolve the social contradictions of their time, or whether we concern ourselves with works from more recent times in which the artists endeavor to praise man the pragmatist—in all cases we encounter a deep interest in the most essential spheres of human life. In all cases, the ideals of the Russian artist are bound up with an elevated moral conception of the human personality.

Russian culture attained this humane condition after a long and tortuous path. It was a difficult path that began at the dawn of the Russian state. Ancient Russia (Rus) took from Byzantium the Eastern variant of Christianity and, therewith, the bases of medieval culture. Due to the Mongolian and Tartar invasion, ancient Russia for a long time was denied progress. Still, this tragic fact of Russian history did, ultimately, have a positive ending: Europe was saved from the barbarians. And then ancient Russia gathered her strength, straightened her back, and drove forth the strangers from her soil. Even so, until the very end of the 17th century, Russian culture remained part of a medieval system and did not witness the true Renaissance. Only at the end of the 17th and beginning of the 18th century did Russian culture suddenly take a leap forward: it was a cultural revolution that paralleled that of the Western European Renaissance. The reforms that took effect at that time reverberated immediately through the whole of Russia and affected her culture, her economy, and the life style of the most diverse social classes. Thereafter, the destiny of Russian culture was a complicated and intricate one. Russian culture assimilated the experience of the West, attempted to catch up with the West, and overcame many difficult obstacles. In some cases, important problems were left unresolved. Different tendencies of cultural development and diverse movements of literature and art seemed to run contrary to each other and destroyed any logical, sequential development. Movement forward became spasmodic, at times too hurried and always uneven.

Russian art was always accompanied by such difficulties. And perhaps it is thanks to them that Russian painting witnessed that very human interpretation of the fundamental questions of life referred to above. On the other hand, from the beginning of the 18th century onward, Russia kept abreast of Western Europe. Russian painting went through more or less the same stages,

manifested itself in the same styles and movements as were evident in the important Western European schools.

Still, in Russian art we should look not for a reflection of the West, but, above all, for a reflection of the national spirit. When compared to the French and German schools, Russian painting seems, at times, to be more restrained, less brilliant, but it always contains deep inner significance.

We can try to find the distinctive features of Russian painting in many spheres—in its iconography, form, and meaning. But surely the most important element is the very ethos of its art, one that encompasses all the mentioned spheres, one that is always inwardly connected to the destiny of the nation, to its national characteristics, and to the idiosyncracies of the national genius.

This ethos was fully visible in ancient Russian painting. From its very beginning, Russian icon painting (despite the fact that it derived entirely from the principles of Byzantine painting) displayed its unique characteristics. Moreover, it often happened that certain works created by the Byzantine masters actually became component parts of the history of Russian painting and became important elements in the artistic life of ancient Russia. This was the case, for example, with the *Our Lady of Vladimir* (an icon of the late 11th or early 12th century) and with the works of the Byzantine artist Theophanes the Greek, who, in Novgorod and Moscow, found a second home and a wide scope for his artistic activities. Ancient Russia reprocessed this foreign experience, she dictated her own conditions to those who came from afar bringing her their creative strength, and, ultimately, she selected exactly what she wanted.

The visitor to this exhibition will be able to view works of the 14th and 15th centuries. These were produced at a time of great tension and excitement in Russian life, at a time of great creative impulse. It was then that ancient Russia was gathering her strength to shake off the Mongol and Tartar yoke, it was then that the Russians scored their first great victory, one that determined their subsequent successes in winning back their land and driving out the foreigners. The ecstatic tension in the painting of Theophanes the Greek was replaced by the radiant clarity and harmony of Andrei Rublev. But, despite their antithesis to one another,

these two great painters joined forces in resolving rather similar problems. It was at that time that the specifically Russian form of the altar screen was born—the iconostasis with its large deesis tier. The idea contained here—of the presence of the saints before the face of Christ—was an allegory suggesting the unity of soul and heart, will and aspiration of people then experiencing the need for national unity.

Several of the icons on display carry the imprint of all these tendencies. The *Archangel Michael* of the late 14th century (one of the masterpieces of icon painting from that period) provides us with an accurate impression of the art of the pre-Rublev period. *Our Lady of the Don*, which appeared at the end of the 14th century, is related to the Theophanes tradition in Russian painting and is, apparently, the replica of a renowned icon produced by the Theophanes circle. In comparison with the austere Byzantine models, this icon expresses more readily the simple feelings of man.

The large nine-icon deesis tier with its full-length figures also relates precisely to this period, the 15th century. In ancient Russia at this time this kind of composition was especially popular; it was established in the Moscow circle of Theophanes and Rublev and then spread to other schools. Novgorod artists gave it their own interpretation.

Many of the icons shown here are imbued with the idea of the spiritual perfection of the hero, of his inner beauty, of qualities that were to constitute a model for all. The sacred and the profane, the celestial and the mundane come close to each other here, they are conditions that interpenetrate. The very harmony of this integration often lends the painting a particularly high artistic quality: it is at this juncture that Rublev's painting emerges as the ideal. Inasmuch as Rublev's painting was itself the expression of an extremely important trend in ancient Russian art and, secondly, exerted a profound influence on the whole process of ancient Russian painting for many years to come, its reflections, so to speak, illumine many icons of the 15th and 16th centuries.

The selection of the icons here was made so that the visitor to the exhibition would be able to acquaint himself with the themes that were popular in ancient Russia and with the ways in which they were treated. For example, we find the depiction of Boris and Gleb: they were the first Russian saints, brothers who, for the

16

people of that time and for their descendants, were not just two men, pure in heart, but also martyrs for the cause of Russian unity. Boris and Gleb are generally depicted on horseback.

The horse, as a matter of fact, became a "popular hero" in the painting of ancient Russia. The horse appeared as a friend and ally of man, as his helpmate in battle (*St. George and the Dragon*), as a domestic animal indispensable to man and blessed with his own patron saints (*Florus and Laurus*). All these images carry the mythological conceptions of man peculiar to ancient Russia. Not by chance did Petrov-Vodkin, at the beginning of the 20th century, turn his attention to the horse, the beloved hero of the ancient myth, imbued with the noble qualities of splendor, majesty, and beauty. In doing this, Petrov-Vodkin was striving to revive the mythological process of thought.

This mythological sentiment also permeated other icons such as the fabulous *The Prophet Elijah and the Fiery Chariot* and the "historical" *Battle Between the Men of Novgorod and the Men of Suzdal*. In the *Battle*, art historians often see the beginning of the historical genre, but this view can be justified only in part. This was a time when Novgorod was trying to preserve its independence of Moscow, a city that had already assumed the glory of Vladimir and Suzdal. For the Novogorod painter who created this icon then, the earlier victory of Novogorod over Suzdal was a kind of historical analogy. But in deference to the laws of medieval art he could not depict a historical scene as such—so he depicted a miracle because, according to tradition, the principal part in the battle had been played by an icon that had put the enemy troops to flight. The artist arranged his narrative in three horizontal bands, imbuing it with distinctive visual mythologems—the brave horsemen attacking the enemy, the forest of lances raised high above the warriors, the silhouette of the "holy city" defending itself against its enemies. Each of these images is archetypal, and analogies can be found in the ancient tales, the *byliny* (traditional heroic poems), and the legends.

In the 17th century icon painting began to lose its former qualities of generalization, ideality, and completeness. Gradually, the old characteristics disappeared as new ones took their place. Art began to turn to tangible reality. It became more loquacious. Painters began to admire detail, they often ceased their search

for holiness and beauty and came to prefer a purely aesthetic principle. Not only new iconographic systems, but also new branches and genres of art appeared. One of these was the *parsuna*, a primitive form of the portrait. The *parsuna* preserved certain elements of the iconic convention (despite a more naturalistic, more concrete depiction of man) and also, in many cases, the technique of icon painting (egg tempera on board). One example of this kind of *parsuna* is the portrait of Prince Skopin-Shuisky. The *parsuna* was clearly symptomatic of a time of transition: it seemed to crystallize that moment when Russian painting was awaiting decisive changes and the discovery of a completely new path of development.

But before we pass on to a discussion of this new path, let us say a few words about the carved panel representing *Saint Ermolai*. This piece represents a whole area of ancient Russian art: wood sculpture. Most of the works in this idiom date from the 16th and 17th centuries.

To a certain extent the very existence of these splendid works by masters of ancient Russia disproves the traditional notion that before the 18th century there was no sculpture in Russia. True, in centuries prior to that we do not encounter such a "boom" in sculpture as we do in architecture and painting. But this gap was filled, so to say, by remarkable artifacts containing concepts peculiar to the common people and relying on the very technique of woodcarving. These artifacts represented a Russian tradition of long standing. It was a tradition belonging to a country covered in endless forests, a country that regarded wood as its chief building material.

The transition to a new system at the end of the 17th century was not unexpected. During the 15th and 16th centuries, within the general framework of medieval thought, certain aspects Russian painting had shared a common basis with the ideals of the Renaissance. In the 17th century some analogies with the European baroque could be found. But at the end of the 17th and beginning of the 18th century this parallel movement with the Western European schools ceased, and the Russian school became part of the general European development. The Russian school now outgrew the obsolete dogmas of medieval thought and made use of the abundant experience that Italy, France, Germany, Holland, and other countries had already had. Aided by

them, Russian art joined the main stylistic directions of the 18th century, the baroque and the classic.

One of the most interesting products of the transitional period is the *Portrait of Yakov Turgenev*, painted anonymously at the very end of the 17th century. This portrait expresses the individual characteristics of the sitter with particular acuity, although the general structure in the painting relies on the iconic convention: the local color of the garments and the monoplanar and graphic qualities of the imagery. When one compares the portraits of the second half of the 18th century with the *Yakov Turgenev* and other pieces from the Petrine era, one is amazed at the dynamic pace with which Russian painting was then advancing. Three artists denote the apogee of this advancement—Rokotov, Levitsky, and Borovikovsky.

Of the three, Rokotov seems the most inspired. The emotional inflections of his models are delicate, almost elusive, and they seem to reflect that process of self-awareness that Russians experienced throughout the 18th century; it was a process that terminated later, with the Pushkin era, when Russian romanticism was nearing its end. Rokotov lifts the veil from our darkest secret, the recesses of the soul. But a mystery remains concealed behind some strange invisible screen, it lives on in the eyes of Rokotov's sitters. Rokotov reveals the beauty of man through his own pictorial equivalent of this spirituality: he constructs his gentle and precious color scale on a complex of tones that "slide" and interfuse.

A rather different quality is identifiable with Levitsky. He embodied that Renaissance pathos for comprehending man and his world that was so characteristic of the entire 18th century in Russia. Levitsky was remarkably accurate in depicting what he saw. This was true both of his human characters and of the concrete world before him. He seemed to touch the silks and satins with his hands, his artistic fingers seemed to brush against the delicate surface of skin.

In their art Rokotov and Levitsky seem to represent two sides of the 18th century. They express an interest in the beauty both of the spiritual and of the physical, two conditions, of course, that intertwine and communicate in the very craft of art. But both Rokotov and Levitsky have their own specific centers of gravity.

Borovikovsky was a product of the turn of the 18th and 19th centuries. He adhered to specific types of portraiture, but always expressed a softness of emotion not only in his treatment of character but also in his subtle perception of colors and skillful harmonies of them. Subsequent generations of artists benefited from Borovikovsky's fruitful approach to painting.

Eighteenth-century painting in Russia included not only the portrait, but other genres—landscape, historical painting (which was considered the most important genre), and domestic genre. There were definite accomplishments in all these disciplines. Nonetheless, in comparison to the other genres, the portrait achieved an extraordinarily high point of quality. This was very logical. When art was confronted with the possibility of fathoming the concrete world, man proved to be at the center of this world. This tradition was maintained in the romantic painting of the first twenty or thirty years of the 19th century. There is no example of the early romantic portraitist Kiprensky in this exhibition, but this absence is compensated for by the two portraits by Briullov: one of these—the portrait of Strugovshchikov—is among the greatest attainments of late romantic painting in Russia. Strugovshchikov's complex personality, full of contradictory thoughts and experiences, is disclosed with such persuasiveness that we see before us the true image of a Russian intellectual of the 1830s-1840s.

Perhaps the most important phenomenon of Russian 19th-century painting was the work of Alexandr Ivanov. His art was permeated with an intense prophetical mood and profound philosophical ideas. In Ivanov was distilled the whole range of problems confronting the 19th century. On the one hand, Ivanov drew certain inferences from the artistic process of the first half of the century; on the other, through the various facets of his own artistic legacy, he pointed to different phases in the subsequent development of Russian art. On the crest of a wave, Ivanov seemed to look both forward and backward, belonging both to the future and to the past.

Visitors to the exhibition will see only a few works of Ivanov, and they will be unable to form a comprehensive idea of his art. But they will be able to perceive and to feel one important characteristic of the artist. Whether in a large painting, a small landscape, a sketch or a study, whether in a watercolor or a drawing, Ivanov—always and in all places—was a man of wisdom, heroic but serene. The great he could recreate in

18

the small, the image of the whole world he could depict in a fragment of nature.

Briullov and Ivanov were of academic background, although both of them overcame the academic routine and "exploded" it from within. Meanwhile, various trends had begun to develop in Russia during the first twenty or thirty years of the 19th century. One such trend derived from Tropinin and Venetsianov and his pupils. Certain points of contact with romanticism can be observed in Tropinin's work, while Venetsianov has something in common with the German humanists of the 1830s. Venetsianov reveals a beauty in the simple world of the Russian countryside, in the life of the peasants, and in Russian nature. Without embellishment, he imbues the simplest elements of the world with their own independent value.

Soroka, Venetsianov's pupil, assumed his mentor's poetic vision of nature. His landscapes and unpretentious genre scenes depict lads fishing or interiors inhabited by groups of individuals conversing or contemplating. They have a naive charm.

The Venetsianov interpretation of genre painting held sway in Russian painting right up until the mid-19th century. But as early as the 1840s, critical realism began to affirm itself in its early, or perhaps one might say, poetic stage. The only consistent supporter of this trend was Fedotov. He began his artistic career with a passive, uneventful observation, and, in his subject matter, avoided the element of conflict and vivid expression. But he soon switched to the satirical narrative and to the methods of caricature. Then he changed his orientation again: he left caricature behind and came back to his essentially lyrical interpretation. But he combined this with a criticism of the laws of life itself and with a tragic sentiment.

Fedotov is rightly considered a forerunner of the realists of the late nineteenth century. But he differs from them by virtue of the poetic sense of his art.

In the 1860s critical realism assumed the role of denunciator. Artists exposed the powers that be, they sympathized with the poor and the weak, they shared the suffering of the "humiliated and the insulted." Perov carried out his program of denunciation with a series of paintings directed against the clergy, the most daring of which was his *Easter Procession*. First and foremost, the realist artists of the 1860s expressed their ideals in the domestic genre. The portrait, the historical painting, and the landscape took a secondary position: their turn would come.

It came in the 1870s and 1880s, the highpoint of the so-called Wanderers, artists who created their own association and embarked upon an extensive program of education and enlightenment through the length and breadth of Russia. With the Wanderers came the final stage in the development of critical realism (one could call it the objective stage). The genres stood almost on an equal footing: the domestic genre, the historical genre, the portrait, the landscape—*all* found a place in the general system of Russian painting of the 1870s and 1880s. Realist art, by its very idea, takes facts from surrounding life and resolves social problems explicitly, not implicitly. So it found its fullest expression in paintings dealing with actuality and in the genre traditionally called "domestic." With realism, however, this genre ceased to simply moralize on domestic issues, but earned the right to be called a social genre.

Repin became the principal supporter of this genre. He faced his contemporary reality fairly and squarely, he derived his subject matter and imagery from it and addressed himself to the main problems of Russian social life. He was interested in human relationships as they manifested themselves in moments of antagonism and conflict; he was drawn to mass scenes. His aim was to depict the world in all its complexity and contradictoriness. In characterizing his people, in creating his portraits, Repin endeavored to penetrate to the most infinitesimal details, to motions of the soul hardly noticeable at first glance. Repin attempted to embody his ideas in an authentic style of painting entirely subordinate to his observation of life and constructed according to his consistent and intense study of objective reality.

Surikov's art marked another highpoint in the development of realism during the late 19th century. Surikov was a historical painter par excellence. With his inner eye he could imagine scenes from the past as if they were happening now. Still, Surikov not only obeyed his imagination, but also pondered long over a composition or an image before constructing and organizing it. He was interested in the decisive moments of Russia's history. The conflicts during the Petrine reforms, the schism in the Church, the struggle of the common people for their rights and their interests—such were the themes of his paintings. Because of this, Surikov occupied a very distinctive position in European paint-

ing of the late 19th century since the European historical genre was at that time controlled by the conventions of the Salon.

Each genre that was used at all extensively in realism of the late 19th century absorbed the peculiarities of this movement. Vereshchagin reformed battle painting by subordinating all artistic means at his disposal to his fight against war and by revealing all the horrors that war brings with it. Kramskoi, Perov, Repin, Yaroshenko, and Ge made radical changes in portraiture, changing it into a programmatic genre, into a specific platform for advocating the contemporary hero—the man of the people or the thinker, the fighter for justice, the pragmatist, the creator. As a genre, the portrait best satisfied the artist's new interest in the positive hero whose aspirations had already replaced the mere denunciations and exposés of the 1860s.

The landscape also responded to these new demands, although perhaps not quite so directly: pictures of nature aroused positive feelings, a love for one's native country. The Wanderers—Savrasov, Shishkin, Vasiliev, Kuindzhi, and many others—ratified a new kind of landscape painting, one that required a narrative element. Nature and human life were presented as a unity. Mother Russia—in everyday life, in her most mundane manifestations—became the subject of landscape painting. The most diverse artists developed their talents within this general framework.

Savrasov was a lyrical painter. He cultivated the "landscape of mood," and favored the kind of painting that could evoke an idea by feeling. In many cases, these were pictures of specific scenes of nature, but they were linked by an invisible strand to the whole of Russia.

In contrast to Savrasov, Shishkin loved the epic motif. He liked to try to transmit what he saw with extreme accuracy, with every fragment and detail painted in. The graphic element is the dominant force in his paintings.

Vasiliev was closer to Savrasov. There were moments when he was carried away by the romantic impulse, but his main theme was the essential movement of nature—changes in the weather, rain, and storms.

Thanks to his support of romanticism, his attraction to light effects, and to specific natural conditions, Kuindzhi produced his own distinctive version of the landscape. In this respect, Kuindzhi occupied an unusual position inasmuch as the romantic tradition had,

essentially, been disrupted with the hegemony of critical realism.

Levitan's work marked the conclusion of the development of the realist landscape of the Wanderers. As a pupil of Savrasov, he took many elements both from his mentor and from many other predecessors. He synthesized the results and created a new kind of lyrical, philosophical landscape. Levitan did much to assimilate the methods of *plein air* painting, and many of his works can be associated with the early phase of Russian impressionism. However, some of his works—for example, *Above Eternal Peace*—anticipated post-impressionist movements, especially the *style moderne.*

Thanks to Levitan, Russian painting moved toward an important turning point in its evolution, although Levitan himself died before he could resolve the crisis. The artists who brought Russian painting to the final stage of its pre-Revolutionary development were Serov, Korovin, and Vrubel. Their independent careers began as early as the 1880s and encompassed the beginning of the 20th century. This was a time of an intense resurgence of Russian painting. The most diverse trends were united by a general artistic impulse, by the artists' creative activity, and by intense group involvement.

At the end of the 19th century most young artists began by attempting to reject the literary themes of the Wanderers and to find instead a spontaneous vision of nature. The result was impressionism. Korovin was its principal supporter and he remained loyal to this artistic credo until the end of his days. He cultivated the form of the étude and integrated a system of impressionist painting with its strokes of pure color, its intricate color mixes, and its orientation toward the decorative. Subsequently, this decorativism became virtually the national characteristic of Russian impressionism.

V. Serov, an outstanding artist of the late 19th and early 20th century, related his creative experiments both to the problems of impressionism and to the *style moderne*, then in its first stage of development. Still, Serov had an original artistic individuality, an exceptional talent, and this enabled him to assume a very special position in the history of national and international art. Serov's artistic evolution was of particular significance to the whole of Russian painting. His early works were permeated with a spontaneous feeling for nature, they relied on a wide diapason of color and on intricate color transitions; his late works depended on

strict calculation and were constructed according to linear silhouette, all-encompassing linear rhythm, and well-defined strokes of color. In his late portraits Serov applied certain formulas: he often used them for the heroic or beautiful effect, but sometimes he also used them for the ironic or the grotesque. The artist used the devices of metaphor and comparison. He used thick layers of color, "wrote testimonials," created a new concrete reality while still relying on the material of everyday life. In his thematic works, Serov preferred mythological subjects and painted them in the form of *panneaux*.

Vrubel's work, regardless of subject, is permeated by the sense of myth. More often than not, Vrubel chose mythological heroes for his paintings, giving preference above all to the Demon and the Prophet. He could imbue nature with a mysterious force and man with a restlessness of spirit. Among his contemporaries Vrubel was the most consistent in his search for, and attainment of, a new system; he eschewed impressionism and turned directly to the painterly form of the *style moderne* with its color for color's sake, its pronounced decorative structure, and its stylized combinations of color. If Serov evolved from the 19th to the 20th century, Vrubel leapt into a new era; his development was a more decisive one, it was irreversible.

Korovin, Serov, and Vrubel were associated with the group known as the World of Art, which played a formative role in Russian artistic life at the turn of the century. The art of the World of Art members is characterized by an interest in the theatricality of life, retrospectivism, a keen sense of style, and a refined artistic skill. Stage and book design, the monumental and the applied arts as a whole occupied an important place in the work of the World of Art artists—something that testified to their attraction toward synthetic art forms and to *Gesamtkunstwerk*. Artists of other groups that began to coalesce in the mid-1900s carried on the endeavors that the World of Art artists had first undertaken.

The first of these was the Blue Rose, a group of artists who united under the banner of Borisov-Musatov (who had died shortly before). The Blue Rose included artists such as Kuznetsov, Sarian, and Krymov, and Petrov-Vodkin was also close to them. They contributed to the one and only Blue Rose exhibition of 1907 and then to the exhibitions organized by the jour-

nal called the Golden Fleece. Larionov and Goncharova were also represented at the Golden Fleece exhibitions.

Historians of Russian art regard Musatov and his disciples as second-generation symbolists. Vrubel was the first symbolist in Russian painting, and his younger colleague, Musatov, presented a softer, more contemplative version of symbolism. As a rule, Musatov painted fairly large compositions containing two or more figures. Amidst these his heroines appeared in deep reflection or moved in some silent procession, acting and yet inactive. Musatov's paintings are melodic and musical, and his melodies move by crescendo, diminuendo, and pause. Indeed, Musatov himself wrote of his intention to bring painting and music closer together.

Kuznetsov assimilated this restrained style from Musatov. It was a style that had left impressionism behind and had alighted upon a kind of reserved decorativism. Kuznetsov's best works treat of the steppes beyond the Volga and of Central Asia, for, like Gauguin, he found in distant places a salvation from urban civilization. In these paintings Kuznetsov adhered to a consistent iconographical scheme and repeated typical scenes from the life of the inhabitants of the steppes. In their simple manifestations of ordinary life Kuznetsov found a kind of perfection and an inner conformity.

Petrov-Vodkin took a different property from Borisov-Musatov—the tendency to transform concrete reality which, with Petrov-Vodkin, developed into an artistic code. The artist's mythological perception dictated the evolution of his symbolist world view. He himself created myths, he created heroes who needed no documentary verification, who were far from the mundane sentiments of everyday life. For example, the symbol that Petrov-Vodkin uses in his *Bathing of the Red Horse* cannot be reduced to any one particular concept: it has many meanings. The color, the perspective, the system of plastic values in this picture acquire a symbolic meaning and, at the same time, transmit the idea of a radical restructuring of the traditional view of the natural world. The artist uses only local color and his perspective is a "spherical" one.

In 1910 the symbolists were replaced by the artists of the Knave of Diamonds group, artists who rejected all their predecessors—the Wanderers, the academic painters, the World of Art artists, and the Blue Rose symbolists. In most cases, the artists of the Russian avant-

garde were associated with the Knave of Diamonds, although the most progressive of them did not stay in the society for very long. But some artists were loyal to the Knave of Diamonds until its termination in 1918 and, through their art, determined its conformity of style. And this style can be defined as the integration of the principles of Cézannism and early cubism with the national traditions of icon painting and the popular, primitive arts and crafts. Among the artists who supported this direction were Lentulov and Falk, both of whom are represented in this exhibition. Each interpreted this general Knave of Diamonds program in his own way. Falk was attracted to the primitive arts only for a short time and then created his system of "lyrical cubism": in this he used cubist devices for the sake of lyrical or psychological expressivity and, thereby, penetrated to the plastic essence of painting. In his large *panneaux*, paintings dedicated to the themes of ancient Russian architecture, Lentulov applied the traditions of icon and fresco painting; simultaneously, Lentulov demonstrated that he was aware of the accomplishments of Delaunay and other French artists.

Among the organizers of the Knave of Diamonds were Larionov and Goncharova. However, they shortly left the society and began to organize their own exhibitions, attracting a number of young artists to their cause. These exhibitions propagated the ideas of neo-primitivism, Rayonism, and cubo-futurism. Larionov was captivated by Russian provincial life, he painted his *Barber* pictures, his provincial dandies and their ladies, and then went on to paint his *Soldier* series. Larionov delighted in the *lubok* (a folk cartoon reminiscent of the old English broadside) and the handmade toy; he parodied them, but—and this is very important—he did not stylize them; on the contrary, he endeavored to view life through the eyes of a real, popular, primitive artist. In this way Larionov combined the primitive approach with an exquisite sense of painting and an accomplished technique.

Goncharova left her own distinctive mark on neo-primitivism. This was evident from her perception of certain elements of the Russian icon, from her heightened expressivity and ecstatic rendition of imagery. Together with Larionov, Goncharova, so to speak, resurrected the domestic genre, and, in so doing, made extensive use of pictorial narrative, scenes from peasant life, and other national themes traditional for Russian painting.

Neo-primitivism was, to some extent, a branch of expressionism, of which Kandinsky provided one version. His art signified the organic link between Russian and German artistic culture. His works in the exhibition were painted just when the artist was developing his synthetic interpretations of nature to an extreme point: beyond this lay abstract expressionism.

The works of Malevich and Tatlin, and also of Rozanova and Popova (influenced by the first two), represent the final stage in the development of pre-Revolutionary painting. Malevich pursued his own artistic path, experiencing the influence of impressionism, then the *style moderne*, cubism, cubo-futurism and, ultimately, suprematism, which he formulated himself. Malevich passed through these stages extremely quickly. His suprematist phase was related to his establishment of new ideas—of how to overcome terrestrial gravity, weightlessness, the plastic condition in outer space. Malevich, as it were, was presenting certain proto-elements of painting out of which painting was to be created anew.

Even before he had begun his counterreliefs, Tatlin demonstrated an unusual constructive sense in his handling of form. Subsequently, he rejected depiction on the canvas and began to create objects in which he found the correlation of materials, surface coloration, the logic and expediency of form to be of particular interest. This was the point of departure of constructivism, destined to follow a long path in the whole evolution of European art.

During the years prior to the Revolution, Russian painting contained many contradictions. Its development was a complex one: progressive tendencies alternated with reactionary ones. The October Revolution resolved many of these contradictions, it confronted art with new demands and directed it along a new path. At the same time, many of the progressive traditions were, indeed, assimilated and continued.

From the very start Soviet art established a close link with the life of the people, of the new Socialist Republic. Art endeavored to come to grips with the practical realities of life. The task was not easy: the vast masses had to be introduced to cultural values; art had to be invested with educational and pedagogical functions; art had to be enlisted so as to create a new environment. So, in the early years, those art forms that could best fulfill these demands were favored and promoted—the politi-

cal poster, monumental sculpture, agit-design and decoration of the cities. Many painters, graphic artists, and sculptors were only superficially involved in these media, but many others did try to implement them—and with great enthusiasm. After this, as Soviet art evolved, it returned increasingly to traditional forms, so that by the 1920s easel painting was already occupying an auspicious position.

This exhibition includes many pre-Revolutionary artists who, in Soviet times, discovered new themes, new images, and, in many cases, rephrased their old vocabulary. Kustodiev would seem to be one of these. To his depiction of the old world of provincial Russia with its merchants and merchants' wives, with its festive carnivals and bazaars (the artist painted these themes before the Revolution when he was a member of the World of Art), Kustodiev added the symbolic image of the *Bolshevik*, an image born of the new era.

Konchalovsky, one of the organizers of the Knave of Diamonds, continued to experiment as a cubist in his portrait of the violinist Romashkov. Yuon had always gravitated towards impressionism, although with a decorative tendency. But after the Revolution he continued to develop this pictorial conception and, at times, to combine it with elements of the new reality.

Filonov, who had begun his innovative career in the 1910s, continued to advance during the 1920s and 1930s and to perfect his analytical method, which he had already proclaimed before the Revolution. He painted pictures full of symbolic meaning and often of tragic intensity.

The 1920s witnessed the formation of several movements which competed—and sometimes polemicized—with each other. Each declared its own program. The Association of Artists of Revolutionary Russia (AKhRR) declared itself to be the heir to the traditions of the Wanderers even though it advocated "heroic" realism. The AKhRR artists documented the characteristics of the new life, recorded its new manifestations, although their actual method of painting remained traditional. Visitors to the exhibition will see a number of works by these artists, for example, Brodsky's portrait of Lenin in the Smolnyi, Grekov's *Gun Carriage* and Riangina's genre scene *Higher, Ever Higher!*

Artists representing another direction, those of the Society of Easel Artists (OST), pursued other aims. They wished to resolve contemporary themes by a contemporary form of easel painting. To this end, they drew on the achievements of Russian and Western European art of the early 20th century, especially expressionism. Shterenberg, whose painting *The Agitator* is shown here, was the permanent leader of OST. Still, the most popular artist of this group was Deineka, who achieved fame during the 1920s thanks to many paintings, but especially to his *Defense of Petrograd*. Deineka invested his picture with a dynamic rhythm and created an image of fearlessness and courage.

Visitors will also find two more important and typical works by the OST group—Pimenov's *Give to Heavy Industry* and Goncharov's *Death of Marat*. These paintings are characterized by an intense expressiveness resulting sometimes in anatomical distortion, by the emphatic gestures of the figures, and by the dynamic style identifiable with OST.

Among the other artists who developed their talents during the 1920s and 1930s, mention should be made of Drevin. His works are close to those of the OST artists, although they are distinguished by a more painterly style. His pictures are dominated by the spontaneous movement of paint, and the depicted objects seem to emerge from this elementalness as if by magic.

Soviet painting of the 1930s owed a great deal to those artists who had matured before the Revolution and who were now given the opportunity of applying their realist style to contemporary needs. In this context, Nesterov should be considered a central figure. After many years of silence, he suddenly produced a series of very interesting portraits that recreated the image of man the creator. His portrait of the sculptress Mukhina relies on a firm sense of structure, is distinguished by its severe plasticity, and expresses through a convincing use of composition and color the energy and creative impulse of the subject.

During the 1930s and 1940s Grabar and S. Gerasimov continued to develop their art while relying on the impressionist tradition. Both artists enjoyed painting subjects of the historical and genre type. But their favorite kind of painting was, as it had always been, their native landscape, which they interpreted with delicate, lyrical feeling.

Plastov, the peasant painter, was also close to the impressionist tradition. He first achieved renown in the 1930s and, up until the 1970s, continued to occupy a central position in artistic life. He lived his entire life in

his native village and derived his themes, his motifs, and images from this environment. Their veracity and credibility constitute the most endearing quality of Plastov's work.

The distinguishing feature of Soviet painting has been its multinationality, something that was already apparent in the early years. Before the Revolution some of the republics had not known professional painting, but during the 1920s and 1930s their own artists came to the fore, contributing to the establishment of new national schools of art. Many of the republics, for example Armenia and Georgia, could boast artistic traditions of long standing and mature development. Each time these traditions changed in accordance with the new demands of the new era, they did so in a distinctive and original manner. But the objective in all cases remained the same: art became an important factor of life; it established a profound, essential connection with life and formulated a method whereby art could reveal the important moments of contemporary reality.

All the national schools developed quite forcefully and, eventually, acquired common meaning and value. In this respect, the 1960s and 1970s are especially significant. During these years each national school has made its contribution to the panorama of Soviet painting. The artists of Latvia, Lithuania, and Estonia have played a major role in certain areas of Soviet painting. The painters of Georgia, Armenia, and Azerbaijan have introduced the decorative principle, a romantic elation, and an austerity into Soviet art. Ukrainian and Moldavian artists have produced interesting results from their examination of the sources of popular, primitive art. The artists of White Russia have been much involved in the theme of the Second World War with its tragic and heroic episodes. Each of the Central Asian republics has given us outstanding painters. They have always derived their inspiration from their local environment, the specific features of their surrounding nature, the national character of their people, and the traditional forms of their applied arts.

To a certain extent this process coincided with the development of a young generation of painters who made their mark in the late 1950s, who achieved recognition, and who today determine the general character of Soviet painting. This generation of painters established itself as the proponent of the so-called "severe style." Later on this style was mollified and its adherents began to treat of lyrical themes. Zarin, Ossovsky, Salakhov, and Muradian (all included in the exhibition) represent this trend, although, of course, it is not limited to their work alone and one could cite other names as additional examples. All these artists aspire to make maximum use of the medium of painting, its plasticity, color, composition, and linear structure, and they aspire toward this each in his own way. They founded a movement that proved to be important for Soviet art, one that now receives the support of our younger generation of painters. Only a few of the latter are included in this exhibition, since their art has yet to formulate its method and its style. But it is clear that their art has potential.

Obviously, it is wrong to apply just the one criterion of the Russian national tradition to the whole of Soviet painting. But this tradition is directly linked to the painting of Soviet Russia and indirectly to that of the other republics. It is important that each national school develop its own traditions, for these traditions interact, allowing artists to share their experiences. Surely, it is this that guarantees the future progress of art.

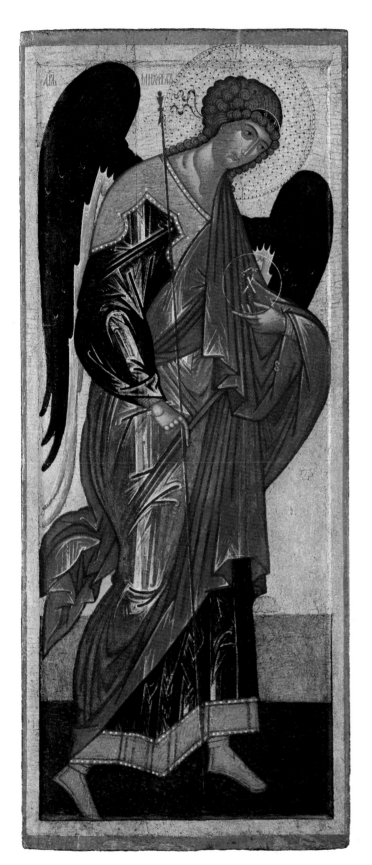

The Archangel Michael

first half of 15th century

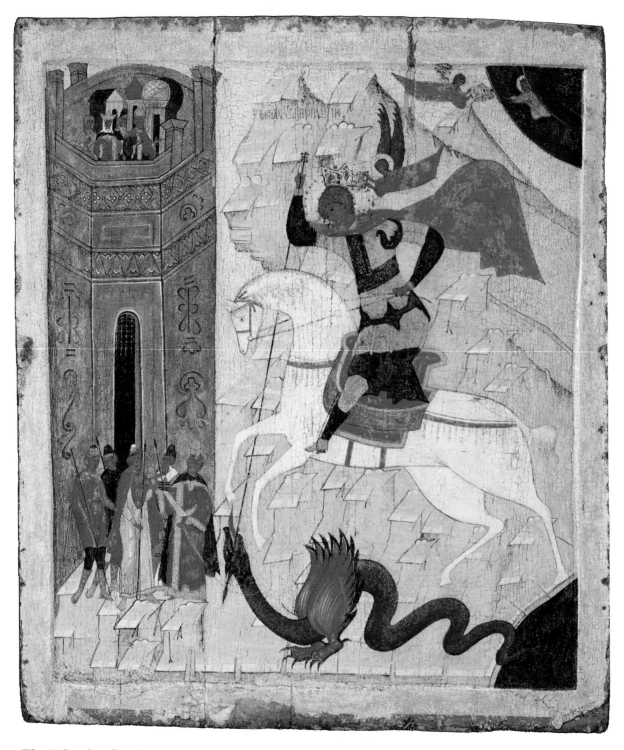

The Miracle of Saint George and the Dragon, early 16th century

F. Y. ALEKSEEV (1753-1824):

View of the Stock Exchange and the Admiralty from the Peter and Paul Fortress

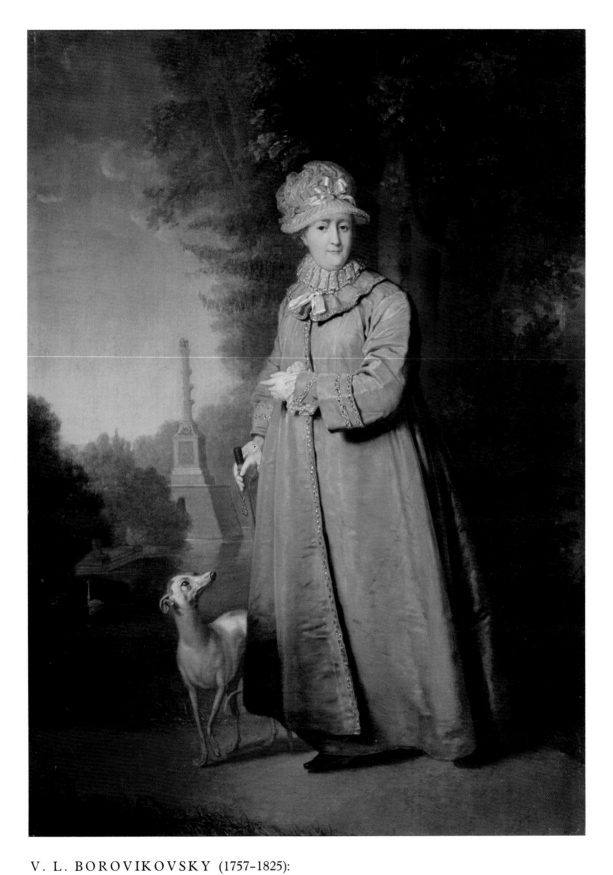

V. L. BOROVIKOVSKY (1757–1825):

Portrait of Catherine the Great Walking in the Park of Tsarskoe Selo

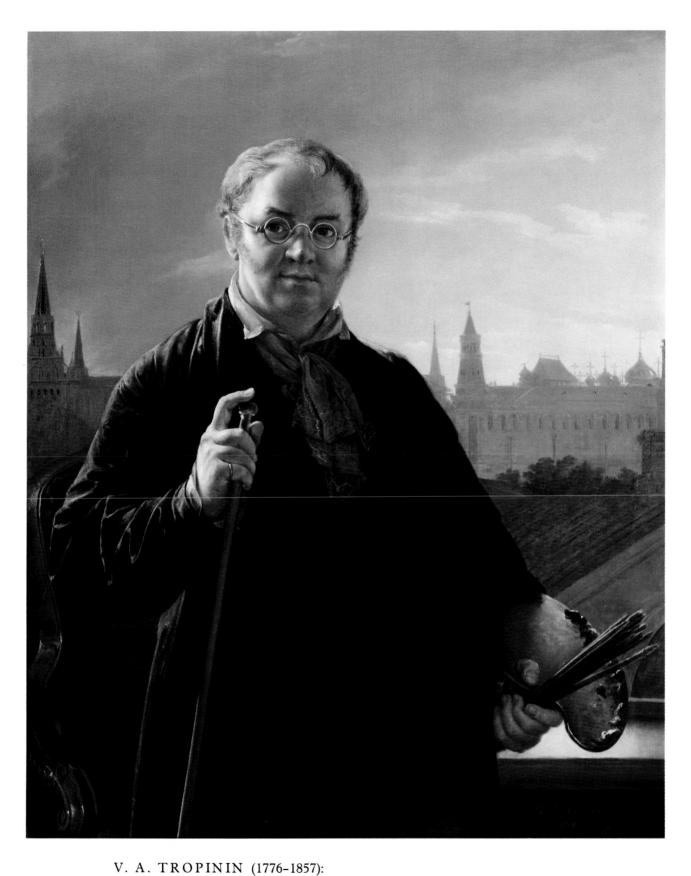

V. A. TROPININ (1776–1857):

Self-portrait with Brushes and Palette against a View of the Kremlin through a Window

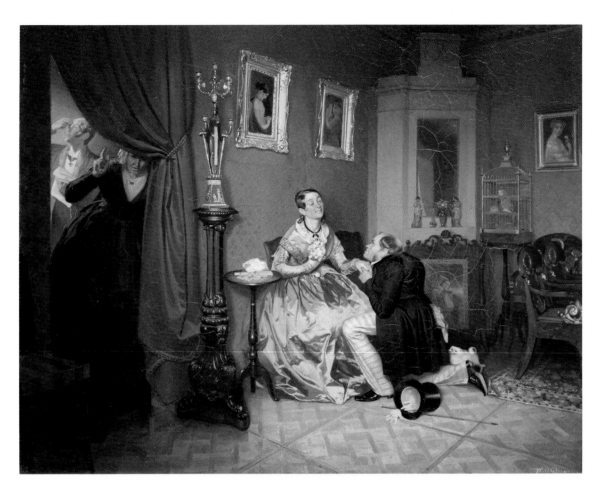

P. A. FEDOTOV (1815–52): **The Fastidious Bride**

A. I. KUINDZHI (1842–1910): **The Birch Grove**

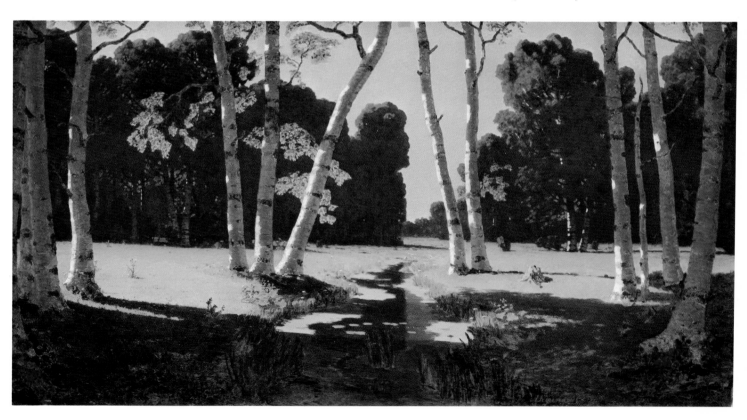

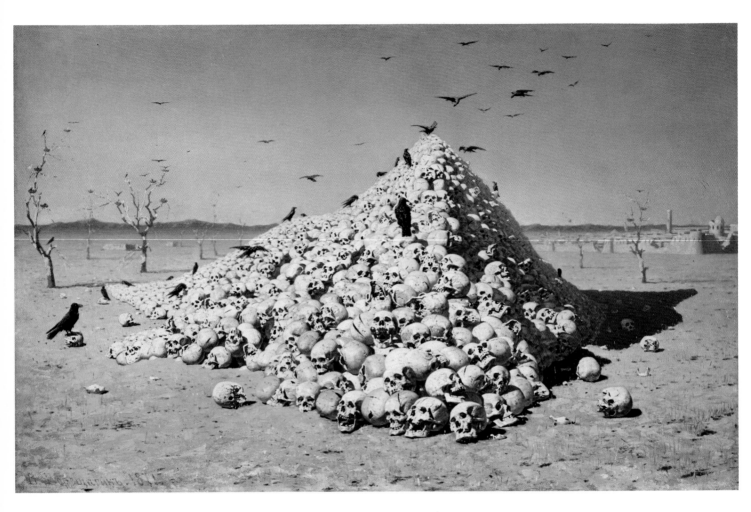

V. V. VERESHCHAGIN (1842–1904): **The Apotheosis of War**

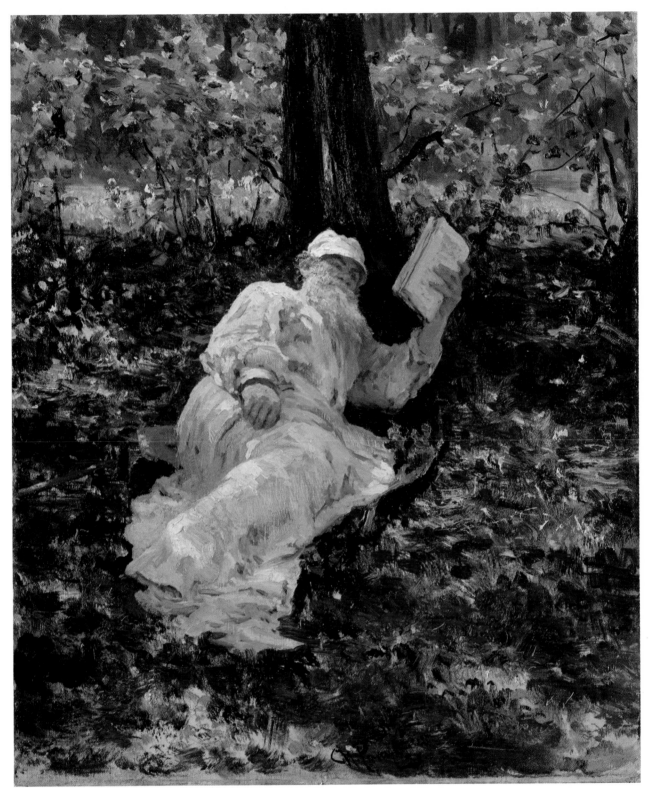

I. E. REPIN (1844–1930): **Lev Nikolaevich Tolstoi Resting in a Forest**

33

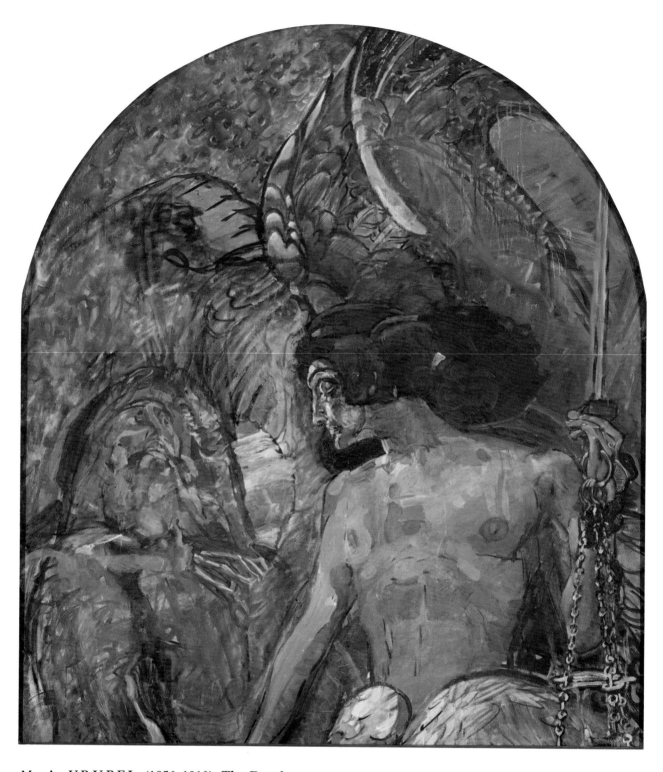

M . A . V R U B E L (1856–1910): **The Prophet**

34

I. I. LEVITAN (1860–1900): **Fresh Wind. The River Volga**

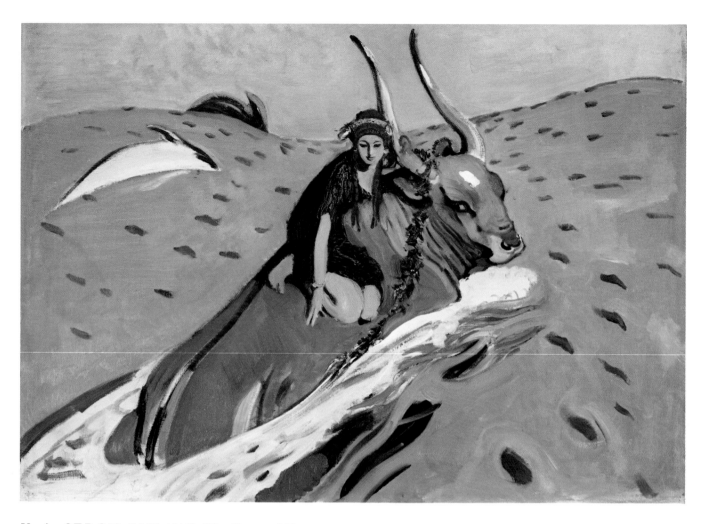

V. A. SEROV (1865-1911): **The Rape of Europa**

B. M. KUSTODIEV (1878-1927): **Portrait of the Singer Feodor Ivanovich Chaliapin**

36

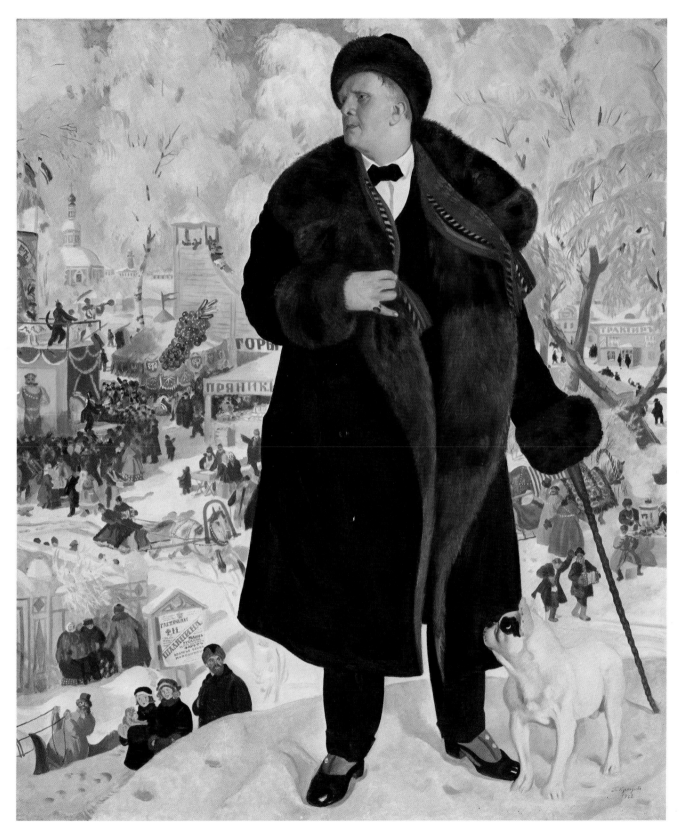

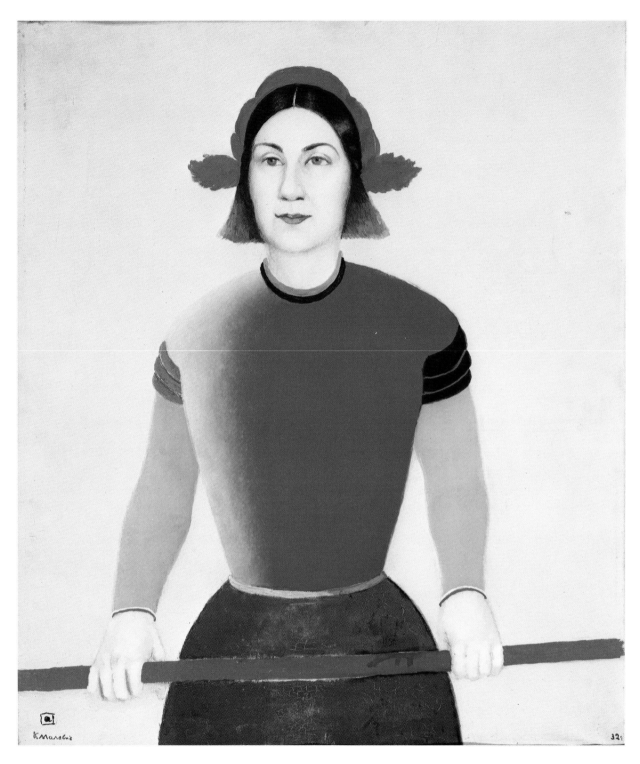

K. S. MALEVICH (1878–1935): **Girl with a Red Pole**

N. S. GONCHAROVA (1881–1962): **Washing Linen**

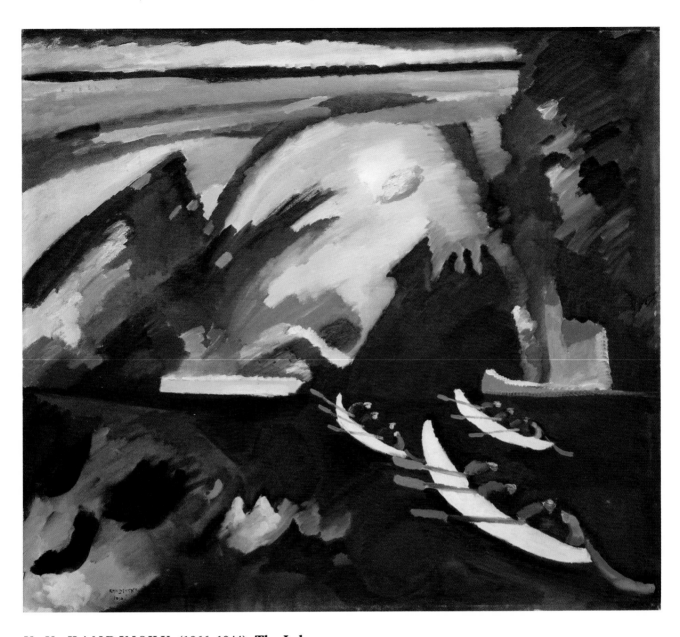

V. V. KANDINSKY (1866–1944): **The Lake**

M. F. LARIONOV (1881–1964): **The Cockerel. Rayonist Study**

M . B . G R E K O V (1882–1934): **The Gun Carriage**

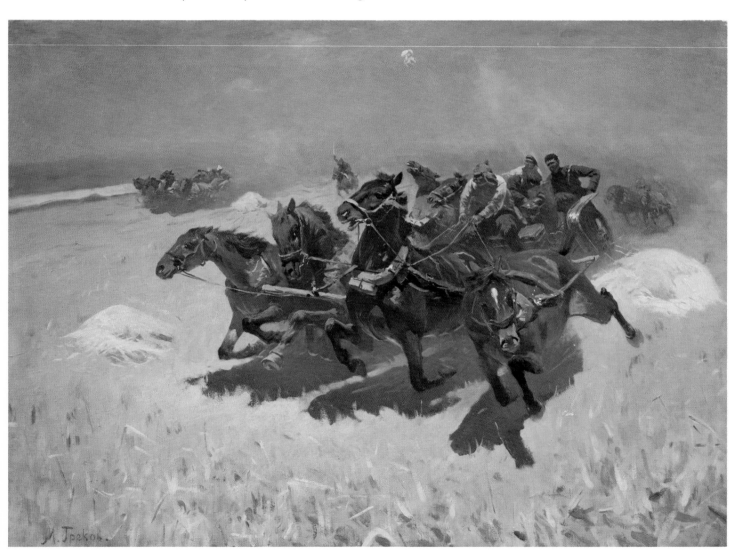

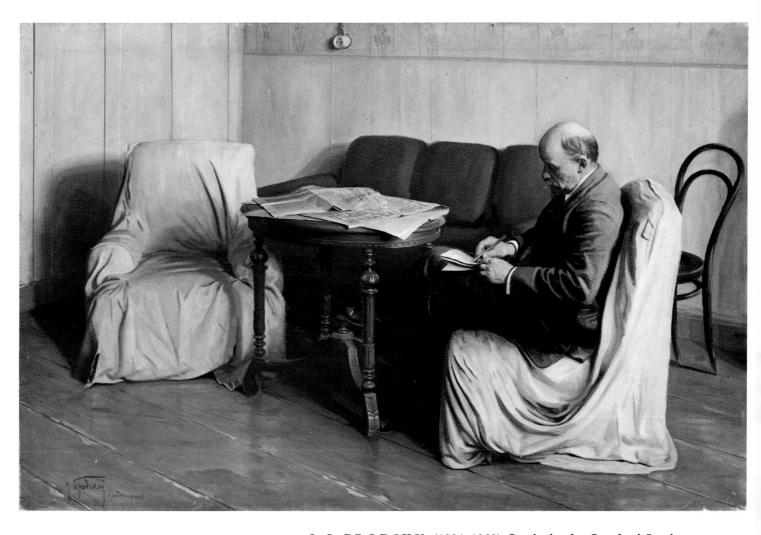

I. I. B R O D S K Y (1884–1939): **Lenin in the Smolnyi Institute**

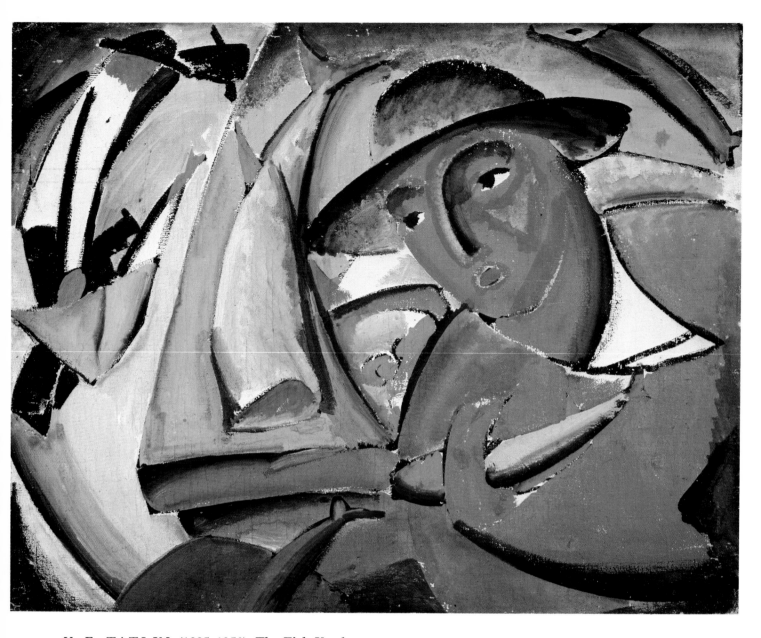

V. E. TATLIN (1885–1953): **The Fish Vendor**

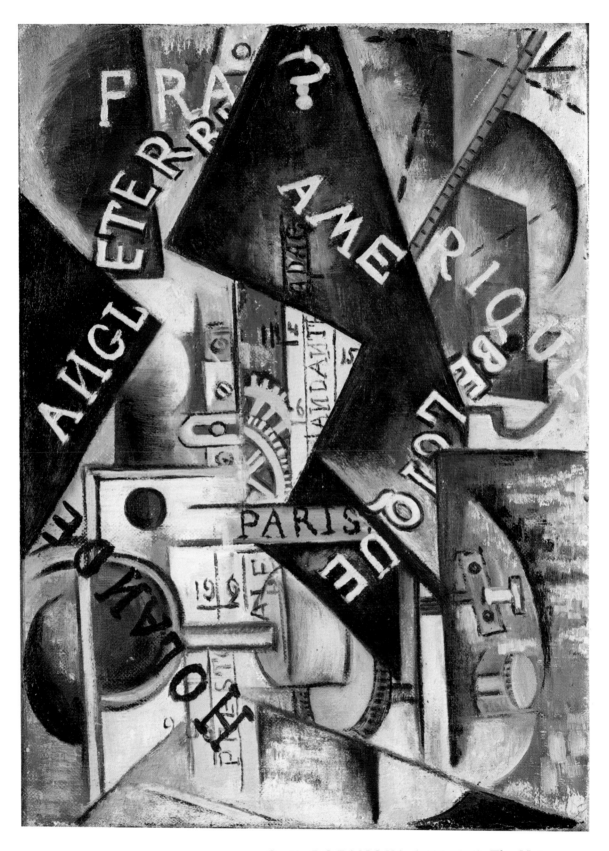

O. V. ROZANOVA (1886–1918): **The Metronome**

Y. I. PIMENOV (1903–): **Give to Heavy Industry**

A. A. DEINEKA (1899–1969): **The Defense of Petrograd**

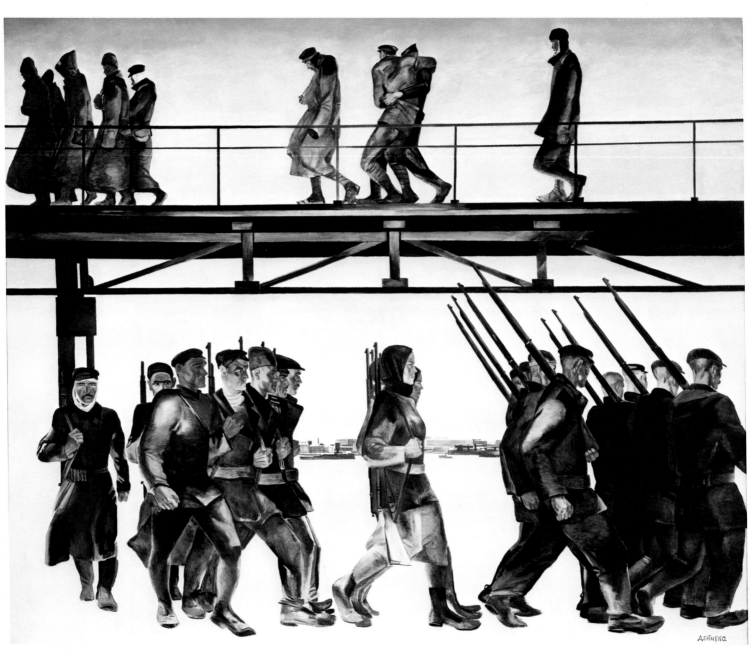

46

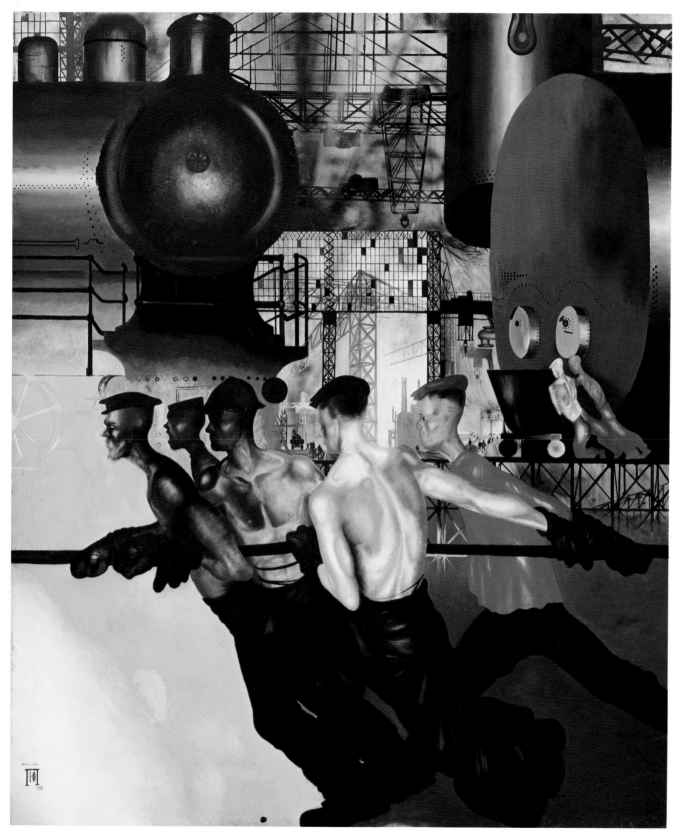

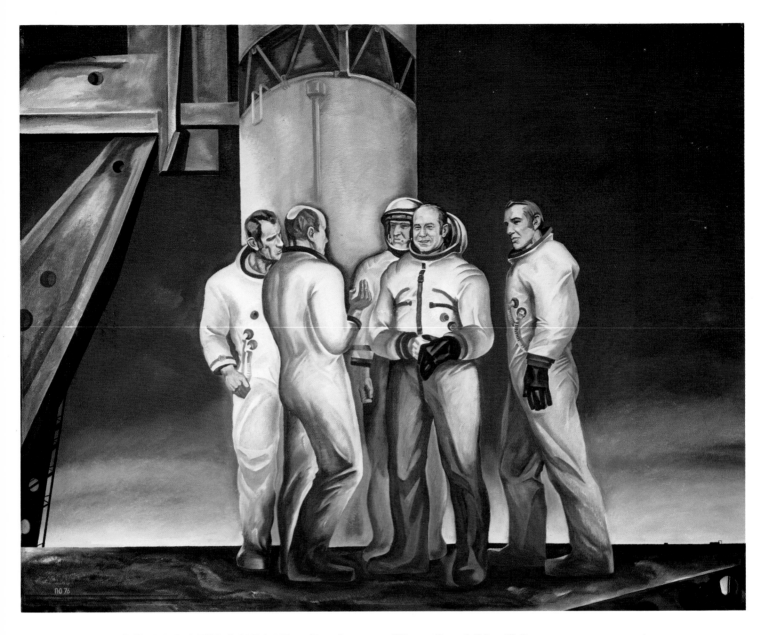

Y. A. POKHODAEV (1927–): **First Rendezvous. "Soyuz" and "Apollo"**

The Paintings

Dimensions are noted in centimeters.
The illustrations appear in a sequence
determined by the artists' birthdates.

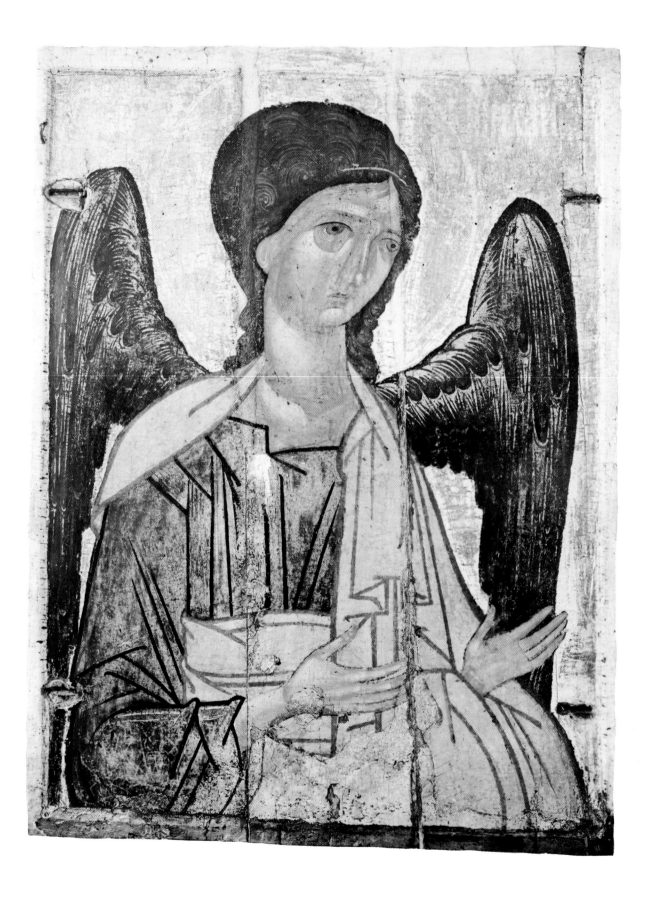

50

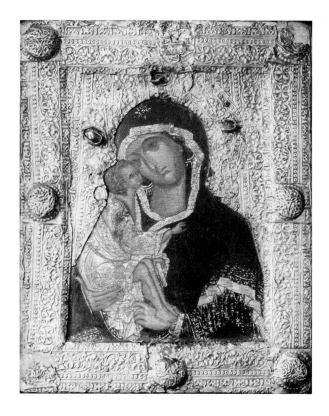

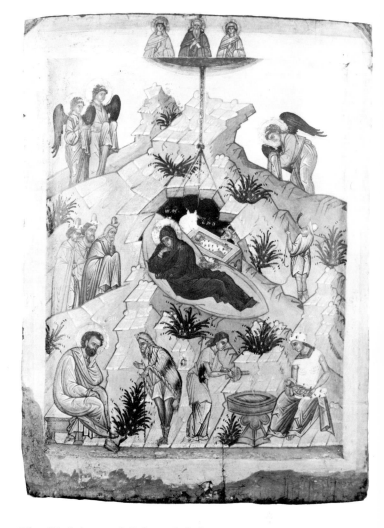

Our Lady of the Don

End of the 14th century. Moscow School.
Limewood, gesso, egg tempera, silver cover with
 punched design, 33 x 26.
Provenance: Troitse-Sergiev Monastery.
Accession: 1930, transferred from the Zagorsk Historical
 and Art Museum.
Tretiakov Gallery. Inventory No. 22958.

The Nativity and Selected Saints

Early 15th century. Novgorod School.
Limewood, gesso on linen, egg tempera, 57 x 42.
Provenance: collection of I. S. Ostroukhov.
Accession: 1929, transferred from the Ostroukhov
 Museum of Icon-Painting and Painting, Moscow.
Tretiakov Gallery. Inventory No. 12010.

The Archangel Michael

Second half of the 14th century. Novgorod School (?).
Board, gesso on linen, egg tempera, 86 x 63.
Provenance: From a deesis tier, Church of the Resurrec-
 tion on Miachino Lake, Novgorod. Formerly in the
 collection of S. P. Riabushinsky.
Accession: 1930, transferred from the Historical
 Museum, Moscow.
Tretiakov Gallery. Inventory No. 12869.

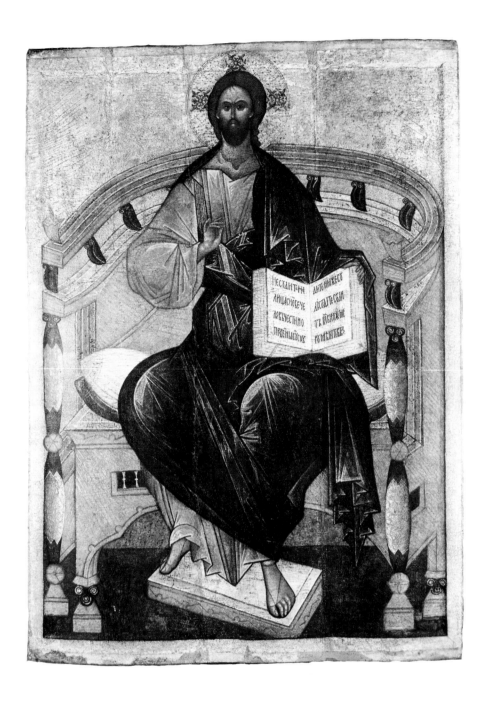

Deesis Tier

First half of the 15th century. Novgorod School.
Christ Enthroned, 157 x 108.
The Virgin, 160 x 58.
St. John the Forerunner (the Baptist), 159 x 59.
The Archangel Gabriel, 159 x 54.
The Archangel Michael, 159 x 64.
The Apostle Paul, 159 x 59.
The Apostle Peter, 158 x 59.

St. George, 159 x 59.
St. Demetrius of Salonica, 170 x 58.
Limewood boards, gesso on linen, egg tempera.
Provenance: the Old Believer Church of the Intercession
 and Assumption, Gavrikovyi Lane, Moscow.
Accession: 1931.
Tretiakov Gallery. Inventory Nos. 20518, 20525, 20519,
 20521, 20522, 20520, 20523, 20524, 20526.

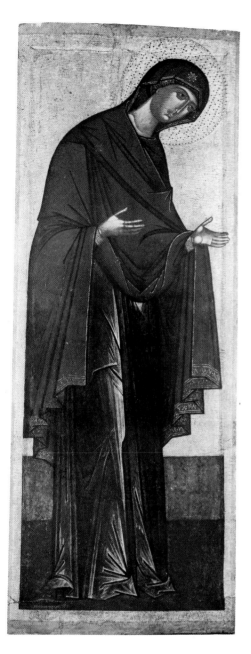

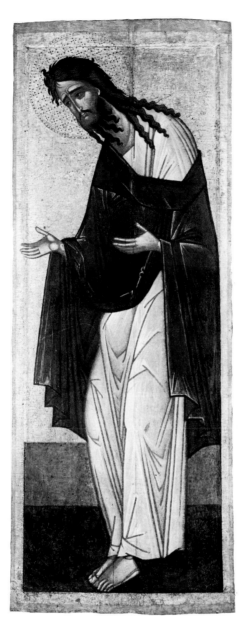

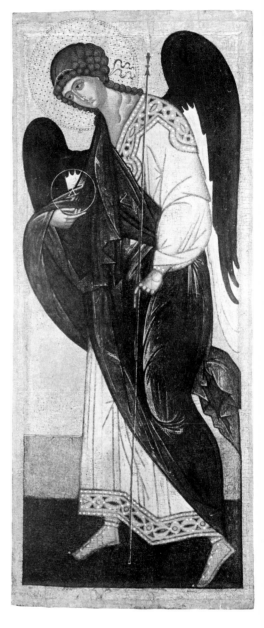

The Virgin

St. John the Forerunner (the Baptist) **The Archangel Gabriel**

53

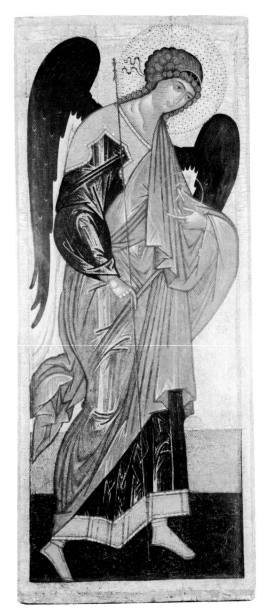

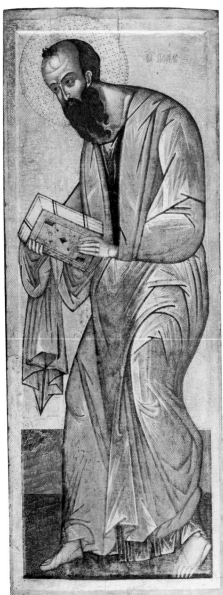

The Archangel Michael

The Apostle Paul

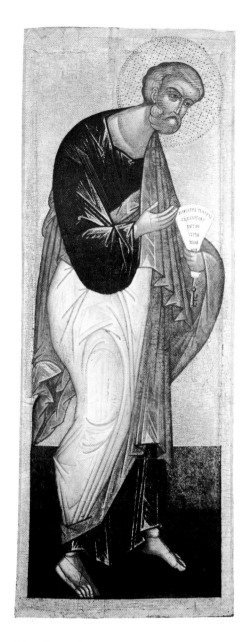

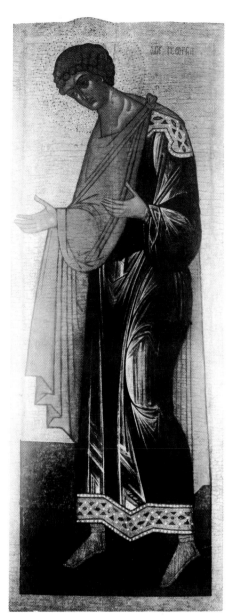

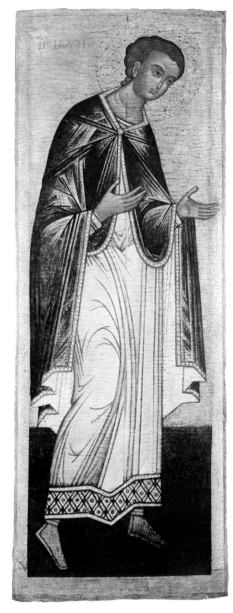

The Apostle Peter

St. George

St. Demetrius of Salonica

55

The Royal Doors (the Annunciation, the Eucharist, the Evangelists)

First half of the 15th century. Novgorod School.
Limewood, gesso on linen, egg tempera. Left door
163 x 45. Right door 164 x 47.
Provenance: collection of A. Morozov.
Accession: 1930, transferred from the Historical
Museum, Moscow.
Tretiakov Gallery. Inventory Nos. 28649, 28650.

Our Lady of Yaroslav

Mid-15th century. Moscow School.
Limewood, gesso on linen, egg tempera, 54 x 42.
Provenance: collection of I. S. Ostroukhov.
Accession: 1929, transferred from the Ostroukhov
Museum of Icon-Painting and Painting, Moscow.
Tretiakov Gallery. Inventory No. 12045.

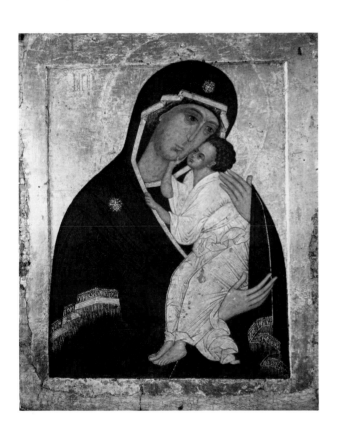

"In Thee Rejoiceth" (Acathistus of Our Lady)

Early 16th century.
Limewood, gesso, egg tempera, 153.5 x 98.
Provenance: Church of St. Nicholas Zariadsky, town of
Murom.
Accession: 1964.
Andrei Rublev Museum of Ancient Russian Art. Inventory No. 96 VP.

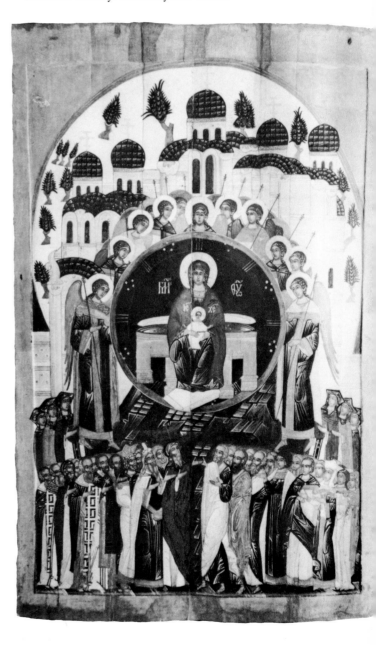

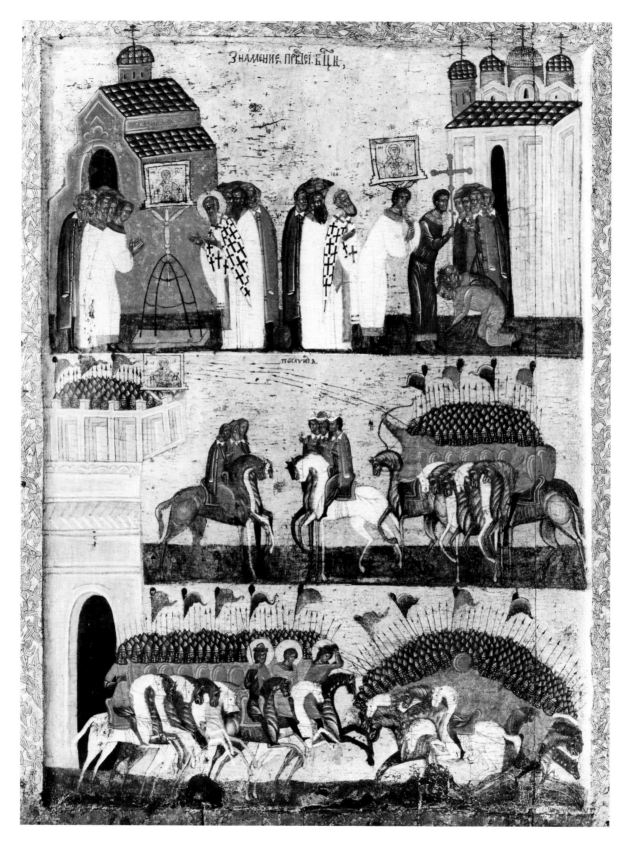

The Battle between the Men of Novgorod and the Men of Suzdal (The Miracle of the Icon of the Sign)

Last quarter of the 15th century. Novgorod School.
Pinewood, gesso on linen, egg tempera, 133 x 90.
Provenance: church in the village of Kuritsk, near Lake Ilmen.
Accession: 1930, transferred from the Historical Museum, Moscow.
Tretiakov Gallery. Inventory No. 14454.

The Miracle of Saints Florus and Laurus

Last quarter of the 15th century. Novgorod School.
Limewood, gesso on linen, egg tempera, 67 x 52.
Provenance: collection of A. V. Morozov.
Accession: 1930, transferred from the Historical Museum, Moscow.
Tretiakov Gallery. Inventory No. 14558.

The Miracle of Saint George and the Dragon

Early 16th century. Rostov-Suzdal School.
Sprucewood, gesso on linen, egg tempera, 115 x 98.
Provenance: church of the cemetery of St. Nicholas by the Cross of Jesus, not far from Rostov. Discovered in the village of Polianka nearby.
Accession: 1937, transferred from the Rostov Museum through the Yaroslav Museum.
Tretiakov Gallery. Inventory No. DR-49.

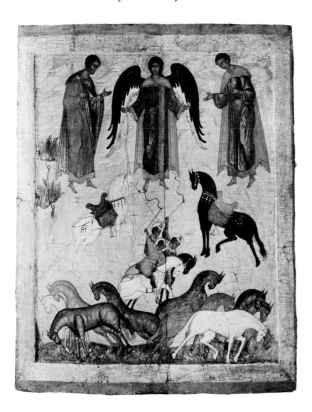

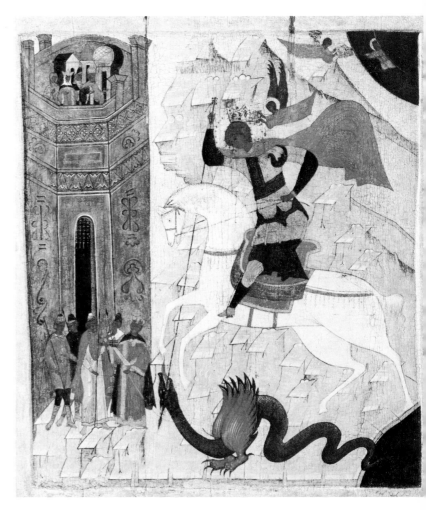

Saints Boris and Gleb

Mid-15th century. Moscow School.
Board, gesso on linen, egg tempera, 89 x 60.
Provenance: village of Vesegonsk, Moscow Region.
Accession: 1975, from the collection of V. A. Aleksandrov.
Tretiakov Gallery. Inventory No. p-45754.

Saint Paraskeva Piatnitsa with Scenes from her Life (not illustrated)

16th century. Tver School.
Wood panel, gesso on linen, egg tempera, 73.5 x 53.
Provenance: village of Porechie, Beretsk Region.
Accession: 1965.
Andrei Rublev Museum of Ancient Russian Art. Inventory No. 435.

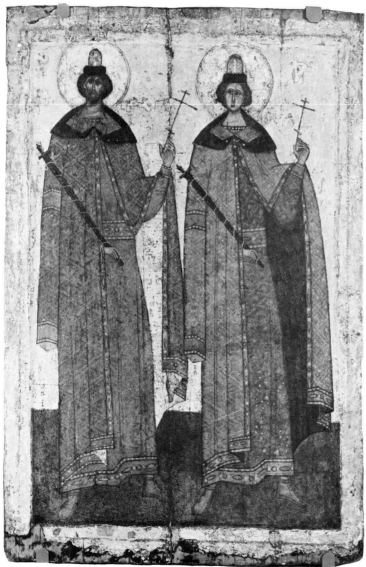

The Prophet Elijah and the Fiery Chariot with Scenes from his Life

Second half of the 16th century. Kostroma (?).
Limewood, gesso on linen, egg tempera, 124 x 107.
Provenance: collection of I. S. Ostroukhov.
Accession: 1929, transferred from the Ostroukhov
 Museum of Icon-Painting and Painting, Moscow.
Tretiakov Gallery. Inventory No. 12072.

Gate to the Altar (The Bosom of Abraham, the Creation of Adam and Eve, the Fall, the Expulsion from Paradise, the Lamentation of Adam and Eve, Daniel in the Lion's Den, the Three Holy Children in the Fiery Furnace, the Pious Soul, the Death of a Monk, the Circles of Hell)

Late 16th or early 17th century.
Board, gesso on linen, egg tempera, 163 x 75.
Provenance: Church of the Epiphany, village of
 Semenovskoe, Moscow Region.
Accession: 1966.
Andrei Rublev Museum of Ancient Russian Art.
 Inventory No. 352.

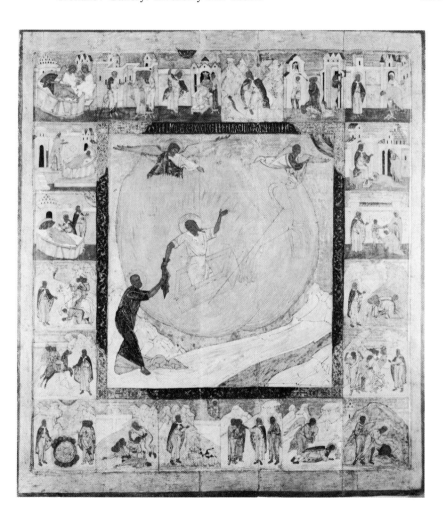

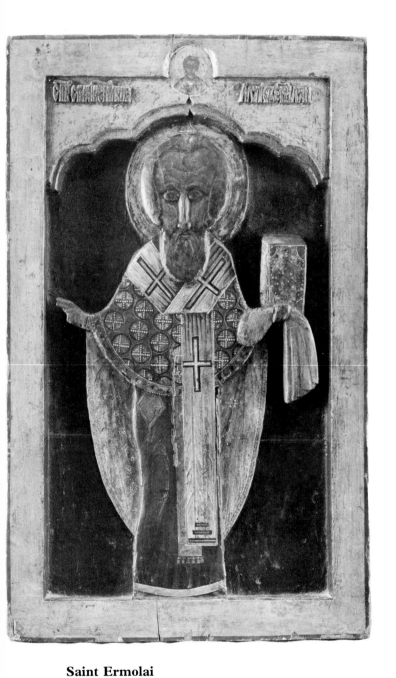

Prince Mikhail Vasilievich Skopin-Shuisky

About 1630. A *parsuna* painted by the Tsar's icon painters.

Limewood, gesso on linen, egg tempera, 41 x 33.

Provenance: Cathedral of the Archangel Michael, in the Moscow Kremlin, where it hung above the tomb of M. V. Skopin-Shuisky. The back carries a wax stamp with a depiction of a church and the inscription: "Of the Moscow Archangel Cathedral."

Accession: 1930, transferred from the Historical Museum, Moscow.

Tretiakov Gallery. Inventory No. 15272.

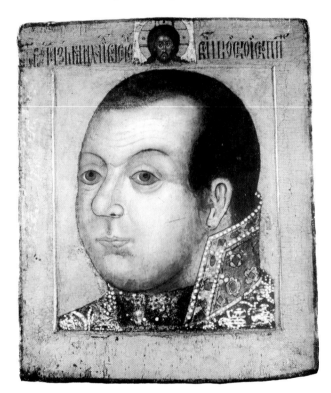

Saint Ermolai

17th century.
Wood panel, carved and painted, 73 x 45.
Accession: 1935.
Tretiakov Gallery. Inventory No. 14951.

UNKNOWN ARTIST. **Portrait of Yakov Fedoro-vich Turgenev (16??–95).** Not later than 1695

Oil on canvas, 105 x 97.5.
Inscription at top: Yakov Turgenev.
Accession: 1929.
Russian Museum. Inventory No. Zh-4902.
*Turgenev was a member of Peter the Great's so-called
"Very All-Drunken and Wild Assembly of the All-
Joking Prince, Daddy of Them All." Peter formed this
association from members of his entourage. It played an
important part in the buffooneries and ceremonies that
accompanied the court entertainments. Turgenev com-
manded a company in the so-called Kozhukhov Cam-*

*paign—grandiose military maneuvers that Peter orga-
nized on the outskirts of Moscow in 1694. Turgenev
celebrated his marriage in January 1695. He died shortly
thereafter. This portrait is part of the so-called Preo-
brazhenskii Cycle (named so from the Preobrazhenskii
Palace where the portraits were hanging in the 18th cen-
tury). The artist, presumably Russian, was probably one
of the masters working in the Armory in Moscow. The
work shows many characteristics of the traditions of
ancient Russian painting. Some scholars ascribe the work
to Ivan Adolsky-Bolshoi (date of birth unknown, died
1750 or later).*

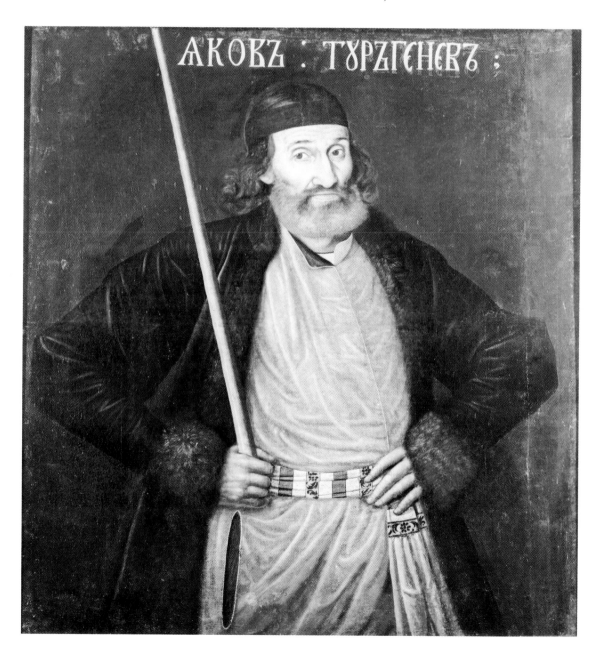

63

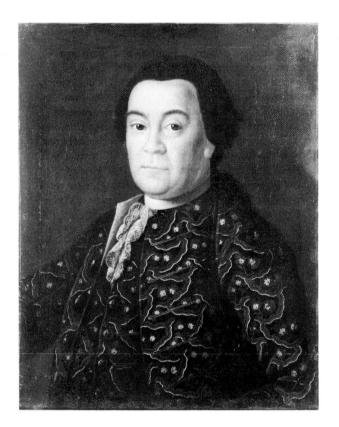

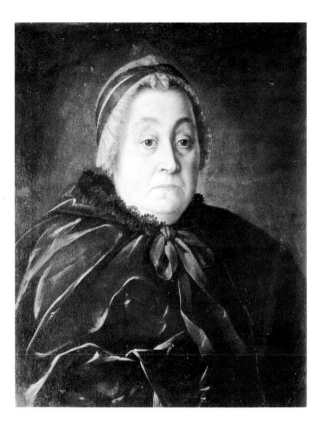

ANTROPOV, A. P. **Portrait of the Collegiate Assessor Dmitrii Ivanovich Buturlin (1703–90).** 1763

Oil on canvas, 60.9 x 47.7.
Signed and dated lower left:.A. Antropov pisa 1763 [A. Antropov painted 1763].
The reverse of the canvas bears the ink inscription: sei portret DmitrIia Ivanovicha ego vysokorodIia Buturlina pisan ot rozhdeniia 59 let [this portrait of His Honor Dmitrii Ivanovich was painted when he was 59]. Upper left: rod. 1703 [born 1703].
Provenance: A. V. Vsevolodsky, P. P. Riabushinsky's estate Aleksandrovskoe, Moscow Province.
Accession: 1920.
Tretiakov Gallery. Inventory No. 4638.

ANTROPOV, A. P. **Portrait of Anna Vasilievna Buturlina (1709–71), Wife of D. I. Buturlin.** 1763.

Oil on canvas, 60.3 x 47.
Signed and dated at right: A. Antropov pisa 1763.
The reverse of the canvas bears the ink inscription: Partret eia vysokorodiia Anny Vasilievny Buturlinoi pisan ot rozhdeniia 54 godu [Portrait of Her Honor Anna Vasilievna Buturlina was painted when.she was 54].
Provenance: A. V. Vsevolodsky, P. P. Riabushinsky's estate Aleksandrovskoe, Moscow Province.
Accession: 1920.
Tretiakov Gallery. Inventory No. 4639.

LEVITSKY, D. G. **Portrait of Aleksandr Dmitrievich Lanskoi (1758–84).** 1782

Oil on canvas, 151 x 117.
Signed and dated at right on pedestal: P. Levitsky 1782 godu.
Accession: 1897.
Russian Museum. Inventory No. 2h-4996.
Lanskoi served in the Life-Guards of the Izmailosky Regiment: in 1779 he served as an aide-de-camp; in 1784 became adjutant general and then lieutenant general. A favorite of Catherine the Great.

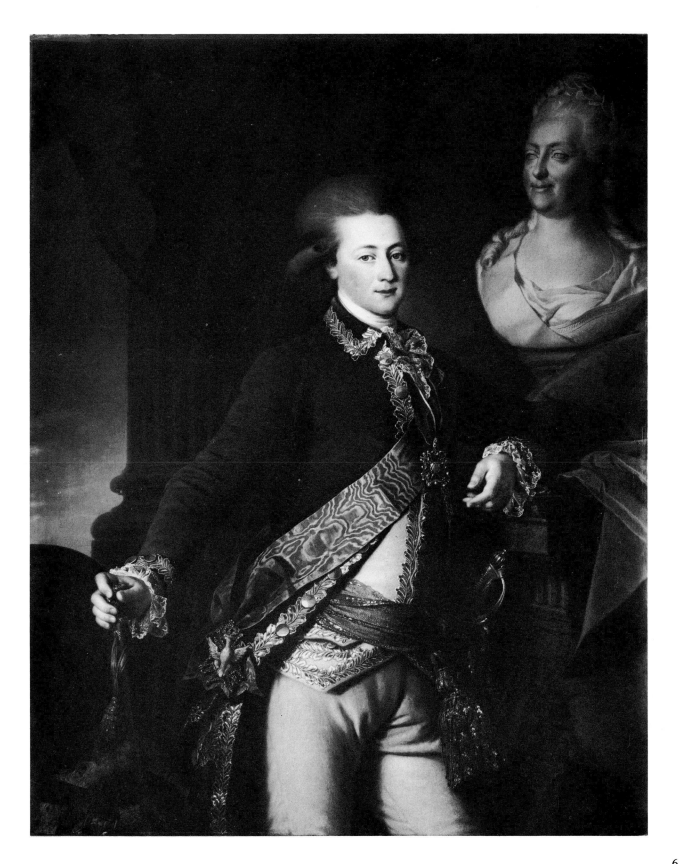

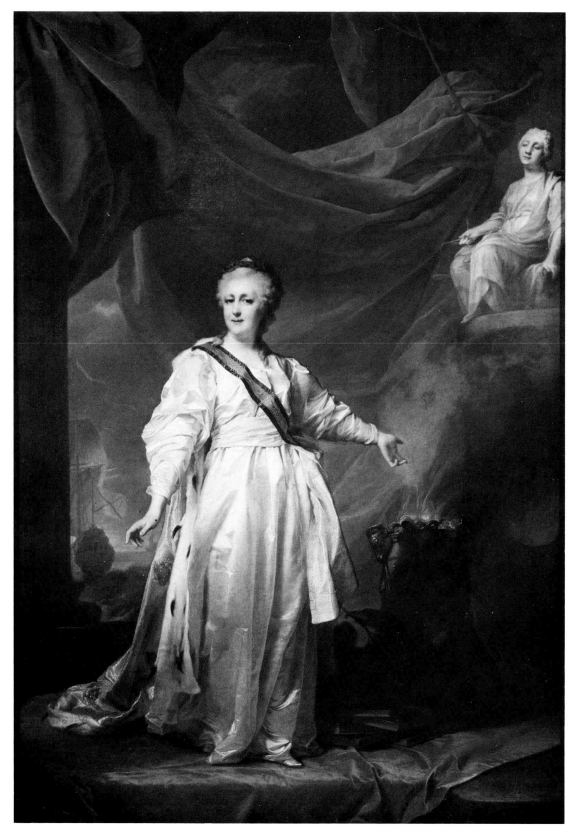

LEVITSKY, D. G. Portrait of Catherine II as Legislatress in the Temple of the Goddess of Justice. Early 1780s

Oil on canvas, 110 x 76.8.
Signed lower right: P. D. Levitsky.
Accession: 1924, from the Leningrad Museum Fund
 (collection of the Academy of Arts).
Tretiakov Gallery. Inventory No. 5813.
This portrait exists in several versions.

ROKOTOV, F. S. Portrait of Varvara Andreevna Obreskova, née Famitsina (1744–1815), Wife of A. M. Obreskov. 1777

Oil on canvas, 59 x 47.3.
Accession: 1919, acquired from V. V. Ushakov.
Tretiakov Gallery, Inventory No. 4330.

ROKOTOV, F. S. Portrait of Aleksei Mikhailovich Obreskov (1720–87), Ambassador to Constantinople. 1777

Oil on canvas, 59.4 x 47.6.
The reverse of the canvas bears the ink inscription
 (Rokotov's?): sei portret Alekseia Mikhailovicha
 Obreskova pisan 1777 Godu ot rozhdeniia Evo na 57
 godu pisal Rokotov [this portrait of Aleksei Mikhail-
 ovich Obreskov was painted in 1777 when he was 57
 Rokotov painted].
Accession: 1919, acquired from V. V. Ushakov.
Tretiakov Gallery. Inventory No. 4329.

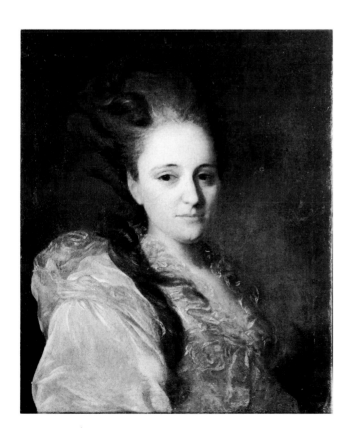

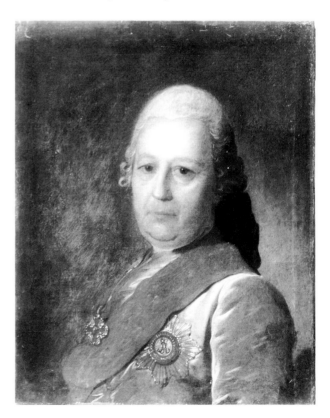

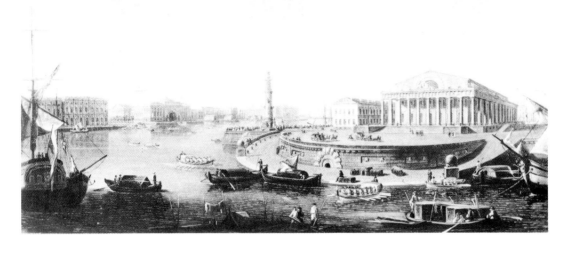

ALEKSEEV, F. Y. **View of the Stock Exchange and the Admiralty from the Peter and Paul Fortress.** 1810

Oil on canvas, 62 x 101.
Signed on the stern of the barge: F. Alekseev. 1810.
Donated by the Grand Duchess Elizaveta Fedorovna
 and Grand Duchess Mariia Pavlovna the Younger,
 1911.
Tretiakov Gallery. Inventory No. 76.
There are several versions of this painting.

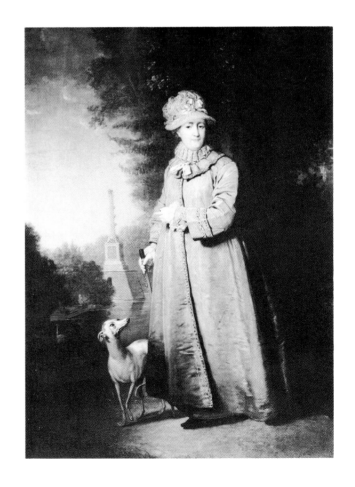

BOROVIKOVSKY, V. L. **Portrait of Catherine the Great Walking in the Park of Tsarskoe Selo.** 1794

Oil on canvas, 94.5 x 66.
Provenance: Collection of P. I. Kharitonenko (formerly
 in the collection of the Counts Benkendorf).
Accession: 1920.
Tretiakov Gallery. Inventory No. 5840.
A version of this portrait is in the Russian Museum.

68

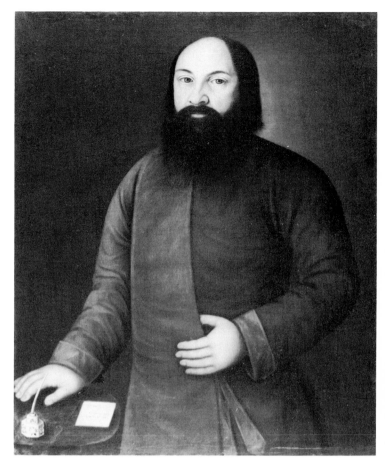

ARGUNOV, N. I. **Portrait of Countess Praskovia Ivanovna Sheremeteva, née Kovaleva, Stage Name Zhemchugova (1768–1803).** 1802

Oil on canvas, 134 x 68.
Accession: 1918, from the main Sheremetev collection.
Ceramics Museum, Kuskovo Estate. Inventory No. Zh-103.

P. I. Sheremeteva, daughter of a serf belonging to Counts P. B. and N. P. Sheremetev, was an outstanding serf actress in the Sheremetev's theater troupe. Her best role was in Grétry's opera Les Mariages samnites. *She was released from serfdom in 1801 and shortly thereafter became the wife of Count N. P. Sheremetev.*

UNKNOWN ARTIST. **Portrait of Vasilii Grigorievich Kusov (1729–88).** 1772

Oil on canvas, 96 x 78.5.
The reverse of the canvas bears the inscription: sei portret pisan s natury sank[t] peterburgskago kuptsa Vasiliia Grigo[r]eva s[y]na v. 1772ᵐ godu v iiune m[esia]tse, otrozhdeniia ego. 43. let i .5 . . . : m[esia]tsev. [this portrait painted from life of the St. Petersburg merchant Vasilii son of Grigoriev . . . in 1772, in the month of June, 43 years and 5 months old].
Accession: 1946.
Russian Museum. Inventory No. Zh-3941.

V. G. Kusov was a merchant of the First Guild in St. Petersburg. He engaged in extensive trade with foreign countries. The artist, probably of the Russian school, was a primitive using the traditions of popular art forms.

TROPININ, V. A. **The Lace-maker.** 1830s

Oil on canvas, 80 x 64.

Provenance: acquired by the Purchasing Commission of the Ostankino Palace Museum from N. V. Frolov, 1970.

Museum of V. A. Tropinin and His Contemporary Moscow Artists. Inventory No. TR-215.

This is a repetition of the painting of the same title, signed and dated 1823, in the Tretiakov Gallery.

TROPININ, V. A. **Self-portrait with Brushes and Palette against a View of the Kremlin Through a Window.** 1844

Oil on canvas, 106 x 83.5.

Signed and dated on window sill: V. Tropinin 1844.

Provenance: acquired by F. E. Vishnevsky from E. K. and Z. B. Krylov, 1967; gift to the Museum, 1969.

Museum of V. A. Tropinin and His Contemporary Moscow Artists, Moscow. Inventory No. TR-1.

Another version (1846) is in the Tretiakov Gallery and still another is in the Saratov Art Museum.

ORLOVSKY, A. O. **A Bashkir on Horseback**

Oil on canvas, 71.2 x 58.
Accession: 1925, transferred from the Rumiantsev
 Museum, Moscow.
Tretiakov Gallery. Inventory No. 5148.

VENETSIANOV, A. G. **Girl with a Harmonica.** 1840s

Oil on canvas, 40 x 30.
Signed lower right: Venestsianov.
Accession; 1918 from the collection of S. S. Abamelek-
 Lazarev.
Gorky Art Museum. Inventory No. Zh-66.

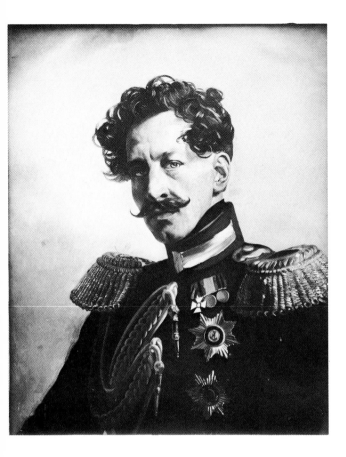

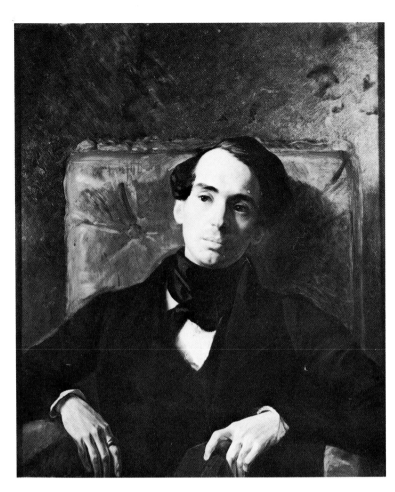

BRIULLOV, K. P. **Portrait of the Adjutant General Count Vasilii Alekseevich Perovsky (1794–1857), Military Governor of Orenburg (1833–42).** 1837

Oil on canvas, 71.3 x 58.
Accession: 1925, from the Rumiantsev Museum, Moscow (collection of F. I. Prianishnikov).
Tretiakov Gallery. Inventory No. 5057.

BRIULLOV, K. P. **Portrait of the Writer Aleksandr Nikolaevich Strugovshchikov (1808–78).** 1840

Oil on canvas, 80 x 66.4.
Provenance: acquired by P. M. Tretiakov from V. A. Diubek, 1871.
Tretiakov Gallery. Inventory No. 219.

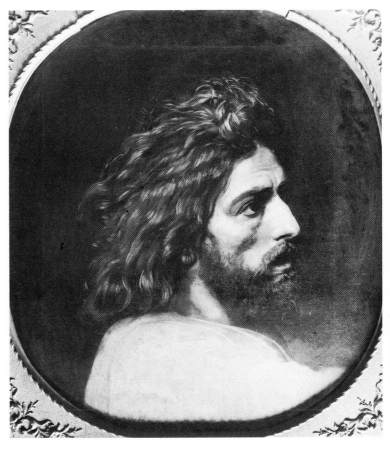

IVANOV, A. A. **Sketch for Left Side of the Painting The Appearance of Christ to the People.** Late 1830s

Oil on paper on canvas, 48.6 x 38.8.
Provenance: acquired by P. M. Tretiakov, 1877.
Tretiakov Gallery. Inventory No. 2514.

IVANOV, A. A. **Head of John the Baptist.** 1840s

Oil on paper on canvas. 64.2 x 58.
Accession: 1927.
Russian Museum. Inventory No. Zh-5284.
Study for the painting The Appearance of Christ to the
 People.

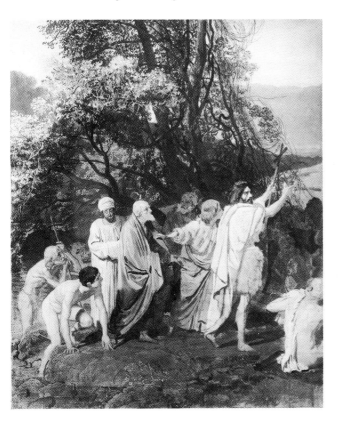

73

IVANOV, A. A. **The Pontine Marshes.** About
1838

Oil on canvas, 31.5 x 94.4.
Provenance: acquired by P. M. Tretiakov.
Tretiakov Gallery. Inventory No. 2585.

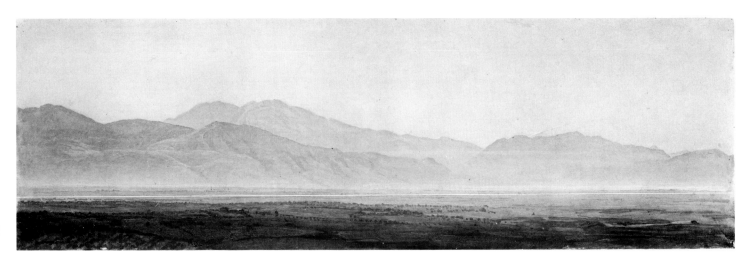

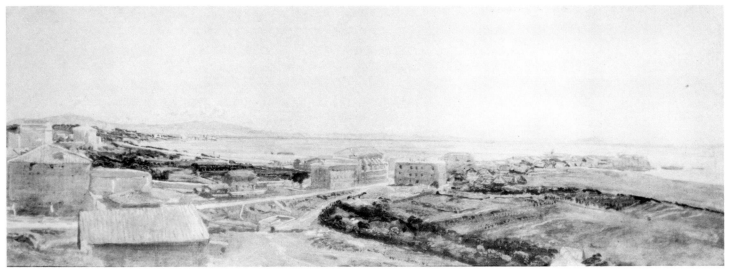

IVANOV, A. A. **Torre-del-Greco, Near Pom-
peii.** 1846

Oil on canvas on cardboard, 22.5 x 60.4.
Accession: 1926.
Tretiakov Gallery. Inventory No. 7980.

FEDOTOV, P. A. **The Fastidious Bride.** 1847

Oil on canvas, 37 x 45.
Signed lower right: P. Fedotov.
The reverse of the canvas bears the artist's inscription
and signature in ink: No. 2. Razborchivaia nevesta.
Soch i Pis . . . Pavel Fedotov. 1847 god [No. 2. The
Fastidious Bride. Composed and Painted by Pavel
Fedotov. 1847]. Below are the words: Prinadlezhit
K. G. Vostriakovoi [Belongs to K. G. Vostriakova].
Accession: 1914, acquired from the brothers R. D. and
B. D. Vostriakov.
Tretiakov Gallery. Inventory No. 291.
Fedotov was nominated for the title of Academician for
this painting. The subject is taken from Krylov's fable
of the same name.

SOROKA, G. V. **View of the Moldino Lake.**
1840s

Oil on canvas, 69 x 88.5.
Signed foreground on tree-trunk: Uchen. Venets.
G. Vasiliev [Pupil of Venetsianov G. Vasiliev].
Kalinin Picture Gallery. Inventory No. Zh-241.

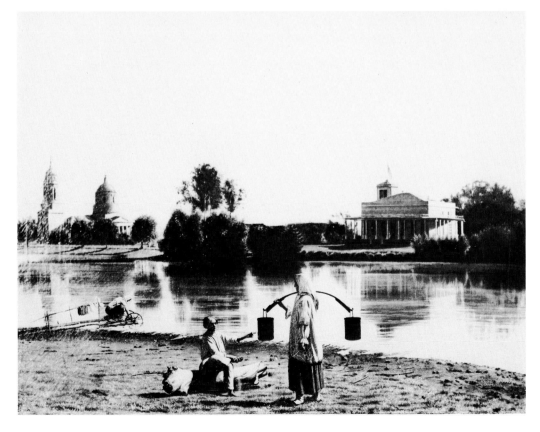

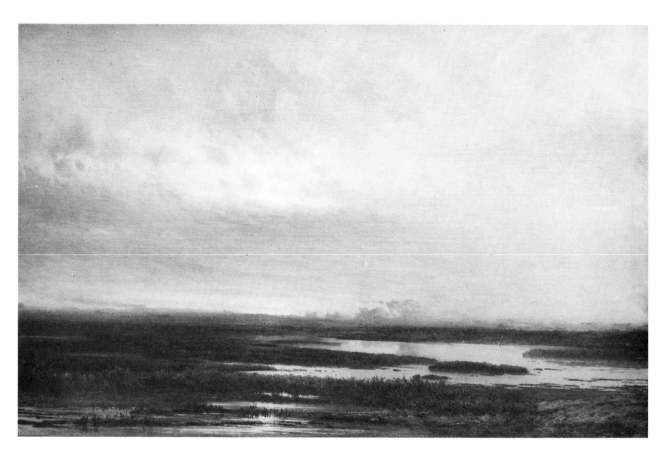

SAVRASOV, A. K. **Sunset Over the Bog.** 1871

Oil on canvas, 88 x 139.5.
Signed and dated lower right: A. Savrasov. 1871.
Accession: 1953.
Russian Museum. Inventory No. Zh-5979.

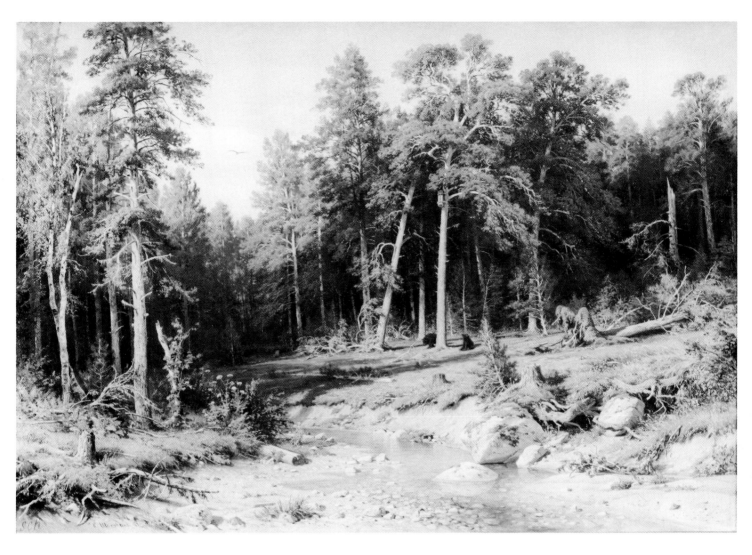

SHISHKIN, I. I. **Pine Forest in Viatsk Province.** 1872

Oil on canvas, 117 x 165.
Signed lower left in pencil: Sh
To the right of this: I. Shishkin. 1872
Provenance: acquired by P. M. Tretiakov from the artist, 1872.
Tretiakov Gallery. Inventory No. 834.

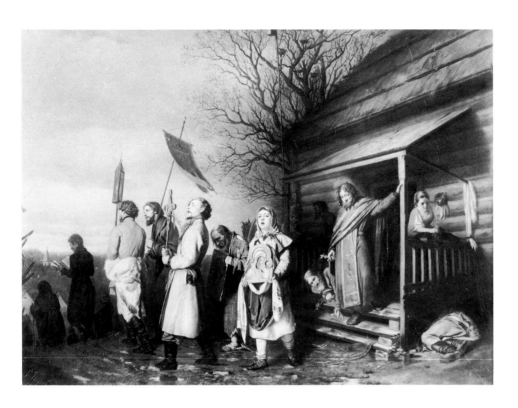

PEROV, V. G. **Easter Procession in the Country.** 1861

Oil on canvas, 71.5 x 89.
Signed and dated lower left: V. Perov. 1861 g.
Provenance: acquired by P. M. Tretiakov from the
 artist, 1861.
Tretiakov Gallery. Inventory No. 359.

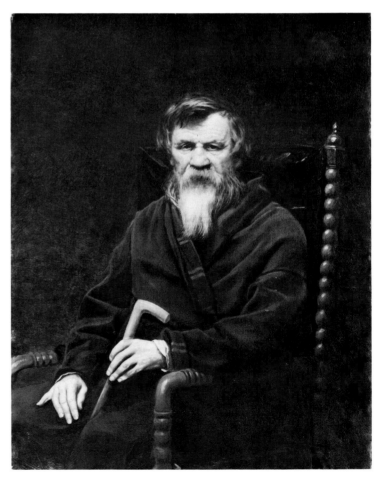

PEROV, V. G. **Portrait of the Historian Mikhail Petrovich Pogodin (1800–75).** 1872

Oil on canvas, 115 x 88.8.
Signed and dated lower left: V. Perov. 1872.
Provenance: acquired by P. M. Tretiakov.
Tretiakov Gallery. Inventory No. 388.

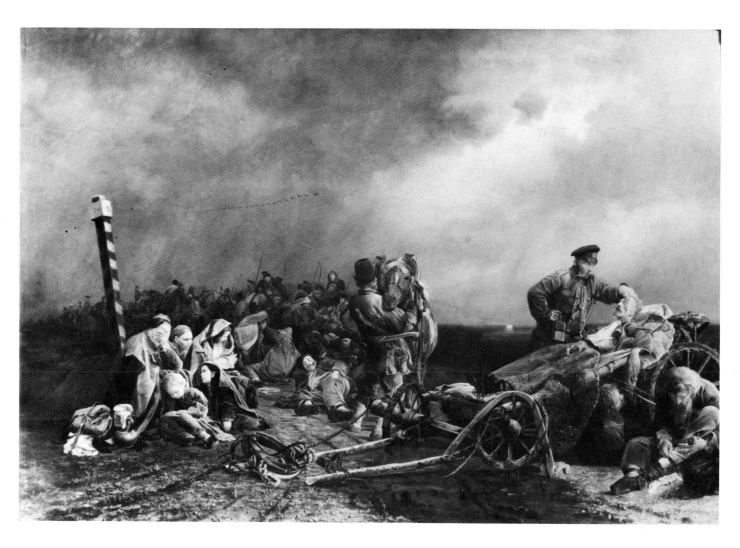

YAKOBI, V. I. **The Prisoners' Halt.** 1861

Oil on canvas, 98.6 x 143.5.
Signed and dated lower left: V. Yakobi 1861 god.
Provenance: acquired by P. M. Tretiakov from the art-
 ist, 1861.
Tretiakov Gallery. Inventory No. 354.
*Yakobi received the Great Gold Medal for this work from
 the Academy of Arts, 1861.*

KRAMSKOI, I. N. **Portrait of the Writer Dmitrii Vasilievich Grigorovich (1822–99).** 1876

Oil on canvas, 86 x 68.
Signed and dated lower left: I. Kramskoi, 1876 (the letters I and K intertwined).
Provenance: acquired by P. M. Tretiakov from the artist, 1876.
Tretiakov Gallery. Inventory No. 662.

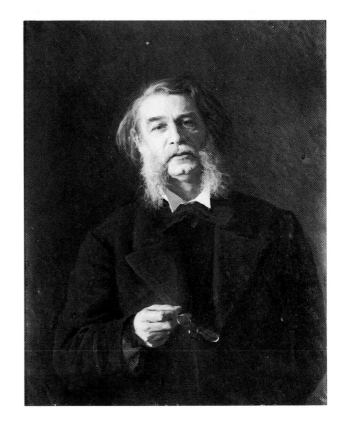

KUINDZHI, A. I. **The Birch Grove.** 1879

Oil on canvas, 91 x 181.
Signed lower right: A. Kuindzhi. 1879 g.
Provenance: acquired by P. M. Tretiakov from the artist, 1879.
Tretiakov Gallery. Inventory No. 882.

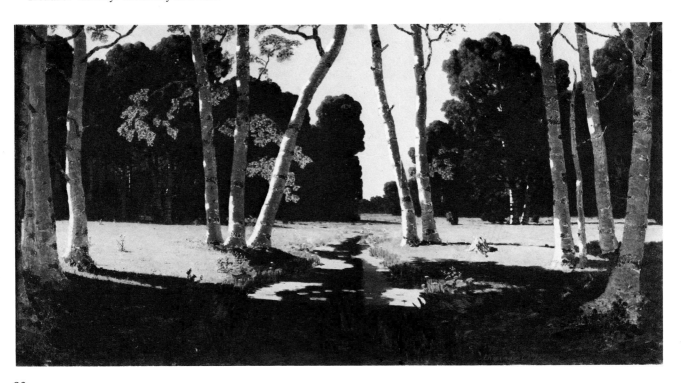

KUINDZHI, A. I. **Autumn.** 1890–95

Oil on paper mounted on canvas, 36.8 x 58.7.
Accession: 1930.
Russian Museum. Inventory No. Zh-4193.

VERESHCHAGIN, V. V. **The Apotheosis of War.** 1871

Oil on canvas, 127 x 197.
Signed lower left: V. Vereshchagin, 1871.
On the frame are the artist's own inscriptions. Top:
Apoteoza voiny [The Apotheosis of War]; Bottom:
Posviashchaetsia vsem velikim zavoevateliam, pro-
shedshim, nastoiashchim i budushchim [Dedicated to
All Great Conquerors Past, Present and Future].
Provenance: acquired by P. M. Tretiakov from the art-
ist, 1874.
Tretiakov Gallery. Inventory No. 1992.
Painted after the artist's travels through Turkestan.

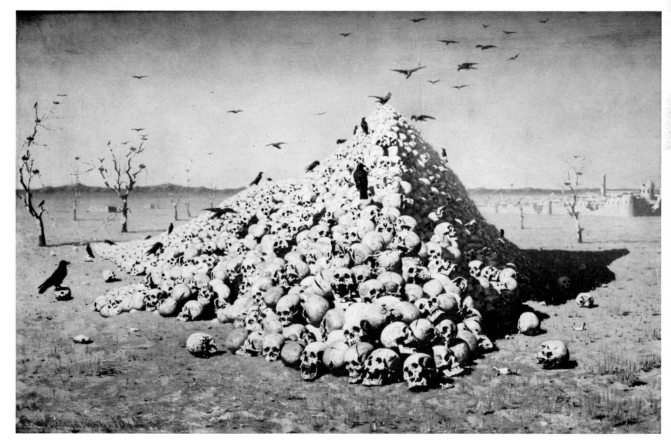

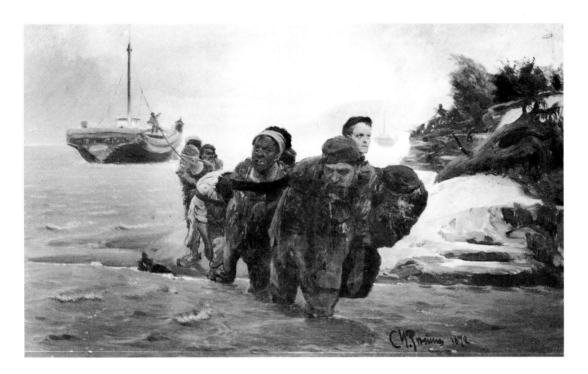

REPIN, I. E. **The Volga Boatmen. Wading.** 1872

Oil on canvas, 62 x 97.
Signed and dated lower right: I. Repin 1872.
Signed and dated above, left of this: I. Repin 1872.
Provenance: acquired by the Council of the Tretiakov

Gallery from D. V. Stasov, 1906.
Tretiakov Gallery. Inventory No. 709.
A variant, entitled The Volga Boatmen (*1870–73*), *is in the Russian Museum.*

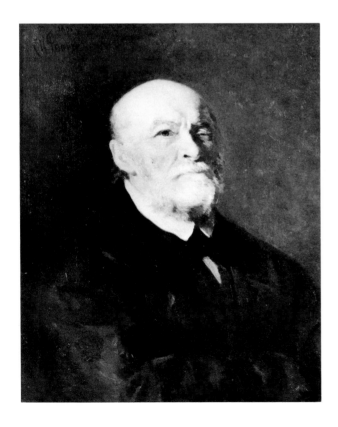

REPIN, I. E. **Portrait of the Surgeon Nikolai Ivanovich Pirogov (1810–81).** 1881

Oil on canvas, 64.7 x 53.7.
Dated and signed upper left: 1881 I. Repin.
Accession: 1921.
Russian Museum. Inventory No. Zh-4065.
Another version, of the same year, is in the Tretiakov Gallery. The Academician N. I. Pirogov was an outstanding surgeon and anatomist. His researches constituted the foundation of experimental anatomy in surgery. He was also the founder of military field surgery and of surgical anatomy.

REPIN, I. E. **Rest. Portrait of Vera Alekseevna Repina (1854–1918), the Artist's Wife.** 1882

Oil on canvas, 140 x 91.5.
Dated and signed in right background: 1882 I. Repin.
Provenance: acquired by P. M. Tretiakov from the artist.
Tretiakov Gallery. Inventory No. 732.

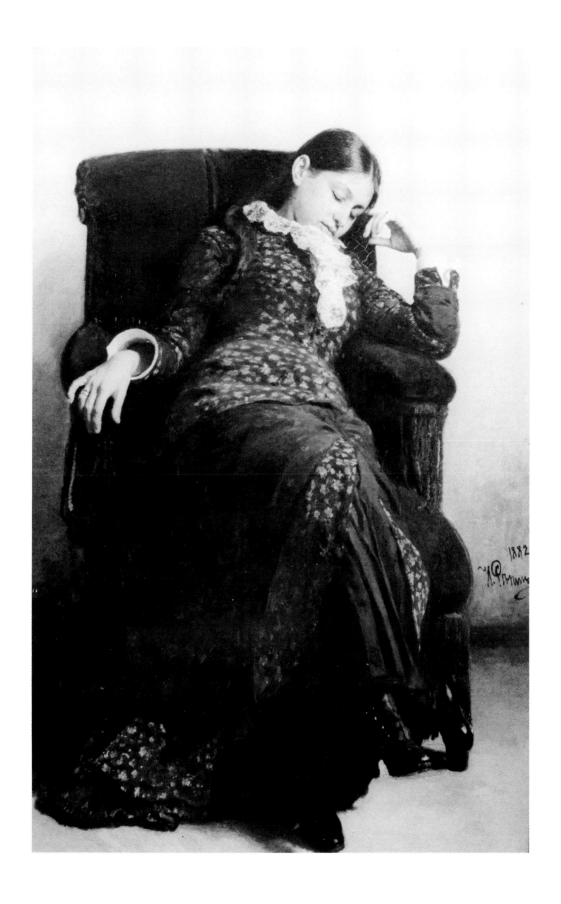

83

REPIN, I. E. **Lev Nikolaevich Tolstoi Resting in a Forest.** 1891

Oil on canvas, 60 x 50.
Dated and signed lower center: 1891 I. Repin.
Accession; 1924, from the Tsvetkov Gallery, Moscow.
Tretiakov Gallery. Inventory No. 6313.

REPIN, I. E. **Portrait of the Composer Nikolai Andreevich Rimsky-Korsakov (1844–1908).** 1893

Oil on canvas, 125 x 89.5.
Signed and dated lower left: I. Repin 1893.
Accession: 1904.
Russian Museum. Inventory No. Zh-4013.

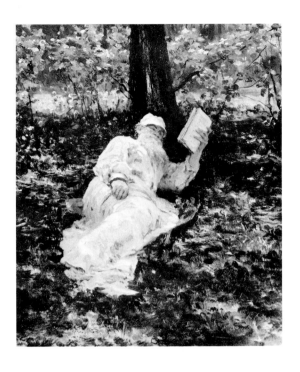

YAROSHENKO, N. A. **Life Is Everywhere.** 1888

Oil on canvas, 212 x 106.
Signed lower right: N. Yaroshenko.
Lower left is the artist's inscription: Kragi. 1888.
Provenance: acquired by P. M. Tretiakov from the artist, 1888.
Tretiakov Gallery. Inventory No. 701.

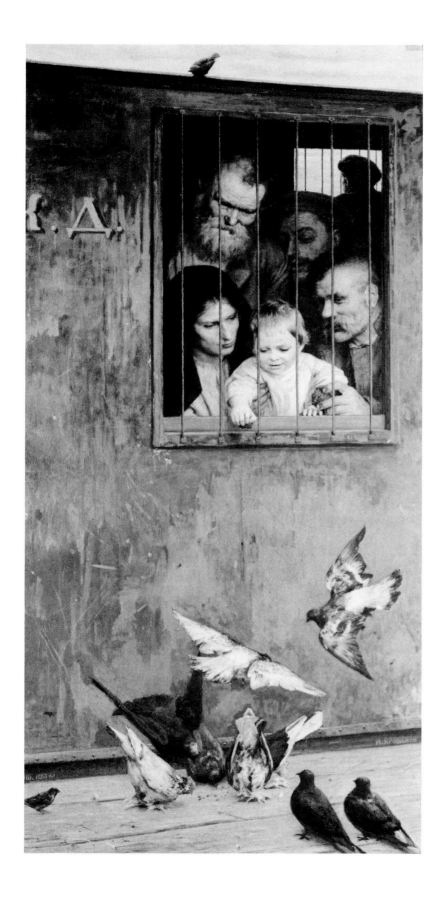

SURIKOV, V. I. **Boiarynia Wearing a Purple Winter Coat.** 1886

Oil on canvas, 62 x 35.7.
Signed and dated upper right: V. Surikov 1886.
The reverse of the canvas bears the inscription: Rabota khudozhnika Surikova udostoveriaiu V. E. Makovskii 1911 20 mart [The work of the artist Surikov. Certified: V. E. Makovsky 20 March, 1911].
Provenance: acquired from Ya. I. Acharkan, 1925.
Tretiakov Gallery. Inventory No. 6046.
Another study for the Boiarynia Morozova.

SURIKOV, V. I. **The Storming of the Snow Town.** 1891

Oil on canvas, 156 x 282.
Signed and dated lower left: V. Surikov. 1891.
Accession: 1908.
Russian Museum. Inventory No. Zh-4235.
Surikov's only painting devoted to an everyday theme. He painted it in his hometown of Krasnoiarsk. It is based on a traditional game played in Siberia at Shrovetide.

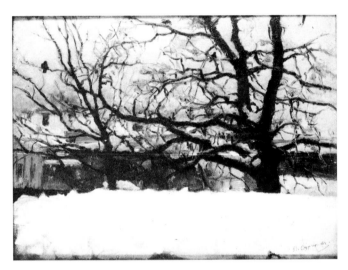

SURIKOV, V. I. **Winter in Moscow**

Oil on canvas, 26 x 34.7.
Signed lower right in ink: V. Surikov.
Provenance: acquired from the artist's heirs, 1940.
Tretiakov Gallery. Inventory No. 25349.
Study for the painting Boiarynia Morozova, *1887, in the Tretiakov Gallery.*

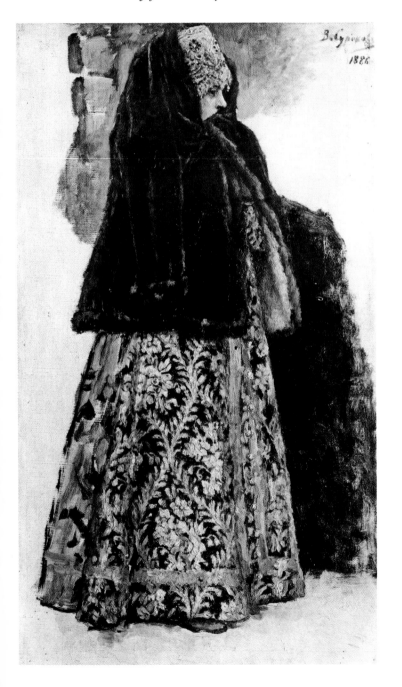

SURIKOV, V. I. **A Tsarevna Visiting a Convent.** 1912

Oil on canvas, 144 x 202.
Signed and dated lower left: V. Surikov. 1912 g.
Provenance: acquired from A. K. Kraitor, 1958.
Tretiakov Gallery. Inventory No. Zh-158.

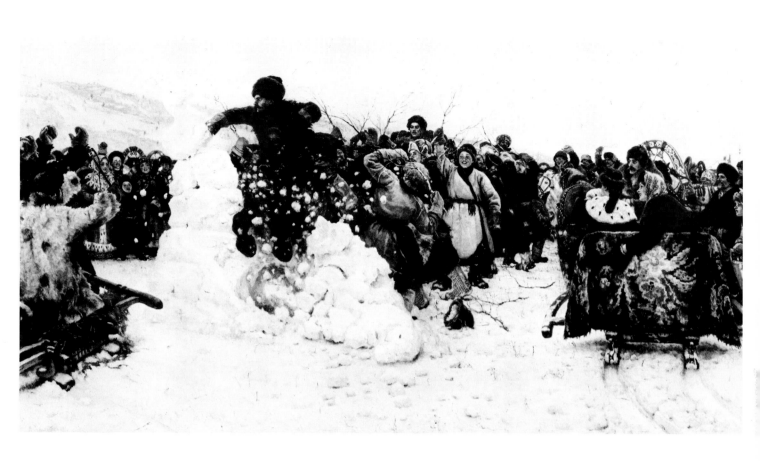

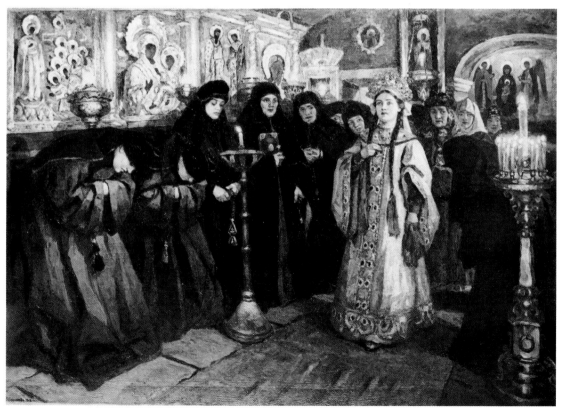

VASILIEV, F. A. **Lagoons on the River Volga**

Oil on canvas, 70 x 127.
Provenance: acquired by P. M. Tretiakov at the posthumous exhibition of Vasiliev's work, 1874.
Tretiakov Gallery. Inventory No. 902.

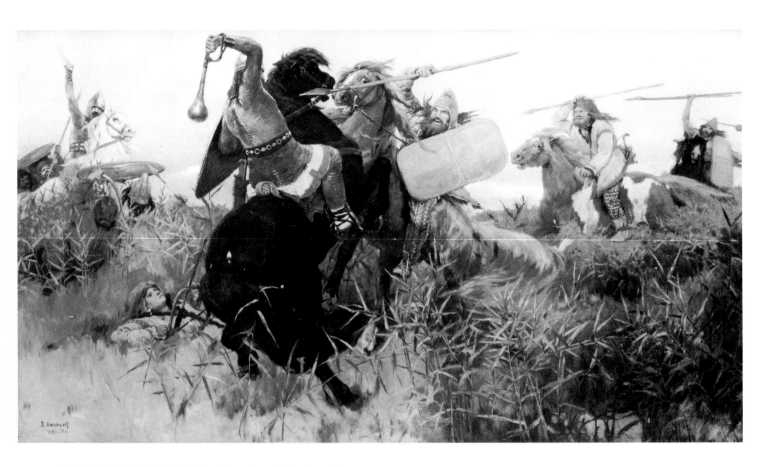

VASNETSOV, V. M. **Battle of the Scythians and the Slavs.** 1881

Oil on canvas, 161.5 x 295.
Signed lower left: V. Vasnetsov 1881 Msk.
Accession: 1903.
Russian Museum. Inventory No. Zh-4215.
A sketch for this painting, The Scythians, *dated 1879, is in the Tretiakov Gallery.*

VASNETSOV, A. M. **Moscow in the Mid-18th Century. Moscow River Bridge and the Water-gate.** 1901

Oil on canvas, 141 x 176.
Provenance: acquired from the artist by the Council of the Tretiakov Gallery, 1900.
Tretiakov Gallery. Inventory No. 973.

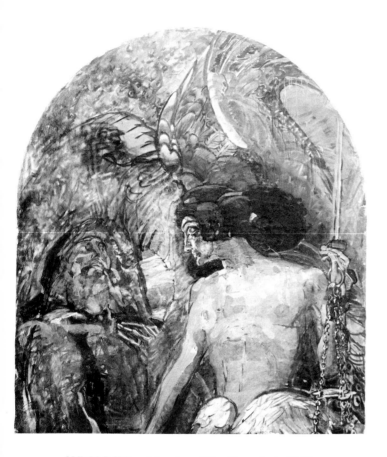

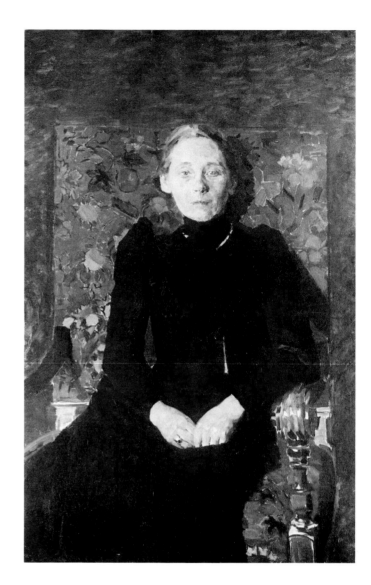

VRUBEL, M. A. **The Prophet.** 1898

Oil on canvas, 145 x 131.
Provenance: acquired by the Council of the Tretiakov
 Gallery from A. A. Vrubel, the artist's sister, 1913.
Tretiakov Gallery. Inventory No. 1460.

VRUBEL, M. A. **Portrait of Mariia Ivanovna
Artsibusheva, née Lakhtina (1859–1919), Wife of
K. D. Artsibushev.** 1897

Oil on canvas (unfinished), 124.9 x 80.2.
Accession: 1927 from the State Museum Fund (for-
 merly in the collection of M. N. Riabushinsky).
Tretiakov Gallery. Inventory No. 9120.

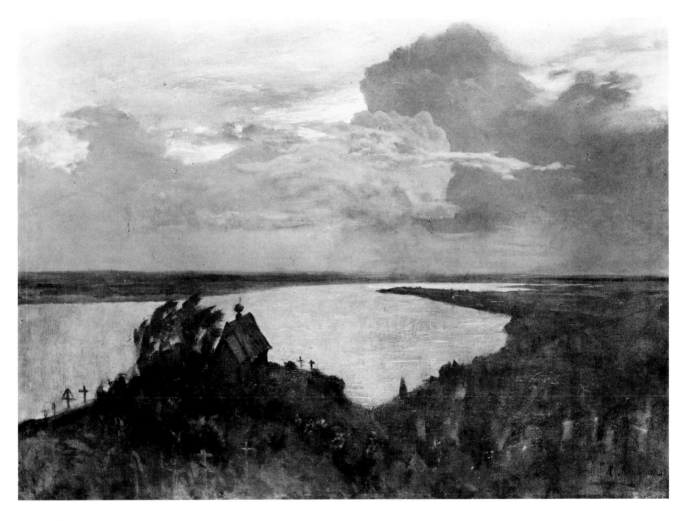

LEVITAN, I. I. **Above Eternal Peace**

Oil on canvas, 95 x 127.
Signed lower right: I. Levitan.
Provenance: acquired by P. M. Tretiakov from the art-
 ist, 1898.
Tretiakov Gallery. Inventory No. 1487.
A study for the painting of the same name (1894) in the
 Tretiakov Gallery.

LEVITAN, I. I. Fresh Wind. The River Volga.
1895

Oil on canvas, 72 x 123.
Signed lower right: I. Levitan 91 [partly erased] 95.
Provenance: bequeathed by M. A. Morozov, accessioned
 1910.
Tretiakov Gallery. Inventory No. 1488.

KOROVIN, K. A. **A Paris Café**

Oil on canvas, 51.8 x 42.8.
Accession: 1927, from the Museum of New Western
 Art (former collection of I. A. Morozov).
Tretiakov Gallery. Inventory No. 9105.

ARKHIPOV, A. E. **In the North.** 1912

Oil on canvas, 80 x 68.5.
Accession: 1929 from the Ostroukhov Museum of
 Icon-Painting and Painting.
Tretiakov Gallery. Inventory No. 11004.

NESTEROV, M. V. **The Vision of the Young Bartholemew.** 1923

Oil on canvas, 103.5 x 135.
Signed and dated lower left: Mikhail Nesterov. 1923 g.
Accession: 1967, acquired from M. G. Chizh.
Abramtsevo Museum. Inventory No. Zh-277.
The first version of this work, dated 1889–1900, is in the Tretiakov Gallery. It portrays an episode in the boyhood of the 14th-century monk and spiritual leader Sergii Radonezhsky (Sergius of Radonezh).

94

NESTEROV, M. V. Portrait of the Sculptress Vera Ignatievna Mukhina (1889–1953). 1940

Oil on canvas, 80 x 75.
Signed and dated lower right: Mikhail Nesterov. 1940.
Accession: 1940, acquired from the artist.
Tretiakov Gallery. Inventory No. 24809.

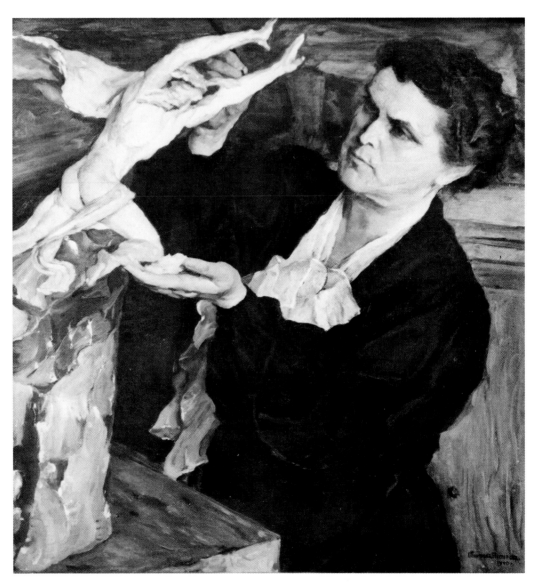

SEROV, V. A. **Portrait of Sofia Mikhailovna Botkina.** 1899

Oil on canvas, 189 x 139.5.
Signed and dated lower left: Serov 99.
Accession: 1934.
Russian Museum. Inventory No. Zh-4314.
Subject was the wife of P. D. Botkin, a Moscow tea merchant.

SEROV, V. A. **Portrait of the Artist Konstantin Alekseevich Korovin (1861–1939).** 1891

Oil on canvas, 111.2 x 89.
Accession: 1927, transferred from the Museum of New
 Western Art.
Tretiakov Gallery. Inventory No. 8633.

SEROV, V. A. **Children.** 1899

Oil on canvas, 71 x 54.
Signed lower right with monogram vs.
Accession: 1900
Russian Museum. Inventory No. Zh-4283.
*The subjects are the artist's sons, Aleksandr (1892–1959)
 and Georgii (1894–1927).*

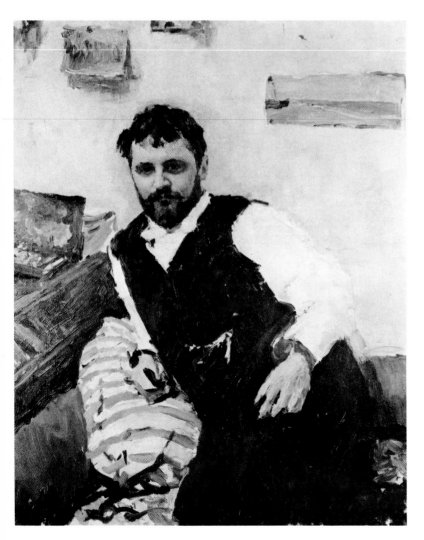

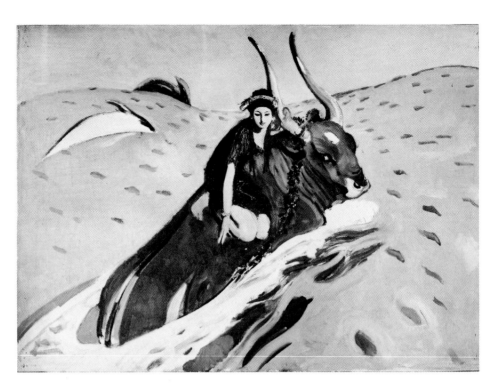

SEROV, V. A. **The Rape of Europa.** 1910

Tempera on canvas, 71 x 98.
Accession: 1911, acquired from O. F. Serova, the artist's
 widow.
Tretiakov Gallery. Inventory No. 1535.
Sketch for an unfinished painting.

SEROV, V. A. **Portrait of Vladimir Osipovich
Girshman (1867–1936).** 1911

Oil on canvas, 96 x 77.5.
Signed and dated lower left: vs 911.
Accession: 1917, from the collection of V. O.
 Girshman.
Tretiakov Gallery. Inventory No. 5587.
Girshman was a Moscow manufacturer and collector.

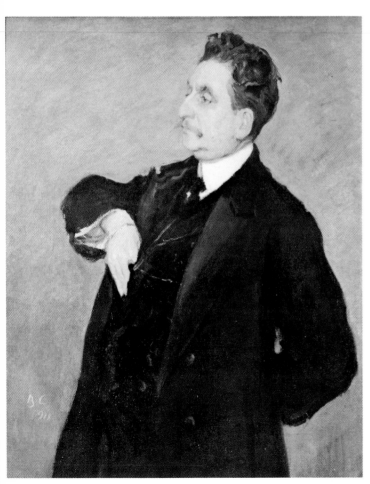

BAKST, L. S. **Supper.** 1902

Oil on canvas, 150 x 100.
Signed upper right, L. Bakst.
Accession: 1920.
Russian Museum. Inventory No. Zh-2118.

SOMOV, K. A. **Portrait of Mefodii Georgie-vich Lukianov (1892–1932), Friend of the Artist.** 1918

Oil on canvas, 91.7 x 102.5 (oval).
Signed and dated lower right: K. Somov 1918.
Accession: 1919.
Russian Museum. Inventory No. Zh-2106.

BENOIS, A. N. **The Italian Comedy.** 1906

Oil on paper on canvas, 68.5 x 101.
Accession: 1920.
Russian Museum. Inventory No. Zh-2102.
*Other versions are in the Tretiakov Gallery and the
Ivanovo Art Museum.*

BORISOV-MUSATOV, V. E. **Gobelin.** 1901

Tempera on canvas, 103 x 141.2.
Signed lower right: V. Musatov. 1901, above gold
monogram м in a circle.
Accession: 1917, from the collection of V. O.
Girshman.
Tretiakov Gallery. Inventory No. 5602.

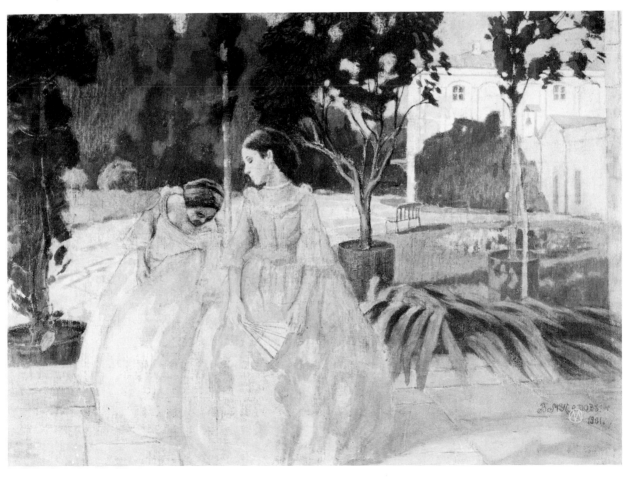

RYLOV, A. A. **The Green Sound**

Oil on canvas, 80 x 107.
Signed lower right: A Rylov.
Accession: 1924, from the State Museum Fund.
Tretiakov Gallery. Inventory No. 5820.

GRABAR, I. E. **Lenin on the Wire.** 1927–33

Oil on canvas, 150 x 200.
Accession: 1936 from the Russian Museum, Leningrad.
Central Lenin Museum. Inventory No. K-56.

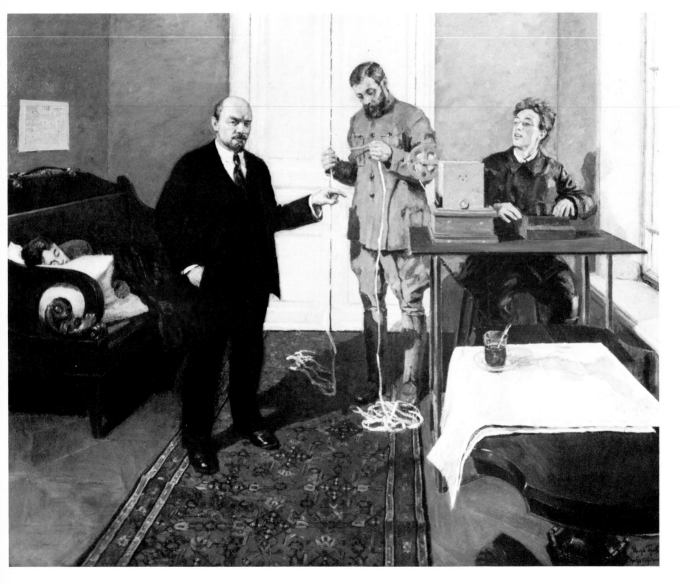

YUON, K. F. **The End of Winter. Midday.**
1929

Oil on canvas, 89 x 112.
Signed lower right: K. Yuon.
Accession: 1933, acquired from the artist.
Tretiakov Gallery. Inventory No. 17341.

KONCHALOVSKY, P. P. **The Violinist.**
1918

Oil on canvas, 143.5 x 106.
Signed and dated upper left: P. Konchalovsky, 1918 g.
Accession: 1918, acquired from the artist.
Tretiakov Gallery. Inventory No. 4271.
*The subject is Grigorii Fedorovich Romashkov (1864–
 1932).*

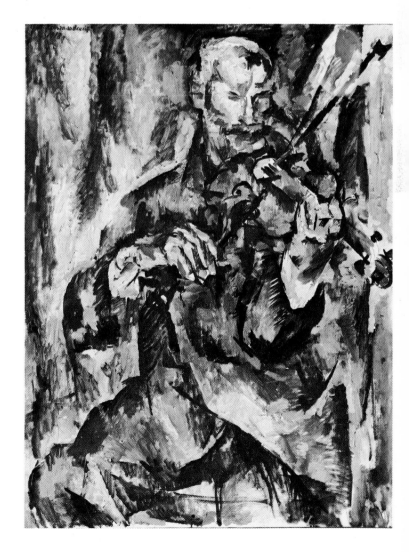

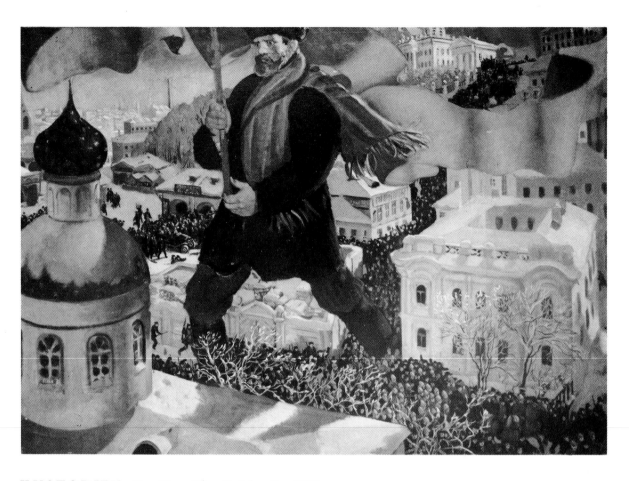

KUSTODIEV, B. M. **The Bolshevik.** 1920

Oil on canvas, 101 x 141.
Signed and dated lower left: B. Kustodiev 1920.
Accession: 1954, transferred from the Central Museum
 of the Soviet Army, Moscow.
Tretiakov Gallery.

KUSTODIEV, B. M. Portrait of the Singer Feodor Ivanovich Chaliapin (1873–1938). 1922

Oil on canvas, 99.5 x 81.
Signed lower right: B. Kustodiev 1922.
Accession: 1927.
Russian Museum. Inventory No. Zh-1869.
This is a smaller version (replica) of the portrait of 1920–21 in the Leningrad Theater Museum. Chaliapin enjoyed international fame for his interpretations of opera roles and Russian folk songs.

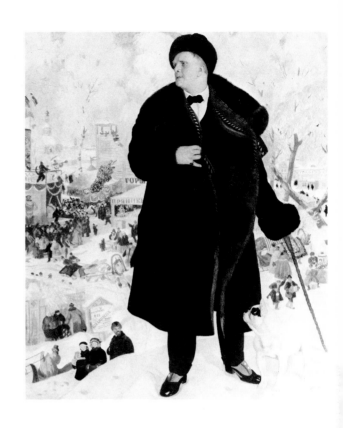

KUSTODIEV, B. M. Merchant's Wife Drinking Tea. 1918

Oil on canvas, 120 x 120.
Signed and dated lower right on tablecloth: B. Kusto-
diev 1918.
Accession: 1925.
Russian Museum. Inventory No. Zh-1868.

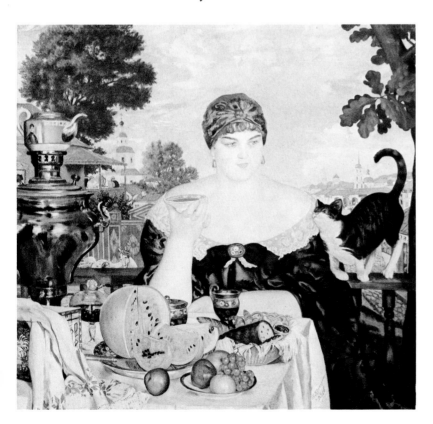

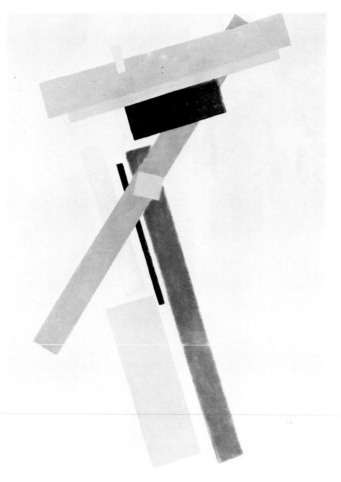

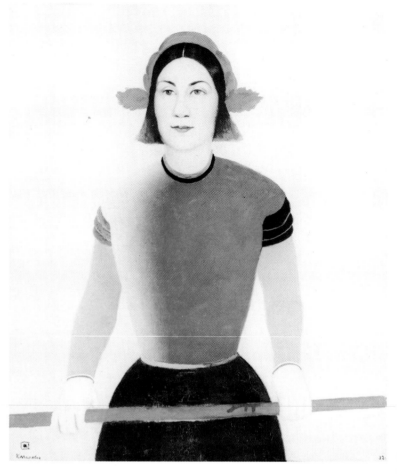

MALEVICH, K. S. **Suprematist Colors.**
About 1915

Oil on plywood, 51 x 71.
Accession: 1935.
Russian Museum. Inventory No. vkh/4348.

MALEVICH, K. S. **Girl with a Red Pole.**
1932–33

Oil on canvas, 71 x 61.
Signed lower left: K. Malevich.
Dated on the right: 32 g.
The reverse of the canvas bears the artist's inscription,
 date, and signature: No. 9 "Devushka s krasnym
 drevkom" 1933 K. Malevich [No. 9 "Girl with a
 Red Pole" 1933 K. Malevich].
Accession: 1934, acquired from the artist.
Tretiakov Gallery. Inventory No. 22570.

106

LARIONOV, M. F. The Cockerel. Rayonist Study. 1912

Oil on canvas, 68.8 x 65.
Accession: 1929, from the Museum of Painterly Culture.
Tretiakov Gallery. Inventory No. 10932.

SHTERENBERG, D. P. The Agitator. The Political Meeting. 1927

Oil on canvas, 135 x 208.
Signed lower left: D. Shterenberg.
Accession: 1934, acquired from the artist.
Tretiakov Gallery. Inventory No. 742.

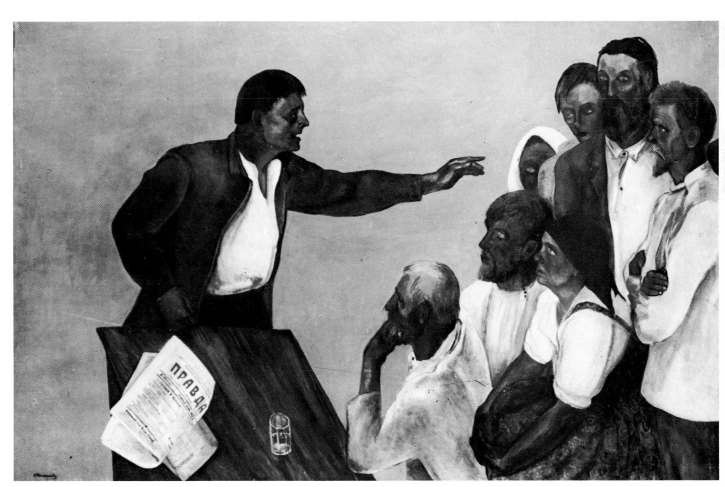

GREKOV, M. B. **The Gun Carriage.** 1925

Oil on canvas, 83 x 114.
Signed lower left: M. Grekov.
Accession: 1934, acquired from A. L. Grekova, the artist's widow.
Tretiakov Gallery. Inventory No. 15191.

FILONOV, P. N. **Faces.** 1919

Oil on canvas, 103 x 103.
Accession: 1927, transferred from the Museum Fund.
Tretiakov Gallery. Inventory No. 9198.

LENTULOV, A. V. **Moscow.** 1913

Oil on canvas, 179 x 189.
Accession: 1976, acquired from the artist's daughter, M. A. Lentulova.
Tretiakov Gallery. Inventory No. 057517.

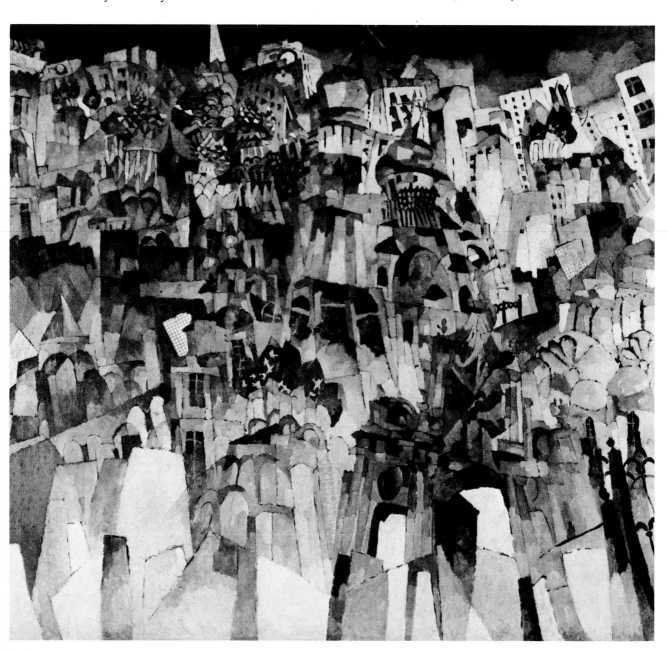

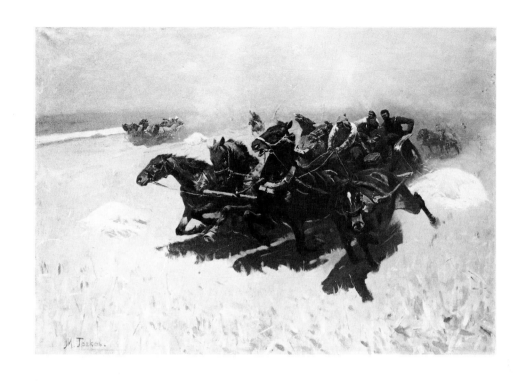

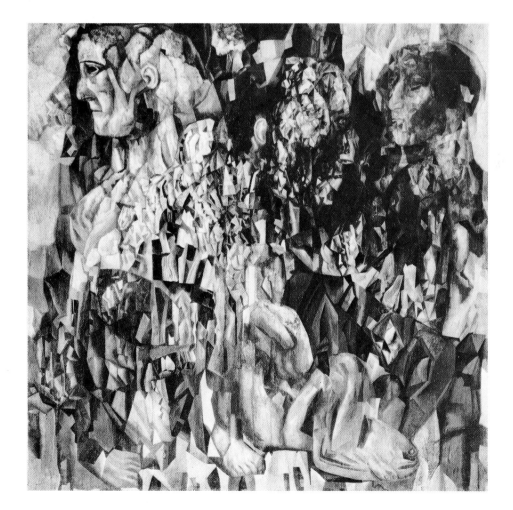

113

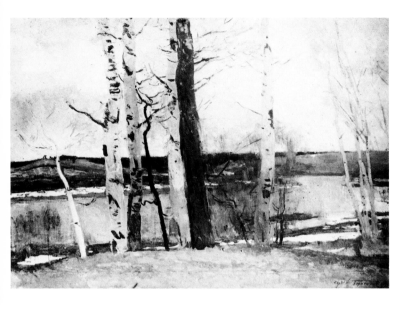

GERASIMOV, S. V. **The Ice Has Gone.** 1945

Oil on canvas, 75 x 100.
Signed and dated lower right: Sergei Gerasimov 1945.
Accession: 1947, acquired from the artist.
Tretiakov Gallery. Inventory No. 27749.

BRODSKY, I. I. **Lenin in the Smolnyi Institute.** 1935

Oil on canvas, 84 x 126.
Signed lower left: I. Brodsky (povtorenie) [I. Brodsky
 (repetition)].
Accession: 1935 from the artist.
Kuibyshev City Art Museum. Inventory No. Zh. 453.
*This is a repetition of the 1930 original in the Tretiakov
 Gallery. Before the Revolution the Smolnyi Institute in
 St. Petersburg was an educational institution for young
 ladies; in August 1917 it became the headquarters of
 the Petrograd Soviet.*

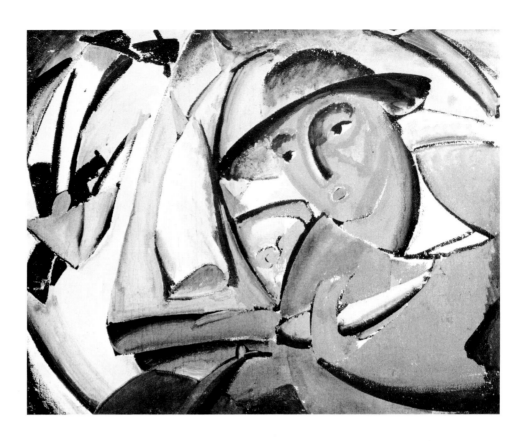

TATLIN, V. E. **The Fish Vendor.** 1911

Gum paints on canvas, 77 x 99.
Accession: 1929, from the Museum of Painterly
Culture.
Tretiakov Gallery. Inventory No. 11936.

FALK, R. R. **Landscape with Tall Trees**

Oil on canvas, 92 x 100.
Accession: 1975, from A. V. Shchekina-Krotova, the
artist's widow.
Tretiakov Gallery. Inventory No. 45510.

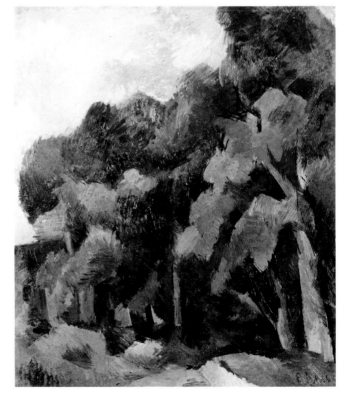

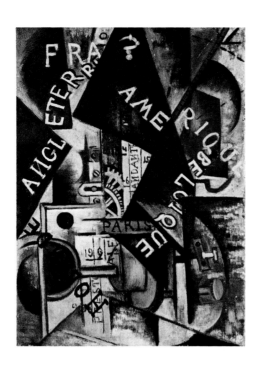

ROZANOVA, O. V. **The Metronome.** 1915

Oil on canvas, 46 x 33.
Accession: 1929, from the Museum of Painterly
 Culture.
Tretiakov Gallery. Inventory No. 11943.

ROZANOVA, O. V. **Jack of Clubs** (not illustrated)

Oil on canvas, 80 x 60.
Accession: 1920, gift of A. V. Lunacharsky.
Sloboda Museum. Inventory No. 464.

UDALTSOVA, N. A. **Still life. Summer.** 1946

Oil on canvas, 80 x 100.
The reverse of the canvas bears the artist's signature
 and inscription: Udaltsova N A Leto 1946 [Udalt-
 sova, N. A. Summer 1946].
Collection A. A. Drevin.

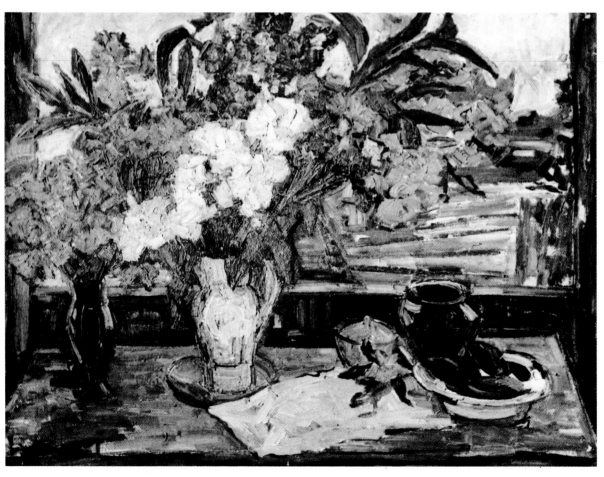

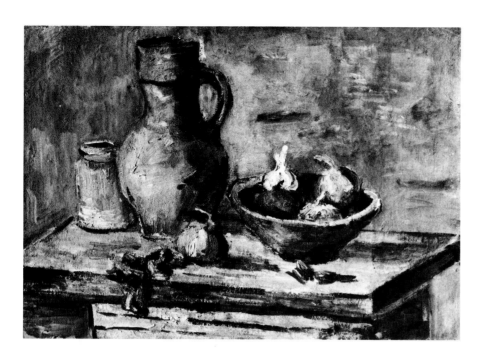

UDALTSOVA, N. A. **Still life. Autumn.** 1952

Oil on canvas, 50 x 70.
The reverse of the canvas bears the artist's signature
 and date: N Udaltsova 1952.
Collection A. A. Drevin.

DREVIN, A. D. **A Garage on the Steppe. Altai
Region.** 1932

Oil on canvas, 68 x 90.
The reverse of the canvas bears the artist's signature
 and inscription: Drevin A D "Garazh v stepi 1932
 (goluboi) [Drevin, A. D. "Garage on the Steppe"
 1932 (blue)].
Collection A. A. Drevin.

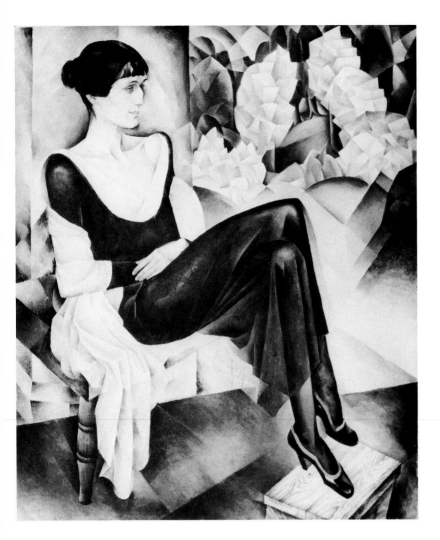

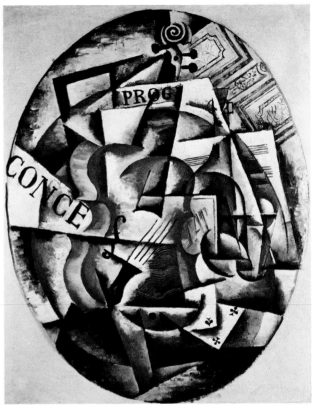

ALTMAN, N. I. **Portrait of the Poetess Anna Akhmatova (Anna Andreevna Gorenko, 1889–1966).** 1914

Oil on canvas, 123.5 x 103.2.
Accession: 1920.
Russian Museum. Inventory No. ZhB-1311.
In her early years Akhmatova belonged to the literary
movement known as Acmeism. Her main poetic theme
was love.

POPOVA, L. S. **The Violin.** 1915

Oil on canvas, 70 x 55.5 (oval).
Accession: 1920, from the Museum of Painterly
 Culture
Tretiakov Gallery. Inventory No. 11939.

RIANGINA, S. V. **Higher, Ever Higher!** 1934

Oil on canvas, 149 x 100.
Signed and dated lower right: Riangina 34 g.
Accession: 1945, from the Tretiakov Gallery.
Kiev Museum of Russian Art. Inventory No. Zh-333.

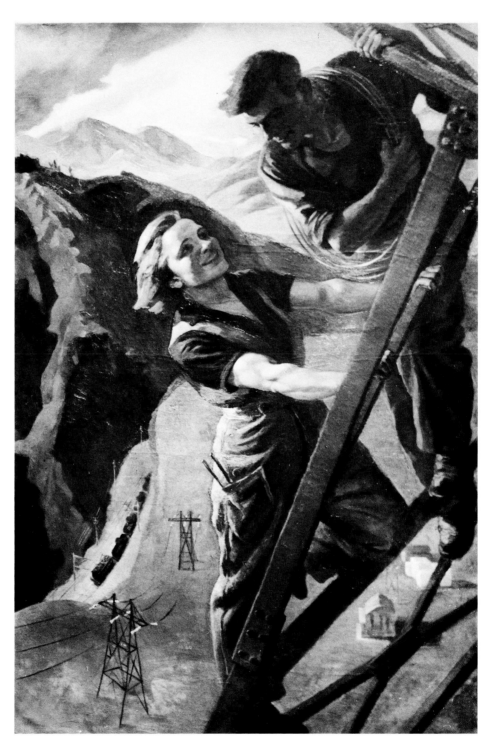

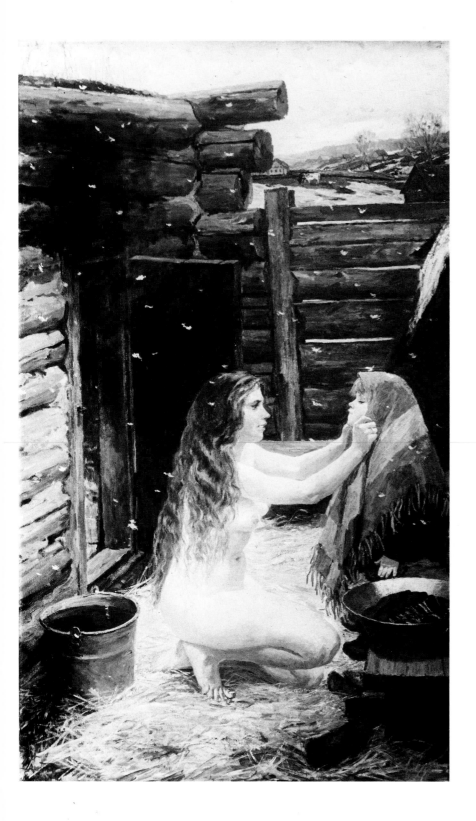

PLASTOV, A. A. **Spring.** 1954

Oil on canvas, 210 x 123.
Signed and dated lower left: Ark. Plastov 54.
The stretcher bears the artist's inscription, signature,
 and date: "Vesna" Ark. Plastov—1954 ["Spring" Ark.
 Plastov—1954].
Accession: 1969, acquired from the artist.
Tretiakov Gallery. Inventory No. ZhS-763.

SAMOKHVALOV, A. N. **Putting the Shot**
1933

Oil on canvas, 124.5 x 65.8.
Signed and dated lower left: A.S. 33
The reverse of the canvas bears the artist's inscription
 and signature: Devushka s iadrom A. Samokhva-
 lovom. Leningr. [Girl with a Shot by A. Samokhva-
 lov. Leningr.].
Accession: 1934, acquired from the artist.
Tretiakov Gallery. Inventory No. 17351.

DEINEKA, A. A. **The Defense of Petrograd.**
1964

Oil on canvas. 209 x 247.
Signed lower right: Deineka.
Accession: 1966, acquired from the artist.
Tretiakov Gallery. Inventory No. ZhS-621
*Artist's duplicate of the painting of the same name, dated
 1928, in the Central Museum of the Armed Forces of
 the USSR.*

VIALOV, K. A. **The Policeman.** 1923

Oil on canvas, 106.9 x 88.5.
Accession: 1934, acquired from the artist.
Tretiakov Gallery. Inventory No. 20842.

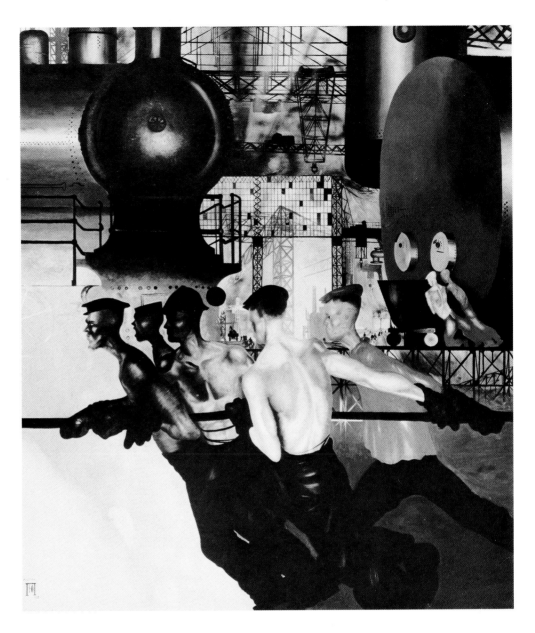

GONCHAROV, A. D. **The Death of Marat.**
1927

Oil on canvas, 161 x 97.5.

Signed and dated lower right: $\dfrac{AD}{27}$

Accession: 1920, acquired from the artist.
Tretiakov Gallery. Inventory No. 11987.

NISSKY, G. G. **Above the Snows.** 1959–60

Oil on canvas, 100 x 187.
Accession: 1960, acquired from the artist.
Russian Museum. Inventory No. Zh-8748.

PIMENOV, Y. I. **Give to Heavy Industry.** 1927

Oil on canvas, 260 x 212.
Inscribed, signed, and dated lower left: Moskva
 P.Yu. 1927.
Accession: 1929, acquired from the artist.
Tretiakov Gallery. Inventory No. ZhS-733.

ROMADIN, N. M. **The Flooded Forest.**
1963–70

Oil on orgalite, 111 x 81.5.
Signed and dated lower right: N. Romadin. 1963–70.
Accession: 1975, acquired from the artist.
Tretiakov Gallery. Inventory No. ZhS-994.

SHURPIN, F. S. **Golden Harvest.** 1953

Oil on canvas, 190 x 158.
Accession: 1969, gift of the artist.
Konenkov Museum of Visual and Applied Arts. Inventory No. 119.

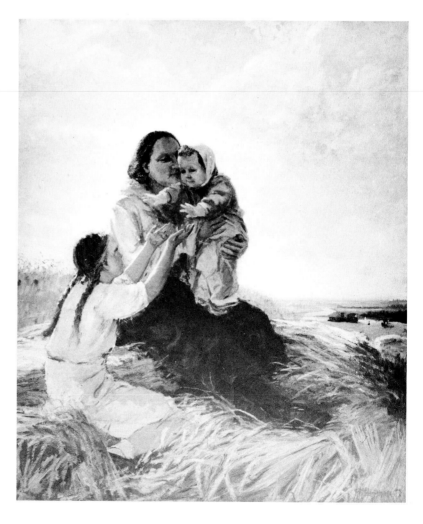

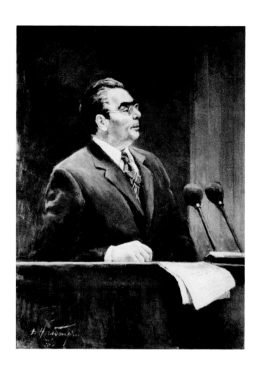

NALBANDIAN, D. A. **L. I. Brezhnev**
1976

Oil on canvas, 130 x 110.
Signed lower left: D Nalbandian 76.
Ministry of Culture of the USSR. Inventory No.
 82611.

PAULIUK, Y. A. **May There Always Be Sunshine!** 1967

Oil on canvas, 180 x 290.
Union of Artists of the USSR. Inventory No. Zh-1310.

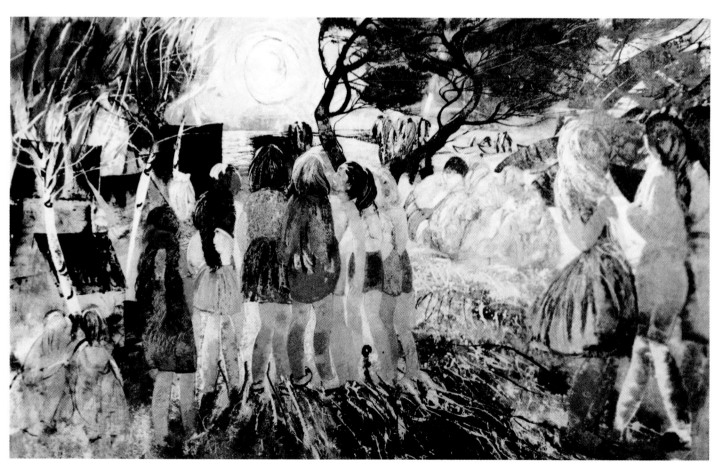

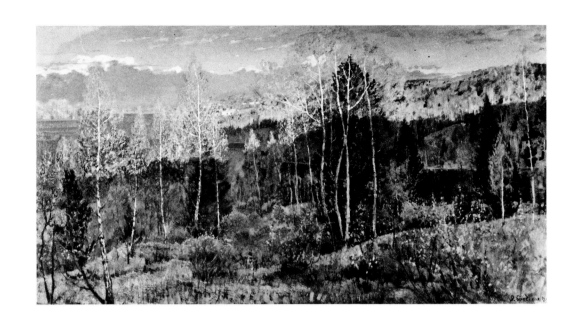

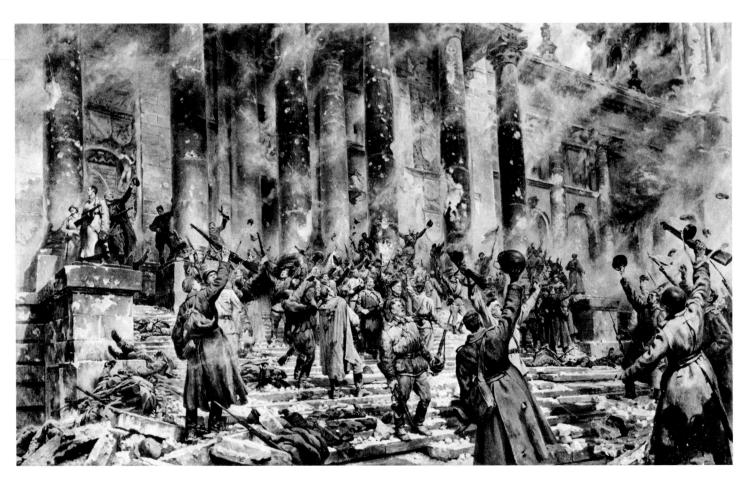

BRODSKAIA, L. I. **Vistas of Spring.** 1975

Oil on canvas, 100 x 80.
Signed lower right: L. Brodskaia 75.
Ministry of Culture of the USSR. Inventory No.
81583.

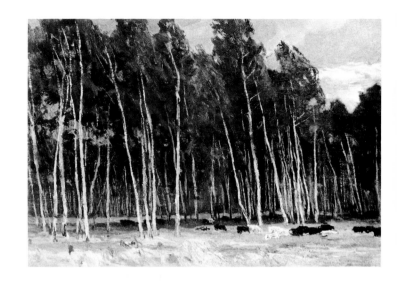

GRITSAI, A. M. **The Storm Approaches.**
1974

Oil on canvas on cardboard, 50 x 70.
Signed lower right: A. Gritsai 1974.
Union of Artists of the USSR.

BASOV, V. N. **Greetings, Earth!** 1961

Oil on canvas, 150 x 343.
Signed lower left: V. Basov 61g.
Accession: 1963, from the Ministry of Culture of the
RSFSR.
Kalinin Picture Gallery. Inventory No. Zh-1477.

KRIVONOGOV, P. A. **Victory.** 1948

Oil on canvas, 242 x 389.
Accession: 1948, acquired from the artist.
Central Museum of the Soviet Army. Inventory No.
12/3932.

DOMASHNIKOV, B. F. **The Urals of Yes-
teryear.** 1974

Oil on canvas, 140 x 170.
Signed lower right: 70–74 Domashnikov, B.
Ministry of Culture of the USSR. Inventory No.
 Zh-10736.

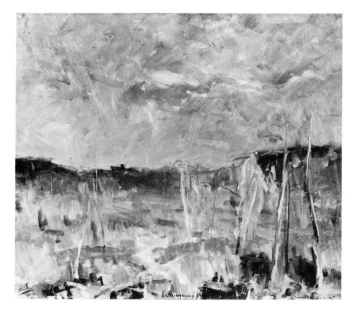

KITAEV, A. I. **Portrait of Igor Vasilievich Petrianov-Sokolov (b. 1907), Academician, Full Member of the Academy of Sciences of the USSR, Doctor of Chemistry, Professor, Winner of the Lenin Prize.** 1974

Oil on canvas, 110 x 70.
Signed and dated lower right: Akhmed Kitaev 74.
Accession: 1974, acquired from the artist.
Karpov Institute of Physics and Chemistry. Inventory
 No. GZ-19000.

NEMUKHIN, V. N. **The Golden Swamp.** 1976

Oil on canvas, 50 x 60.
Signed lower center: V. Nemukhin-1976.
Artist's inscription lower right: Nizhne-Vartovsk.
Ministry of Culture of the USSR.

STOZHAROV, V. F. **Bread, Salt and Winebowl.** 1964

Oil on canvas, 100.5 x 130.
Signed and dated lower left: V. Stozharov 64 g.
The reverse of the canvas bears the artist's signature, date, and inscription: V. Stozharov. 64 "N-t khleb, sol i bratina" 99 x 130 [V. Stozharov. 64 "Still-life Bread, Salt and Winebowl" 99 x 130]
Accession: 1965, acquired from the artist.
Tretiakov Gallery. Inventory No. ZhS-600.

MANIZER, G. M. **Summer Evening in Red Square.** 1975

Oil on canvas, 85 x 150.
Signed lower right: G. Manizer. 75 g.
Ministry of Culture of the USSR.

OSSOVSKY, P. P. **Her Sons.** 1969–75

Oil on canvas, 150 x 140.
Signed and dated lower right: P. Ossovsky 1969–75 gg.
Union of Artists of the RSFSR.

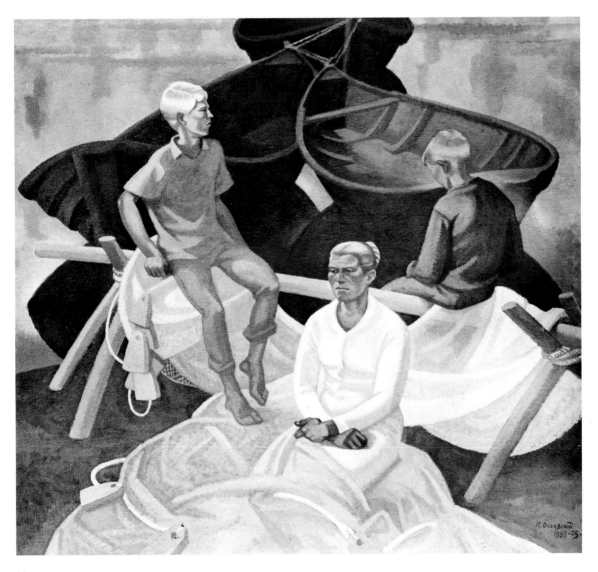

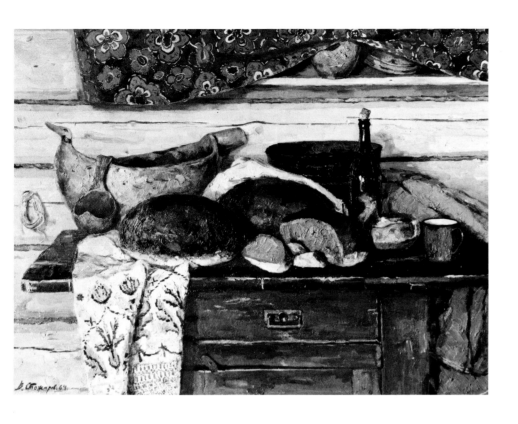

POKHODAEV, Y. A. **First Rendezvous. "Soyuz" and "Apollo".** 1976

Oil on canvas, 165 x 204.
Signed with monogram and dated lower left: PYu 76.
Ministry of Culture of the USSR. Inventory No.
 82619.

MURADIAN, S. M. **Under Peaceful Skies.** 1972

Oil on canvas, 170 x 200.
Signed lower left: S. Muradian 1972.
Ministry of Culture of the USSR. Inventory No.
 77067.

IVANOVA, K. S., & EZDAKOV, V. D. **In the Viatsk Region.** 1975

Oil on canvas, 140 x 245.
Signed lower left: K. Ivanova
 V. Ezdakov 75 g.
Union of Artists of the USSR. Inventory No. Zh-4783.

KASUMOV, N. S. o. **Morning Voyage.** 1972

 Oil on canvas, 150 x 170.
 Signed lower right: N. Kasumov 72.
 Ministry of Culture of the USSR. Inventory No.
 75808.

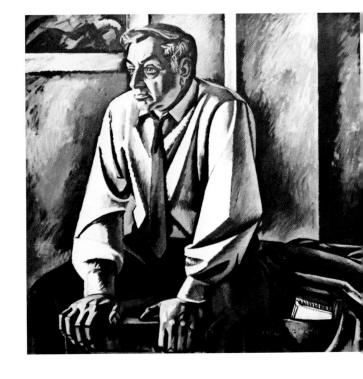

SALAKHOV, T. T. o. **Portrait of the Poet
Rasul Rza (Rzaev Rasul Ibragim ogly), b. 1910.**
1971

 Oil on canvas, 140 x 140.
 Ministry of Culture of the USSR. Inventory No.
 73213.

134

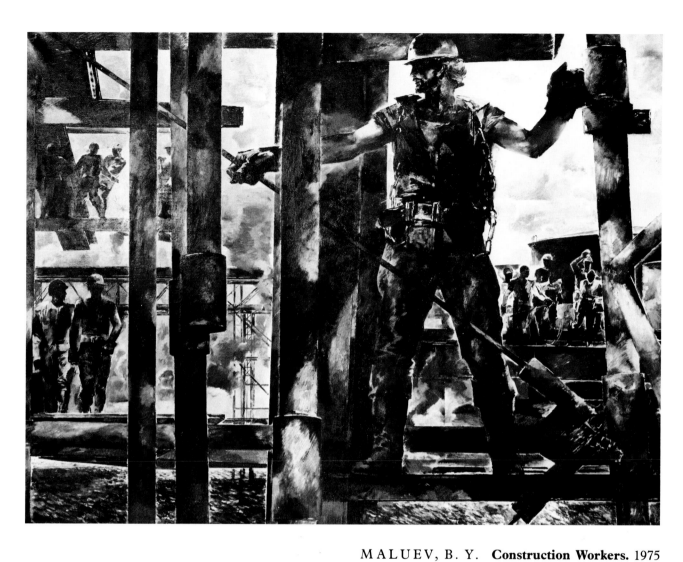

MALUEV, B. Y. **Construction Workers.** 1975

Oil on canvas, 158.5 x 201.
Signed lower right: b. Maluev 75.
Union of Artists of the USSR. Inventory No. Zh-4589.

ZARIN, I. A. **Let Us Plant Gardens.** 1975

Oil on canvas, 200 x 164.
Ministry of Culture of the USSR. Inventory No.
81569.

TOIDZE, G. V. **Toilers of the Mountains.** 1975

Tempera on canvas, 110 x 180.
Signed lower right: Toidze, G. V.
Ministry of Culture of the USSR. Inventory No.
82342.

PENUSHKIN, Y. I. **Morning. Winter Apples.**
1972

Oil on canvas, 130 x 215.
Ministry of Culture of the USSR. Inventory No.
75932.

136

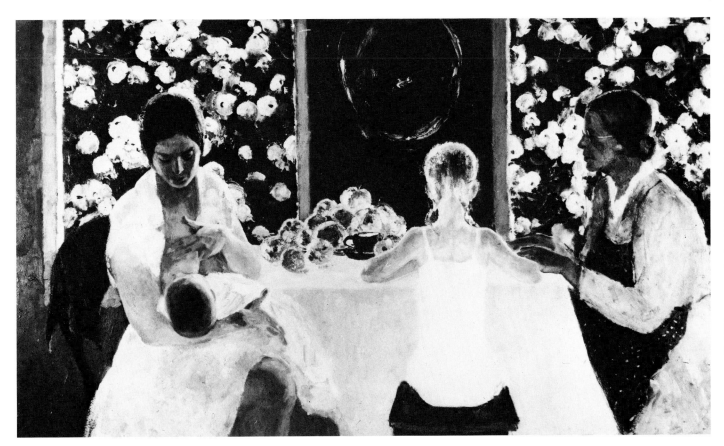

137

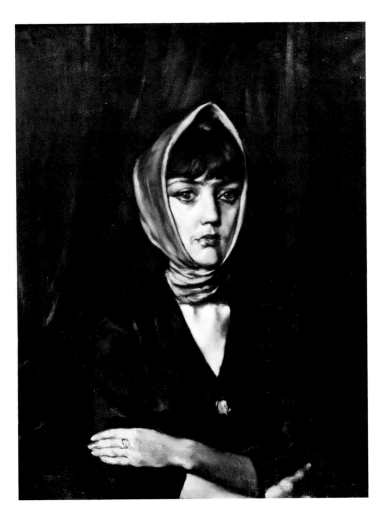

KANDAUROV, O. Z. **Tania in a Yellow Kerchief.** 1965

Oil on canvas, 81 x 60.
Ministry of Culture of the USSR. Inventory No.
 81833.

PLAVINSKY, D. P. **Still Life with an Old Painting.** 1975

Oil on canvas, 50 x 91.
Ministry of Culture of the USSR. Inventory No.
 81860.

GRYZLOV, V. D. **First Snow. Sunday. Bai-kal-Amur Railroad.** 1975

Oil on canvas, 100 x 200.
Signed lower right: V. Gryzlov, 1975.
Ministry of Culture of the USSR. Inventory No.
 81586.

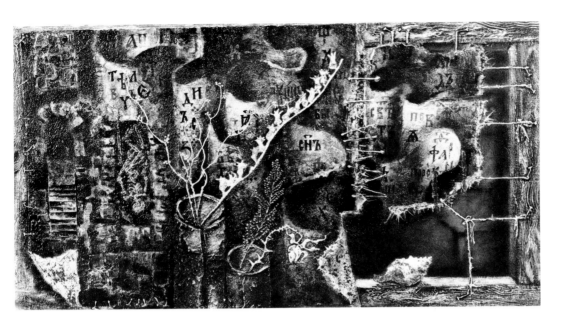

KURBANOV, S. U. **Nurek Under Construc-
tion.** 1971

Oil on canvas, 130 x 170.
Accession: 1972, acquired from the artist.
Tadzhik Art Museum. Inventory No. 6573 kp.

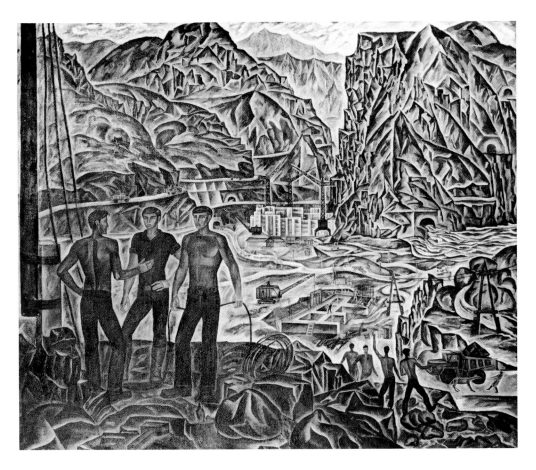

Addendum

VENETSIANOV, A. G. (1780-1847)
Spring: Plowing. Late 1820s

Oil on canvas, 51.2 x 66.5
Tretiakov Gallery. Inventory No. 155.

AIVAZOVSKY, Ivan Konstantinovich
(1817-1900)
The Rainbow. 1873

Oil on canvas, 102 x 132.
Tretiakov Gallery.

GE, Nikolai (1831-94)
Christ Leading His Disciples into the Garden of Gethsamene. 1888

Study for the painting.
Oil on canvas, 65.1 x 84.8
Tretiakov Gallery. Inventory No. 2638.

REPIN, I. E. (1844-1930)
The Zaporozhtsy. 1886/91

Study for the painting.
Oil on canvas, 67 x 87.
Tretiakov Gallery. Inventory No. 757.

ARKHIPOV, A. E. (1862-1930)
Washerwomen

Oil on canvas, 91 x 70.
Tretiakov Gallery. Inventory No. 1435.

KANDINSKY, V. V. (1866-1944)
The Lake. 1910

Oil on canvas, 98 x 103.
Tretiakov Gallery. Inventory No. 4901.

KLIUN, Ivan Vasilievich (1870-1942)
Suprematism. 1915

Oil on canvas, 88 x 71.
Tretiakov Gallery.

POPOVA, L. S. (1889-1924)
Painterly Architectonic.

Oil on canvas.
Tretiakov Gallery.

RODCHENKO, Aleksandr (1891-1956)
Nonobjective Painting: Composition 66/86. Density and Weight. 1919

Oil on canvas, 122 x 73.
Tretiakov Gallery.

TYSHLER, Aleksandr (1898-)
Dance with a Red Veil. 1932

Oil on canvas, 79 x 92.
Tretiakov Gallery.

NEPRINTSEV, Yuriy (1900-)
Rest after the Battle. 1951

Oil on canvas, 146 x 226.
Tretiakov Gallery. Inventory No. ZhS-93.

Chronology

1757 Academy of Arts founded, St. Petersburg. Following reorganization, holds first exhibition, 1763.

1821 Society for the Encouragement of the Arts founded, St. Petersburg. (Until 1875 called Society for the Encouragement of Artists.) Continues till 1929.

1825 Stroganov Institute founded, Moscow (at first called School of Drawing in Relation to the Arts and Crafts).

1843 Institute of Painting and Sculpture established, Moscow, carrying on the Life class, founded 1832.

1863 Secession of fourteen artists from the Academy of Arts, led by Kramskoi.

1870 Association of Traveling Art Exhibitions (the Wanderers) founded, St. Petersburg. Mamontov buys Abramtsevo, estate outside Moscow, and makes it into artistic center.

1892 Tretiakov donates his gallery to Moscow.

1896 Moscow Association of Artists founded; regular exhibitions till 1924.

1898 Russian Museum, St. Petersburg, founded.

1899 First World of Art exhibition, St. Petersburg. Later exhibitions irregularly till 1906.

1903 Union of Russian Artists, Moscow.

1904 Crimson Rose exhibition, Saratov. New Society of Artists founded, St. Petersburg.

1907 Blue Rose exhibition, Moscow.

1908 *Golden Fleece* magazine organizes first of three exhibitions.

1909 Kuindzhi Society founded, St. Petersburg.

1910 Knave of Diamonds association founded, Moscow. Union of Youth association founded, St. Petersburg.

1911 Donkey's Tail society founded. Exhibition following year.

1913 Target exhibition, Moscow, organized by Larionov.

1914 No. 4 exhibition, Moscow, organized by Larionov.

1915 Tramway V exhibition, Petrograd.

1915 –16 O.I0 exhibition, Petrograd, Malevich showing suprematist works first time.

1918 SVOMAS established.

1920 Institute of Artistic Culture founded, Moscow.

1924 OST founded, Moscow; exhibitions 1925–28.

1925 Four Arts Society founded, Moscow.

1926 Circle of Artists founded, Leningrad.

1928 October group founded, continues to 1932.

1935 Grekov Studio of Battle Painters founded, Moscow

1957 First All-Union Congress of Soviet Artists, Moscow.

Abbreviations used in the biographies

AKhRR (Assotsiatsiia khudozhnikov revoliutsionnoi Rossii): Association of Artists of Revolutionary Russia. Founded in Moscow, 1922, by artists who favored a realist or, at least, documentary style of painting. In 1928 the name was changed to AKhR (Assotsiatsiia khudozhnikov Rossii): Association of Artists of Russia. The Association held regular exhibitions 1922-32.

OST (Obshchestvo khudozhnikov-stankovistov): Society of Easel Artists. Founded in Moscow, late 1924, by Deineka, Pimenov, Shterenberg, and others. Held four exhibitions 1925-28.

RSFSR (Rossiiskaia Sovetskaia Federativnaia Sotsialisticheskaia Respublika): Russian Soviet Federal Socialist Republic.

SVOMAS (Svobodnye gosudarstvennye khudozhestvennye masterskie): Free State Art Studios. See note below.

VKhUTEIN (Vysshii gosudarstvennyi khudozhestvenno-tekhnicheskii institut): Higher State Art-Technical Institute. See note below.

VKhUTEMAS (Vysshie gosudarstvennye khudozhestvenno-tekhnicheskie masterskie): Higher State Art-Technical Studios. See note below.

NOTE: In 1918 the old Moscow Institute of Painting, Sculpture and Architecture and the Stroganov Art School were integrated to form the Free State Art Studios (SVOMAS), and the Academy of Fine Arts in St. Petersburg (Petrograd) was abolished to be replaced by PEGOSKhUMA (Petrogradskie gosudarstvennye svobodno-khudozhestvenny uchebnye masterskie [Petrograd State Free Art Educational Studios]), then by SVOMAS and then by the Academy again. The Moscow SVOMAS was renamed VKhUTEMAS in 1920, VKhUTEIN in 1926. Similar changes of organization and name were made in provincial cities.

WANDERERS (Peredvizhniki): Tovarishchestvo peredvizhnykh khudozhestvennykh vystavok (Association of Traveling [or Wandering] Exhibitions). The Association was founded in St. Petersburg in 1870 by Kramskoi, Perov, Shishkin, and others. It attracted the prominent realist painters of the time, including Repin and Surikov. It held regular exhibitions in St. Petersburg, Moscow, and other cities between 1871 and 1923.

Biographies
of the Artists

ALEKSEEV, Fedor Yakovlevich
 Born St. Petersburg 1753. Died St. Petersburg 1824.

Founder of the Russian topographical landscape. Son of a retired soldier who worked as a watchman in the Academy of Sciences, St. Petersburg. Attended a presidiary school, then the Academy of Arts in St. Petersburg (1766–73). From 1773 to 1777, a *pensionnaire* of the Academy of Arts in Venice, he studied with G. Moretti. Beginning in 1779, a stage designer for the imperial theaters in St. Petersburg. Received title of Academician, 1794. In 1795 commissioned to paint views of cities in the Ukraine and the Crimea, and then, about 1800, of Moscow and its environs. With his pupil M. N. Vorobiev, commissioned to paint views of Russian provincial cities, 1809–11; visited Moscow, Orel, Voronezh. Painted views of St. Petersburg and Moscow throughout his life and gained deserved recognition for them.

ALTMAN, Natan Isaevich
 Born Vinnitsa 1889. Died Leningrad 1970.

Received title Honored Art Worker of the RSFSR, 1955. Painter, graphic artist, sculptor. Known for his portraits, landscapes, still lifes. Also active as book illustrator and stage designer. Attended the Odessa Art Institute (1902–07) and the Académie Russe in Paris (1910–11). Contributed to the exhibitions of the World of Art, the Knave of Diamonds, and others. Taught at the Academy of Arts (1918–21). Between 1928 and 1935 worked in France. Lived in St. Petersburg/ Leningrad 1912–21, Moscow 1921–28, then again Leningrad.

ANTROPOV, Aleksei Petrovich
 Born St. Petersburg 1716. Died St. Petersburg 1795.

Painter, miniaturist (on enamel), portrait painter, decorator, icon painter. Son of a metalworker and instrument-maker at the St. Petersburg Armory and Chancery of Buildings. Pupil of A. Matveev, M. Zakharov, I. Vishniakov, L. Caravaque, and, later, of P. Rotari.

Apprenticed to a department in the Chancery of Buildings (1732), and to I. Vishniakov's "team of painters" (1739). From 1761 until his death worked for the Patriarch's Synod of Appeal. Executed decorative work for the Summer and Winter Palaces and also for the Anichkov Palace in St. Petersburg, for Peterhof and Tsarskoe Selo, and for the Golovin Palace in Moscow. Contributed to the decorations for the coronation festivities in Moscow, 1762. Had his own private school. In 1789 offered his house to the Office for Public Charity so that a public college could be established there. Among the artist's pupils the best known are D. G. Levitsky and P. S. Drozhdin.

ARGUNOV, Nikolai Ivanovich
 Born St. Petersburg (?) 1771. Died Moscow after 1829.

Painter, especially of portraits. Son of the artist I. P. Argunov (a serf of Counts P. V. and N. P. Sheremetev). Studied under his father. Painted copies of pictures in the Hermitage, St. Petersburg, in 1790s. Worked in St. Petersburg, Moscow, and at the Moscow country estates of the Sheremetevs: Kuskovo and Ostankino. Released from serfdom, 1816, and nominated for academic title. Received title of Academician for his portrait of P. S. Runich, 1817. Painted several family portraits of the Sheremetevs and undertook many commissions. No information available on his later life.

ARKHIPOV, Abram Efimovich
 Born Egorovo, Riazan Province, 1862. Died Moscow 1930.

Painter of domestic genre scenes and landscape. Studied at the Moscow Institute of Painting, Sculpture and Architecture (1877–83, 1886–88) under V. G. Perov and V. D. Polenov, and at the Academy of Arts, St. Petersburg (1884–86). Lived in Moscow. Visited France, Germany, Italy, 1896–1912. Made a long journey through Russia up to the White Sea, 1902. Member of the Wanderers, beginning 1891, of the Union of Russian Artists, beginning 1904, and of AKhRR, be-

ginning 1924. Taught at the Moscow Institute of Painting, Sculpture and Architecture (1894-1918), Moscow SVOMAS (1918-20), and VKhUTEMAS (1922-24).

BAKST (ROZENBERG), Lev Samoilovich
Born Grodno 1866. Died Paris 1924.

Painter and graphic artist: worked on portraits, landscapes, book design, and illustration. Famous as a stage designer. Studied at the Academy of Arts, St. Petersburg, 1883-87, then in Paris in the studio of Jean-Léon Gérôme, at the Académie Julien, and with A. Edelfeld. Lived in St. Petersburg. Returned to Paris after 1910. Taught at E. P. Zvantseva's art school in St. Petersburg, 1906-10. Cofounder of, and active contributor to, the World of Art group. Contributed to exhibitions of the Society of Russian Watercolorists, the Union of Russian Artists (1903-10), the Salon d'automne, and others. A principal artist of the Diaghilev Ballets Russes. Designed productions for theaters in St. Petersburg, Paris, London, Rome, Brussels, New York.

BASOV, Vasilii Nikolaevich
Born Nekrasovo, Vologda Province, 1918. Died 1962 Moscow.

Winner of the USSR State Prize. Painted genre scenes, landscapes, and portraits. Studied at the Moscow Art Institute (1934-38) under P. K. Ivanov and at the Surikov Art Institute in Moscow (1938-48). Lived and worked in Moscow. Began to exhibit in 1943.

BENOIS, Alexandre Nikolaevich
Born St. Petersburg 1870. Died Paris 1960.

Graphic artist, painter, art critic, and art historian; museum worker. Worked on book illustration and design, stage design, painted landscapes. Studied at the Academy of Arts, St. Petersburg, 1887-88, and at the Law School, St. Petersburg University. Lived in St. Petersburg and, after 1926, in Paris. Traveled a great deal in western Europe. Cofounder and "ideological" leader of the World of Art group, 1898-1904, 1910-24. Contributed to exhibitions of the Society of Russian Watercolorists (1892-96), the Union of Russian Artists (1903-10), and others. Senior Curator and Director of the Painting Gallery at the Hermitage (1918-26). Worked as a designer for Diaghilev's Ballets Russes. Contributed to stage productions in St. Petersburg, Moscow, Paris, Milan, London, Vienna.

BORISOV-MUSATOV, Viktor Elpidiforovich
Born Saratov 1870. Died Tarusa 1905.

Painter and graphic artist: landscapes, portraits, and other genres. Studied under V. V. Konovalov in the studio of the Saratov Society of Lovers of the Fine Arts, at the Moscow Institute of Painting, Sculpture, and Architecture (1890-91), at the Academy of Arts, St. Petersburg, under P. P. Chistiakov (1891-93), and with F. Cormon in Paris (1895-98). Beginning in 1898 lived and worked in Saratov; from 1903 onward in Podolsk and Tarusa. Member of the Moscow Association of Artists (from 1899) and the Union of Russian Artists (from 1904).

BOROVIKOVSKY, Vladimir Lukich
Born Mirgorod, Ukraine 1757. Died St. Petersburg 1825.

Outstanding portraitist. His father, a Cossack, painted icons. Received initial tuition from his father. Served in the army. Attaining the rank of lieutenant, retired and gave all his time to painting. The poet V. V. Kapnist, Marshal of the Nobility for Kiev Province, commissioned Borovikovsky to paint pictures to decorate the house in Kremenchug where Catherine the Great was to stay during her Crimean tour of 1787. Catherine liked Borovikovsky's allegorical compositions, and in 1788 he was invited to St. Petersburg where he studied under D. G. Levitsky and the Viennese portrait-painter Jean-Baptiste Lampi. Received title of Academician, 1795. In 1804 was commissioned to work on designs for the Kazan Cathedral in St. Petersburg, then being built, and later painted icons for it. Painted religious pictures and also compositions for iconostases for churches in Torzhok and Mogilev. Ran his own private school in St. Petersburg.

BRIULLOV, Karl Pavlovich
Born St. Petersburg 1799. Died Italy 1852.

Historical painter, draughtsman, and watercolorist, specializing in portraits and genre. Representative of the Romantic movement in Russian painting. Son of the Academician P. I. Briullov, a decorative sculptor. Received initial tuition from his father and then from Andrei Ivanov, A. Egorov, and V. Shebuev at the Academy of Arts, St. Petersburg, 1809-21. Beginning 1823, lived in Italy as a *pensionnaire* of the Society for the Encouragement of Artists. Worked 1830-33 on his great historical canvas called the *Last Day in Pompeii,* awarded the Grand Prix in Paris. Traveled in Greece

and Turkey, 1835. Receiving title of Professor, taught at the Academy of Arts in St. Petersburg, 1836. Worked on monumental murals for St. Isaac's Cathedral in St. Petersburg, 1834-47. Painted portraits of writers, artists, and actors. In 1849, because of illness, left for the warmer climate of Madeira. In 1850, settled in Italy. Member of the Milan and Parma Academies and of the Accademia Nazionale di San Luca, Rome.

BRODSKAIA, Lidiia Isaakovna

Born St. Petersburg 1910. Lives Moscow.

Corresponding Member of the Academy of Arts of the USSR and Honored Artist of the RSFSR. Painter of landscapes. Received her initial art education from her father, the artist I. I. Brodsky. Audited courses in his studio at the Academy of Arts, 1933-39. Also studied under N. P. Krymov. Began to exhibit in 1945.

BRODSKY, Isaak Izrailevich

Born Sofievka, Ukraine, 1884. Died Leningrad 1939.

Honored Art Worker of the RSFSR. Painter and graphic artist: portraits, landscapes. Studied at the Art Institute of the Odessa Society of Lovers of the Fine Arts under K. K. Kostandi and G. A. Ladyzhensky (1896-1902) and under I. E. Repin at the Academy of Arts, St. Petersburg (1902-08). Visited Germany, France, Italy, Greece, Spain, and England as a *pensionnaire* of the Academy of Arts (1909-11). Lived in Leningrad. Member of the Union of Russian Artists, AKhRR (from 1924), and the Kuindzhi Society (1930). Professor (1932-39) and Director (1934-39) of the Academy of Arts.

DEINEKA, Aleksandr Aleksandrovich

Born Kursk 1899. Died Moscow 1969.

Hero of Socialist Labor. Full Member of the Academy of Arts of the USSR. People's Artist of the USSR. Corresponding Member of the Academy of Arts of the German Democratic Republic. Winner of the Lenin Prize. Professor. Worked in studio and monumental painting, in graphics and sculpture: portraits, landscapes. Studied at the Kharkov Art Institute under M. R. Pestrikov (1914-18), at VKhUTEMAS in Moscow under V. A. Favorsky and I. I. Nivinsky (1920-26). Traveled to the USA, France, and Italy (1934-35). Traveled to Germany (1945). Lived in Moscow. Founder-member of OST (1924). Vice-president of the Academy of Arts of the USSR (1962-65). Began to exhibit in 1924. Taught at VKhUTEIN in Moscow

(1928-30), at the Moscow Institute of Polygraphy (1928-34), the Moscow Art Institute (1934-46, 1957-63), the Moscow Institute of Applied and Decorative Art (1945-53); Director of the Institute, 1949-47. Taught at the Moscow Architecture Institute (1953-57).

DOMASHNIKOV, Boris Fedorovich.

Born Krigouzovo, Ivanovo Region, 1924. Lives Ufa.

Honored Artist of the RSFSR since 1968. Landscape painter. Studied at the Institute of Theater and Art in Ufa under A. E. Tiulkin, P. M. Lebedev and N. S. Bespalova (1945-50). Began to exhibit in 1954.

DREVIN, Aleksandr Davidovich

Born Vendene, Latvia, 1889. Died 1938 (?).

Painter of landscapes, genre scenes, portraits. Studied at the Riga Art School under V. Purvit (1908-13), then studied independently. After 1914 lived in Moscow. Member of, and exhibition contributor to, the World of Art, the Knave of Diamonds, the Society of Moscow Painters (1925), AKhRR (1926), the Society of Moscow Artists (1928). Began to exhibit in 1916. Professor of painting at VKhUTEMAS/VKhUTEIN (1920-32). With N. A. Udaltsova traveled extensively in Russia. Visited Kazakhstan and the Altai region in 1930, Armenia in 1933-34.

EZDAKOV, Vasilii Dmitrievich

Born Novorossiisk 1929. Lives Moscow.

Painter of landscapes and genre scenes. Studied at the Moscow Art School (1942-49) and at the Surikov Art Institute in Moscow under G. G. Riazhsky (1950-55). Began to exhibit in 1956.

FALK, Robert Rafailovich

Born Moscow 1886. Died Moscow 1958.

Painter, draughtsman, stage designer: portraits, landscapes, still lifes. Studied at the art school run by K. F. Yuon and I. O. Dudin and at the studio of I. I. Mashkov (1903-04), and at the Moscow Institute of Painting, Sculpture and Architecture under K. A. Korovin and V. A. Serov (1905-10). Traveled in Italy (1910-11). Lived in Moscow, Paris (1928-38), and Central Asia (1938-44). Cofounder of the Knave of Diamonds (1910-18), a member of the World of Art (contributing to its exhibitions of 1910-17, 1921-22), of the Society of Moscow Artists (1925-28), and AKhRR (1925-28).

Member of the Collegiate within the Department of Visual Arts of the People's Commissariat for Enlightenment (1918-21). Taught at SVOMAS/VKhUTEMAS/VKhUTEIN (1918-28), at the Samarkand Regional Art Institute (1942-43), and the Moscow Institute of Applied and Decorative Art (1945-58).

FEDOTOV, Pavel Andreevich
Born Moscow 1815. Died St. Petersburg 1852.

Painter and draughtsman: genre scenes and portraits. Son of a low-ranking civil servant. Studied at the First Moscow Military School; graduated 1833. Served in the Lifeguards of the Finland Regiment in St. Petersburg. At first taught himself painting and drawing, then, in the late 1830s, attended evening classes at the Academy of Arts, St. Petersburg. Retired and gave all his time to painting, 1843. Received title of Academician, 1848, for his painting *The Major's Betrothal, or How to Correct One's Material Condition by Marrying*. Fedotov painted as a chronicler of everyday domestic life and as a critic of the morals and dark sides of social life of his time. Began the movement of Critical Realism in Russian art.

FILONOV, Pavel Nikolaevich
Born 1883 Moscow. Died Leningrad 1941.

Painter, graphic artist, book illustrator: symbolic and philosophical compositions, portraits, landscapes, still lifes. Wrote poetry and theoretical studies on various questions of art. Studied at the School of Drawing attached to the Society for the Encouragement of the Arts in St. Petersburg (1893-1902), the art school of L. E. Dmitriev-Kavkazsky (1903-08), and the Higher Art Institute attached to the Academy of Arts, St. Petersburg, under G. R. Zaleman and V. E. Savinsky (1908-10). Visited the Volga region, Jerusalem, the Caucasus (1905). Visited Italy and France (1911-12). Member of the Union of Youth. Lived in St. Petersburg/Leningrad. Headed his own art studio in which he taught the elements of his system of analytical art (mid-1920s until 1933).

GERASIMOV, Sergei Vasilievich
Born Mozhaisk 1884. Died Moscow 1964.

Full Member of the Academy of Arts of the USSR. People's Artist of the USSR. Winner of the Lenin Prize. Painter, graphic artist: landscapes, social themes; illustrator of Russian and Soviet literature. Studied at the Stroganov Institute, Moscow, under K. A. Korovin and S. I. Ivanov (1901-07), at the Moscow Institute of Painting, Sculpture and Architecture under S. I. Ivanov and K. A. Korovin (1907-12). Lived in Moscow and Mozhaisk. Member of the Moscow Salon, the World of Art, Makovets, Society of Moscow Artists (1930), and the Association of Artists of Russia (1930). Visited Italy, Greece, and Turkey in 1925 and various countries in Europe in the fifties and sixties. Taught at VKhUTEMAS (1920-23), the Institute of Polygraphy (1930-36), the Moscow Art Institute (1936-50); Rector of the Institute (1946-48). Supervised the Department of Monumental Painting in the Moscow Higher Institute of Art and Industry (formerly the Stroganov Institute), 1950-64. Received title of Professor, 1932, and Doctor of Art History, 1956. First Secretary to the Board of the Union of Artists of the USSR (1958-64).

GONCHAROV, Andrei Dmitrievich
Born Moscow 1903. Lives Moscow.

Corresponding Member of the Academy of Arts of the USSR. Honored Art Worker of the RSFSR. Engraver and painter of portraits and landscapes; xylographer, monumentalist, designer for theater and the cinema; book illustrator. Studied in Moscow at the studios of K. F. Yuon (1915-16) and I. I. Mashkov (1917), then at SVOMAS/VKhUTEMAS/VKhUTEIN under A. A. Shevchenko (1921-27) and V. A. Favorsky. Cofounder of OST. Taught at the Moscow Institute of Visual Arts (1934-38), the Moscow Institute of Applied and Decorative Art (1947-48), and the Moscow Institute of Polygraphy (1930-34, and 1948 onward).

GONCHAROVA, Nataliia Sergeevna
Born Tula Province 1881. Died Paris 1962.

Painter and graphic artist: genre scenes, landscapes, still lifes, portraits, theater designs, book illustrations. Audited the Moscow Institute of Painting, Sculpture and Architecture and studied in the sculpture class of P. P. Trubetskoi (1898-1909). Traveled to the Crimea and elsewhere (1903), to Central Russia, and then to Lausanne (1915). Lived and worked in Moscow. After 1915 lived abroad. Beginning 1920, worked for M. Fokine's ballet troupe as stage designer. Contributed to the exhibitions of the World of Art, the Wreath, the Link, the Golden Fleece, and others. Was co-organizer of the first exhibition of the Knave of Diamonds (1910-11) and of the leftist exhibitions of 1910-14: the Union of Youth, the Donkey's Tail, the Target, and No. 4. Futurists, Rayonists and Primitivists. In her work of the late 1900s and early 1910s Goncharova combined both

expressionist and primitivist tendencies, and made extensive use of the traditions of the popular kinds of Russian art and of ancient Russian icon painting. She was influenced by fauvism, cubism, and futurism and, together with M. F. Larionov, created Rayonism (1912–14), a variant of abstract art, but after working with it for only a short while she returned to figurative painting.

GRABAR, Igor Emmanuilovich
Born Budapest 1871. Died Moscow 1960.

People's Artist of the USSR. Full Member of the Academy of Sciences of the USSR and the Academy of Arts of the USSR. Winner of the State Prize of the USSR. Professor, Doctor of Art History, teacher, writer. Painter of landscapes, still lifes, portraits. Innovative museum worker, restorer. Also worked as an architect. Organizer of the Society for the Preservation of Ancient Monuments. Studied at St. Petersburg University (1890–93), the Academy of Arts, St. Petersburg, under V. E. Savinsky and N. A. Bruni, and in the studios of I. E. Repin and P. P. Chistiakov (1894–96), and at Anton Ažbè's art school in Munich (1896–1901). Member of the World of Art. Contributor to the exhibitions of the World of Art and the Union of Russian Artists. Director of the Tretiakov Gallery (1913–25). Director of the Central Art Restoration Studios (1918–31); Artistic Supervisor of same (1944–60). Rector of the Surikov Art Institute, Moscow (1937–43). Director of the Institute of Art History of the Academy of Sciences of the USSR (1943–60).

GREKOV, Mitrofan Borisovich
(Before 1911 known as MARTYSHENKO, Mitrofan Pavlovich)
Born Sharpaevka, South Russia, 1882. Died Sevastopol 1934.

Painter of battle scenes. Studied at the Odessa Art Institute, attached to the Society of Fine Arts, under K. Kostandi and G. Latyshevsky (1898–1903), then at the Academy of Arts, St. Petersburg, under P. Chistiakov, F. Rubo, and I. Repin (1903–11). Member of AKhRR from 1925. Began to exhibit in 1906. The Grekov Studio of Battle-Painters, Moscow, was founded in 1935 in his honor.

GRITSAI, Aleksei Mikhailovich
Born Petrograd 1914. Lives Moscow.

People's Artist of the USSR. Full Member of the Academy of Arts of the USSR. Winner of the State Prize of the USSR. Professor. Painter of landscapes, genre scenes, and portraits. Studied at the Academy of Arts, Leningrad, under I. I. Brodsky and V. N. Yakovlev (1932–37). Visited many countries in Europe and the USA. Teaches at the Surikov Art Institute, Moscow (beginning 1948). Began to exhibit in 1938.

GRYZLOV, Valerii Dmitrievich
Born Moscow 1943. Lives Moscow.

Painter of genre scenes and landscapes. Studied in the Department of Graphic Arts at the Moscow Pedagogical Institute under V. A. Dreznina and V. P. Efanov (1960–65) and at the Moscow Institute of Polygraphy, under N. A. Goncharova in the Department of Printing Design (1965–68). Traveled to Siberia to observe the construction of the Baikal-Amur Railroad. Began to exhibit in 1968.

IVANOV, Aleksandr Andreevich.
Born St. Petersburg 1806. Died St. Petersburg 1858.

Historical painter, landscape painter, draughtsman. Ivanov integrated the traditions of Classicism with a new realist method. Son of Andrei Ivanov, a professor at the Academy of Arts, St. Petersburg. Received initial art tuition from his father and then at the Academy of Arts, St. Petersburg, under A. E. Egorov (1817–28). In 1830 he was sent as a *pensionnaire* of the Society for the Encouragement of Artists to Italy. On the way, visited Germany, Austria, and various towns in northern Italy, including Florence. Lived in Rome. Received title of Academician, 1836, for his painting *The Appearance of Christ to Mary Magdalene*. From about 1830, throughout his stay of twenty years or more in Italy, Ivanov worked on his monumental canvas *The Appearance of Christ to the People*. In connection with research for this painting, Ivanov visited towns in central and northern Italy, including Venice and Naples. In 1857 he traveled to London to meet with A. I. Herzen, the prominent Russian Revolutionary-Democrat then living in exile. Returned to Russia, 1858. Ivanov's art reflected essential questions of his society, including the problem of the liberation of the masses. Ivanov at first perceived this from a moral, that is, Christian, viewpoint, but then changed this to a social one. He was also interested in the educational role of art within society.

IVANOVA, Kira Sergeevna
Born Kuibyshev 1928. Lives Moscow.

Painter of landscapes and genre scenes. Studied at the

Moscow Art School (1942-49) and at the Surikov Art Institute, Moscow, under P. I. Kotov (1950-55). Began to exhibit in 1956.

KANDAUROV, Otarii Zakharovich
Born Kemerovo 1937. Lives Moscow.

Painter, graphic artist, book illustrator. Portraits and compositions reflecting humanist and spiritual concerns. Studied at the Moscow Secondary Art School (1951-56) and in the Department of Art and Graphics at the Lenin Pedagogical Institute, Moscow, under V. P. Efanov (1957-62). Began to exhibit in 1957.

KANDINSKY, Vasilii Vasilievich
Born Moscow 1866. Died Neuilly-sur-Seine, France, 1944.

Painter and graphic artist. Studied at the Law School, Moscow University (1886-93). Traveled to Munich to study art; there attended the art school of Anton Ažbè (1897-98) and the drawing class of Franz Stuck at the Akademie der Künste. Taught in a private school in Munich, 1901-03. Between 1903 and 1907 visited Odessa and Moscow, North Africa, Italy, and France. In 1907 lived in Berlin and from 1908 to 1914 in Munich. A founder of the Munich associations Phalanx (1901), the Neue Künstlervereinigung (1909), and, together with Franz Marc, the *Blaue Reiter* (1911). Passing through a neoromantic phase of Jugendstil to the nascent movement of expressionism, Kandinsky, by 1910, was painting in a virtually abstract manner. He elucidated his principles of nonfigurative art in his book *On the Spiritual in Art* (begun in 1910, published 1912). Lived in Moscow, 1914-21. After the Revolution, active as a teacher and organizer; contributed to exhibitions, participated in founding the Museum of Painterly Culture (1919) and the Institute of Artistic Culture (1920). At the end of 1921 moved to Germany, became a professor at the Bauhaus in Weimar and Dessau. After the Nazis closed the Bauhaus (1933), moved to Paris.

KASUMOV, Nadir Sadykh ogly
Born Baku 1928. Lives Baku.

Honored Artist of the Azerbaijan SSR. Landscape painter. Studied at the Azim Azim-Zade Art Institute, Baku (1941-46), and at the Repin Institute of Painting, Sculpture and Architecture under B. I. Ioganson, E. I. Pavlovsky, and A. D. Zaitsev (1947-55). Began to exhibit in 1947.

KITAEV, Akhmed Ibadullovich
Born Yunich, Mordvinian Autonomous Republic, 1925. Lives Moscow.

Painter of genre scenes, portraits, historical subjects. Studied at the Moscow Art School under N. A. Andriako (1940-45) and at the Surikov Art Institute, Moscow, under G. G. Riazhsky and D. K. Mochalsky (1945-50). Began to exhibit in 1950.

KONCHALOVSKY, Petr Petrovich
Born Slavinsk 1876. Died Moscow 1956.

Full Member of the Academy of Arts of the USSR. People's Artist of the RSFSR. Winner of the State Prize of the USSR. Painter and watercolorist: genre scenes, still lifes, portraits, landscapes; also a stage designer. Studied at M. D. Raevskaia-Ivanova's School of Drawing, Kharkov; attended evening classes at the Stroganov Central Institute of Technical Drawing, Moscow, under V. D. Sukhanov; studied in Paris at the Académie Julien under B. Constant and Jean Paul Laurens, then at the Academy of Arts, St. Petersburg, under V. E. Savinsky, G. R. Zaleman, and P. O. Kovalevsky (1903-07). Began to exhibit in 1907. Visited Rome, 1904, traveled to Italy, France, Spain, and other countries, 1907-14. Often journeyed to the Crimea, Novogorod, and the Caucasus. Cofounded the Knave of Diamonds group 1910, and contributed regularly to its exhibitions. Also represented at the exhibitions of the Golden Fleece, the Union of Youth (1911), the World of Art (1911-22), the Society of Moscow Artists, Life, and AkhR. Taught at SVOMAS/VKhUTEMAS/VKhUTEIN, Moscow (1919-29).

KOROVIN, Konstantin Alekseevich
Born Moscow 1861. Died Paris 1939.

Painter of landscapes, portraits, still lifes, genre scenes; designer of theater scenery and costumes. Studied at the Moscow Institute of Painting, Sculpture and Architecture under A. K. Savrasov and V. D. Polenov (1875-83) and at the Academy of Arts, St. Petersburg (1882). Received title of Academician, 1905. Traveled to the Caucasus, to the north of Russia (1894), and Central Asia (late 1890s). Was often in Europe and, beginning in 1924, lived in Paris. Contributed to exhibitions of the Wanderers (1889-99), was a member of the World of Art group and of the Union of Russian Artists (1903-22). Taught at the Moscow Institute of Painting, Sculpture and Architecture (1901-18) and at SVOMAS (1918-19).

KRAMSKOI, Ivan Nikolaevich
Born Ostrogozhsk 1837. Died St. Petersburg 1887.

Painter, draughtsman: portraits, historical subjects, literary subjects. Studied at the Academy of Arts, St. Petersburg, under A. T. Markov (1857-63). Was one of the fourteen artists who resigned in protest against the stagnant routine of the Academy competitions (the so-called Revolt of the Fourteen). Left the Academy, therefore, before graduating. Was one of the founders and ideological leaders of the St. Petersburg Artel of Artists (1863). Lived in St. Petersburg. Visited western Europe in 1869, 1876, and 1884. Founder-member of the Wanderers (1870); played a major role in the artistic and social activities of this society. Taught at the School of Drawing attached to the Society for the Encouragement of Artists (1863-68). Wrote a number of articles on art questions.

KRIVONOGOV, Petr Aleksandrovich
Born Kiiasovo (now in the Udmurt Autonomous Republic) 1911. Died Moscow 1967.

Honored Art Worker of the RSFSR. Winner of the State Prize of the USSR. Painter of battle scenes. Studied at the Institute of Applied and Decorative Art, Leningrad, under P. A. Shillingovsky (1930-38). Research assistant in the Department of Drawing there (1938-39). Lived in Leningrad and then, beginning in 1939, in Moscow. Member of the Grekov Studio of Battle-Painters, Moscow (1939-67). Began to exhibit in 1939.

KUINDZHI, Arkhip Ivanovich
Born Mariupol 1842 (1841?). Died St. Petersburg 1910.

Landscape painter. Represented a romantic trend within the realist art of the second half of the 19th century. Highly individual style. Outstanding teacher. Received no systematic training in art. Received title of Professor, 1892. Supervised the Landscape Studio in the Higher Art School attached to the Academy of Arts, St. Petersburg, 1894-97. Beginning 1875, a member of the Wanderers. Lived in St. Petersburg and the Crimea. After 1882 did not exhibit, although he continued to paint. Bequeathed all these late works to the Kuindzhi Society; they became known only after his death.

KURBANOV, Sukhrob Usmanovich
Born Kurgan-Tiube, Tadzhik SSR, 1946. Lives Dushanbe.

Easel and monumental painter: genre scenes, portraits, still lifes, gobelins, mosaics. Studied in the Republican Art Institute, Dushanbe (1959-64), at the Moscow Secondary Art School (1964-65), the Surikov Art Institute, Moscow, in the Class for Monumental Painting under K. A. Tutevol, A. L. Orlovsky, A. V. Myzin, and N. P. Khristoliubov. Began to exhibit in 1967.

KUSTODIEV, Boris Mikhailovich
Born Astrakhan 1878. Died Leningrad 1927.

Painter, graphic artist, sculptor: genre scenes, portraits, book illustrations, stage designs. Studied under P. A. Vlasov in Astrakhan, at the Higher Art School attached to the Academy of Arts, St. Petersburg, under V. E. Savinsky and I. E. Repin (1896-1903). Traveled in France and Spain as a *pensionnaire* of the Academy of Arts. Lived in St. Petersburg, traveled in the Volga regions. Received title of Academician, 1909. Visited Italy (1907), Austria, Italy, France, Germany (1909), Switzerland (1911-12), France and Italy (1913), Finland (1917). Cofounder of the New Society of Artists (1904), member of the World of Art group (beginning 1910), the Union of Russian Artists (beginning 1910), and AkhRR (beginning 1923). Taught at the New Art Studio, St. Petersburg (1913).

KUZNETSOV, Pavel Varfolomeevich
Born Saratov 1878. Died Moscow 1968.

Painter, graphic artist, and monumentalist: genre scenes, landscapes, portraits, still lifes. Studied at the Bogoliubov School of Drawing in Saratov (1891-97), at the Moscow Institute of Painting, Sculpture and Architecture under K. A. Korovin and V. A. Serov (1897-1903), and in private studios in Paris (1906). Visited France, Italy, England. Member of the World of Art group, of the Blue Rose, the Union of Russian Artists, and Four Arts. Lived in Moscow. Taught at the Stroganov Institute of Industrial Art, at SVOMAS/VKhUTEMAS/VKhUTEIN, and the Moscow Institute of Visual Arts (1918-37). Taught at the Moscow Higher Institute of Industrial Art (formerly the Stroganov) (1945-48).

LARIONOV, Mikhail Fedorovich
Born near Tiraspol 1881. Died Paris 1964.

Painter, graphic artist, stage designer: landscapes, portraits, still lifes, genre scenes. Studied at the Moscow Institute of Painting, Sculpture and Architecture under V. A. Serov and I. I. Levitan (1898-1908). Traveled to

Paris in 1906 with P. V. Kuznetsov and S. P. Diaghilev; also visited London. Together with N. S. Goncharova formulated the abstract system known as Rayonism (1912-14). Lived in Paris. Between 1914 and 1929 worked as a designer for Diaghilev's Ballets Russes. Member of the Knave of Diamonds group and co-organizer of the Donkey's Tail (1912) and Target (1913) exhibitions.

LENTULOV, Aristarkh Vasilievich
Born Penza Province 1882. Died Moscow 1943.

Painter: landscapes, still lifes, portraits, genre scenes, stage designs. Studied at the Seliverstov Art Institute, Penza, under N. K. Pimonenko and N. F. Seleznev (1900-04), in D. N. Kardovsky's studio in St. Petersburg (1906-10), and independently in the studio of Henri Le Fauconnier in Paris (1911). Lived in Moscow from 1910 onward. Often traveled to the Crimea. Co-organizer of the Knave of Diamonds society in 1910. Contributed to the exhibitions of the World of Art (1911, 1912), Leftist Trends (1915), Contemporary Russian Painting (1916). Member of AKhR (beginning 1926), the Society of Moscow Artists (beginning 1928). Taught at SVOMAS/VKhUTEMAS/VKhUTEIN (beginning 1919) and at the Moscow Art Institute (1919-43).

LEVITAN, Isaak Ilich
Born Vilna Province 1860. Died Moscow 1900.

Painter of landscapes. Studied at the Moscow Institute of Painting, Sculpture and Architecture under A. K. Savrasov and V. D. Polenov (1873-85). Lived mainly in Moscow. Worked in the Crimea (1886, 1899), Finland (1896), Italy, France, and Switzerland (1890, 1894, 1897, 1898). His several trips to the Volga regions (1887-89, 1891), exerted a formative influence on his work. A member of the Wanderers, beginning 1891; began exhibiting with this society in 1884. Supervised the landscape class at the Moscow Institute of Painting, Sculpture and Architecture, 1898-1900.

LEVITSKY, Dmitrii Grigorievich
Born in the Ukraine 1735. Died St. Petersburg 1822.

Received initial art tuition from his father, a clergyman and engraver, and then from A. P. Antropov, who arrived in Kiev in 1752 to work on murals for St. Andrei's Cathedral there. In 1758 Levitsky moved to St. Petersburg, lived and studied with Antropov. It is probable that he took lessons from Jean Louis Lagrenée the Elder and from Giuseppe Valeriani. Received title of Academician, 1770. Beginning in 1771 taught in the portrait class at the Academy of Arts.

MALEVICH, Kazimir Severinovich
Born Kiev 1878. Died Leningrad 1935.

Painter of landscapes, genre scenes; painted cubist and abstract (Suprematist) compositions, created spatial compositions and constructions called *arkhitektony* and *planity*. Also worked on stage design and applied art. Wrote many theoretical tracts on art. Studied at the School of Drawing in Kiev (1895-96), at the Moscow Institute of Painting, Sculpture and Architecture (1904-05), and in the studio of F. I. Rerberg (1905-10). Lived in Kiev, then in Moscow (from 1900), Vitebsk (1919-22), and Leningrad (1923 onward). Visited Warsaw and Berlin (1927). Member of the Knave of Diamonds (beginning 1910). Contributed to many exhibitions (1911-17), including those of the Union of Youth, the Donkey's Tail, the Target, Tramway V, and 0.10. Taught at SVOMAS (1918) and the Vitebsk Art School (1919-22). Professor at the Institute of Artistic Culture (Leningrad branch) (1923-27).

MALUEV, Boris Yakovlevich
Born Stalingrad 1929. Lives Leningrad.

Painter and monumentalist: genre scenes, mosaics, vitrages, and murals. Studied at the Saratov Art and Pedagogical Institute under V. I. Borodin (1946-48) and the Mukhina Higher Institute of Industrial Design in Leningrad under G. A. Savinov and A. A. Kazantsev (1951-57). Began to exhibit in 1960.

MANIZER, Gugo Matveevich
Born Leningrad 1927. Lives Moscow.

Landscape painter. Studied at the Moscow Art School under M. V. Dobroserdov (1943-46), at the Surikov Art Institute, Moscow, under G. G. Riazhsky (1946-52). Received professorial rank in 1958. Taught at the Moscow Textile Institute (1963-76) and, beginning in 1976, at the Surikov Art Institute, Moscow. Began to exhibit in 1954.

MURADIAN, Sarkis Mambreevich
Born Erevan 1927. Lives Erevan.

Honored Art Worker of the Armenia SSR. Winner of the State Prize of the USSR. Painter of genre scenes, portraits, landscapes. Studied at the Shumian Secondary

Art School, Erevan (1935–43), the Terlemezan Art Institute, Erevan (1943–45), and the Erevan Art Institute (1945–51). Teacher at the Erevan Art and Theater Institute (1961–63 and from 1971 onward). Nominated for title of Docent (professorial rank). Began to exhibit in 1947.

NALBANDIAN, Dmitrii Arkadievich
Born Tiflis 1906. Lives Moscow.

People's Artist of the USSR. Full Member of the Academy of Arts of the USSR. Winner of the State Prize of the USSR and of the Jawaharial Nehru Prize. Painter of genre scenes, portraits, landscapes, still lifes. Studied at the Tiflis Academy of Arts under E. E. Lancéray and E. M. Tatevosian (1924–29). Visited India many times. Began to exhibit in 1935.

NEMUKHIN, Vladimir Nikolaevich
Born Moscow 1925. Lives Moscow.

Painter of landscapes, still lifes. Received initial art training at the art studio of the All-Union Central Soviet of Professional Unions (1943–46). In close contact with the artist P. E. Sokolov, 1943–67; regards him as his major formative influence. Often visits the Crimea, the Volga, the Caucasus, the North, Moldavia, the Ukraine, and Siberia. Has visited Poland. Began to exhibit in 1952.

NESTEROV, Mikhail Vasilievich
Born Ufa 1862. Died Moscow 1942.

Honored Art Worker of the RSFSR. Winner of the State Prize of the USSR. Painter of portraits, landscapes, historical and religious themes; also worked on monumental art. Studied at the Moscow Institute of Painting, Sculpture and Architecture under V. G. Perov, A. K. Savrasov, and I. M. Prianishnikov (1877–81, 1884–86), and at the Academy of Arts, St. Petersburg, under P. P. Chistiakov (1881–84). Received title of Academician, 1898. Lived in Moscow, then Kiev (1890–1910), then Moscow again. Visited Italy, France, Austria, Germany, Greece, Turkey. Organized a study trip of ancient Russian cities, mid-1890s. Traveled along the Volga and Kam rivers, 1905. Beginning 1898, a member of the Wanderers; began exhibiting with this society 1889. Cofounder and member of the Union of Russian Artists.

NISSKY, Georgii Grigorievich
Born Novobelishche, Belorussia, 1903. Lives Moscow.

Full Member of the Academy of Arts of the USSR. People's Artist of the RSFSR. Winner of the State Prize of the USSR. Painter of landscapes, still lifes. Studied at VKhUTEMAS/VKhUTEIN under A. D. Drevin and R. R. Falk (1925–30). Began to exhibit in 1930.

ORLOVSKY, Aleksandr Osipovich
Born Warsaw 1777. Died St. Petersburg 1832.

Painter, graphic artist, and lithographer: battle paintings, genre scenes, landscapes, animal scenes, caricatures, portraits. Of Polish extraction. Worked in Poland and in Russia. Studied in Warsaw with the painter Jean Pierre Norblin; visited the studio of Marcello Bacciarelli. His youth was full of travel and adventure. Took part in the Polish liberation movement and uprising of 1794. Moved to St. Petersburg in 1802 where he served as a court artist. Attached to the General Staff, 1819. Received title of Academician of Battle Painting, 1809. Painted military and domestic scenes, robbers, seascapes and shipwrecks, troika rides, and scenes from everyday life. Also painted types from the nomadic tribes of Russia. Traveled extensively in Russia; visited Persia. He left many portraits of people from various social spheres, and of men of letters and artists.

OSSOVSKY, Petr Pavlovich
Born Malaia Viska, the Ukraine, 1925. Lives Moscow.

Honored Artist of the USSR. Painter of genre scenes, landscapes, portraits. Studied at the Moscow Art School under V. V. Pochitalov and A. P. Shorchev (1940–44), and at the Surikov Art Institute, Moscow, under S. V. Gerasimov (1944–50). Visited Cuba and Mexico, 1960. Often travels in Siberia, the Far North, and the Pskov region. Began to exhibit in 1956.

PAULIUK, Yanis Antonovich
Born Riga 1906. Lives Riga.

Painter of genre scenes, portraits, landscapes. Studied at the Latvian Academy of Arts, Riga, under A. Khanus and E. Tone (1939–46). Began to exhibit in 1945.

PENUSHKIN, Yurii Ivanovich

Born Leningrad 1935. Lives Leningrad.

Painter of genre scenes, landscapes, still lifes. Studied at the Leningrad Secondary Art School attached to the Academy of Arts of the USSR (1948-54) and the Repin Institute of Painting, Sculpture and Architecture, Leningrad, under P. T. Fomin and E. E. Moiseenko (1954-62). After graduation, worked in the art studio of Professor A. A. Mylnikov. Began to exhibit in 1960.

PEROV, Vasilii Grigorievich

Born Tobolsk 1834. Died Moscow 1882.

Painter, draughtsman: genre scenes, portraits, historical themes. Studied at the Stupin School of Painting in Arzamas (irregularly 1846-49), and at the Moscow Institute of Painting, Sculpture and Architecture under M. I. Skotti, A. N. Mokritsky, and S. K. Zarianko (1853-61). From 1862 to 1869 was a *pensionnaire* of the Academy of Arts, St. Petersburg. Lived in Paris, 1860, 1862-64, where he painted and sketched many scenes from the slums and suburbs. Received title of Academician, 1870. Beginning 1864, lived in Moscow and headed the group of Realist artists. Founder-member of the Wanderers. Taught at the Moscow Institute of Painting, Sculpture and Architecture (1871-82). Among his students were M. V. Nesterov, A. P. Riabushkin, S. A. Korovin, N. A. Kasatkin. Wrote many literary essays often connected with the themes of his paintings. Also wrote his memoirs of the Moscow Institute of Painting, Sculpture and Architecture in the 1850s.

PETROV-VODKIN, Kuzma Sergeevich

Born Khvalynsk, Saratov Province, 1878. Died Leningrad 1939.

Honored Art Worker of the RSFSR. Painter, graphic artist, art theorist, writer, teacher: portraits, still lifes, landscapes, stage designs. Studied in the painting and drawing classes conducted by F. E. Burov in Samara (1893-95), at the Stieglitz Central Institute of Technical Drawing, St. Petersburg (1895-97), the Moscow Institute of Painting, Sculpture and Architecture under N. A. Kasatkin, A. E. Arkhipov, and V. A. Serov (1897-1905), in Anton Ažbè's studio in Munich (1901), and in private academies in Paris (1905-08). Visited Italy, Greece, France, and Africa during this period. Beginning 1909, contributed to the exhibitions of the Golden Fleece, the World of Art (of which he was a member 1910-24), and Four Arts (beginning 1925).

Taught at E. P. Zvantseva's art school, St. Petersburg (1910-16), and at the Petrograd SVOMAS and the Institute of Applied and Decorative Art, Leningrad.

PIMENOV, Yurii Ivanovich

Born Moscow 1903. Lives Moscow.

Full Member of the Academy of Arts of the USSR. People's Artist of the USSR. Winner of the Lenin Prize. Painter, graphic artist, and stage designer: specializes in lyrical genre scenes. In 1925 graduated from the Department of Graphic Art (V. A. Favorsky's studio) at VKhUTEMAS. Began to exhibit, 1924. Cofounder of OST (1924). Taught at the Institute for Advanced Qualifications for Painters (1936-37) and the All-Union Institute of Cinematography (1945-72). Nominated for professorial rank, 1947.

PLASTOV, Arkadii Aleksandrovich

Born Prislonikha (now Ulianov region) 1893. Died Moscow 1972.

Full Member of the Academy of Arts of the USSR. People's Artist of the USSR. Winner of the Lenin Prize and State Prize of the USSR. Painter of genre scenes, landscapes, portraits; also worked as a book illustrator in watercolor. Studied at the Stroganov Central Institute of Art and Industry, Moscow (1912-14), and the Moscow Institute of Painting, Sculpture and Architecture (1914-17). Began to exhibit in 1929. Lived and worked in Moscow and in his native village.

PLAVINSKY, Dmitrii Petrovich

Born Moscow 1937. Lives Moscow.

Painter, graphic artist, etcher: still lifes, symbolic compositions influenced by themes from dead civilizations and from the biological universe. Studied at the 1905 Institute in Moscow under V. A. Shestakov (1951-56). Travels a great deal in Central Asia, Armenia, the Baltic States, and the Far East. Began to exhibit in 1957.

POKHODAEV, Yurii Arkhipovich.

Born Essentuki 1927. Lives Moscow.

Painter of genre scenes and landscapes. Studied at the Kalinin Institute of Art and Industry, Moscow, under V. Baksheev (1942-47) and the Surikov Art Institute, Moscow, under G. G. Riazhsky (1948-54). Began to exhibit in 1955.

POPOVA, Liubov Sergeevna.

Born Moscow Province 1889. Died Moscow 1924.

Painter, graphic artist, textile and stage designer. Studied in Moscow in the studios of K. F. Yuon and S. Yu. Zhukovsky (1907-08) and in Paris in the studios of Henri Le Fauconnier and Jean Metzinger (1912-13). Worked in Tatlin's studio in Moscow. Taught at VKhUTEMAS (beginning 1921) and in the Proletkult studios.

REPIN, Ilia Efimovich

Born Chuguev, the Ukraine, 1844. Died Kuokkala, Finland, 1930.

Painter, draftsman, etcher, lithographer: portraits, contemporary scenes, historical subjects, book illustrations. Received his initial training from M. I. Bubnov in Chuguev (Kharkov region). Studied at the School of Drawing attached to the Society for the Encouragement of the Arts, St. Petersburg, under I. N. Kramskoi (1863), then at the Academy of Arts, St. Petersburg, while still consulting with Kramskoi (1864-76). Worked in Paris as a *pensionnaire* of the Academy of Arts (1872-76). On his return, lived in Chuguev (1876-77), St. Petersburg (1882), and then at his own estate, Penaty, in Kuokkala. From 1878 to 1882, together with V. M. Vasnetsov and V. D. Polenov, Repin was the driving force of S. I. Mamontov's Abramtsevo Circle. Traveled throughout Russia a great deal, collecting materials for his paintings: on the Volga (1870, 1872), in the Ukraine (1880), in Kursk Province (1882), the northern Caucasus (1888). Was often in Europe (1883, 1889, 1894, 1900). Member of the Wanderers 1878-90, 1897-1918; first exhibited with the society in 1874. Contributed to the exhibitions of the World of Art group. Professor and studio supervisor at the Higher Art Institute attached to the Academy of Arts, St. Petersburg (1894-1907); Rector thereof, 1898-99. Simultaneously taught at the studio school run by Princess M. K. Tenisheva. Among his many students were V. A. Serov, B. M. Kustodiev, K. A. Somov, A. P. Ostroumova-Lebedeva, I. E. Grabar, I. Brodsky. Wrote many important articles on questions of Russian and European art; also wrote his memoirs of his contemporaries and of his own creative career.

RIANGINA, Serafima Vasilievna

Born St. Petersburg 1891. Died Moscow 1955.

Honored art worker of the RSFSR. Painter of genre scenes, portraits, landscapes, still lifes. Studied in the studio of Ya. F. Tsionglinsky, St. Petersburg (1912-18), and the Academy of Arts, St. Petersburg, under D. N. Kardovsky (1912-18, 1921-23). Beginning 1923, lived in Moscow. Beginning 1924, member of AKhRR.

ROKOTOV, Fedor Stepanovich

Born Moscow 1735 (1736?). Died Moscow 1808.

Portrait painter. Born into a serf family. Spent his childhood and youth on the estate of the Repnins outside Moscow. No information available on this period of the artist's life. After he was twenty, released from serfdom, he was a pupil at the Academy of Arts, St. Petersburg. Studied at the Academy while earning his living by executing commissions for the Academy. Had his own studio and pupils there. Painted an official portrait of Catherine the Great in connection with her coronation, 1763. Received title of Academician, 1763. Moved to Moscow where he executed private commissions, working only occasionally for the Academy.

ROMADIN, Nikolai Mikhailovich.

Born Samara 1903. Lives Moscow.

People's Artist of the USSR. Full Member of the Academy of Arts of the USSR. Winner of the State Prize of the USSR. Landscapist. Studied at the Samara Art Technical School (1922) and at VKhUTEMAS/VKhUTEIN under R. R. Falk, I. I. Mashkov, and P. P. Konchalovsky (1923-30). Began to exhibit in 1929.

ROZANOVA, Olga Vladimirovna

Born Malenki, Vladimir Province, 1886. Died Moscow 1918.

Painter, graphic artist. Contributed to the exhibitions of the Knave of Diamonds. Her works were exhibited posthumously at the First State Exhibition, Moscow, 1918, at the Tenth State Exhibition, entitled Nonobjective Creation and Suprematism, Moscow, 1919, and at the exhibition Latest Trends in Art, Leningrad, 1927.

RYLOV, Arkadii Aleksandrovich

Born Istobenskoe, Viatsk Province, 1870. Died Leningrad 1939.

Landscape painter, graphic artist. Studied at the Stieglitz Central Institute of Technical Drawing in St. Petersburg under K. Ya, Kryzhitsky (1888-91) and at the Academy of Arts, St. Petersburg, under A. I. Kuindzhi (1894-97). Lived in St. Petersburg. Visited France and Germany (1898). Member of the World of

Art society (from 1901), and of AKhRR. Founder-member of the Kuindzhi Society. Taught at the School of Drawing attached to the Society for the Encouragement of the Arts (1902–18), the Leningrad Art and Pedagogical Technical School (1923–26), and the Academy of Arts, Leningrad (1918–29).

SALAKHOV, Tair Teimur ogly
Born Baku 1928. Lives Moscow.

People's Artist of the USSR. Full Member of the Academy of Artists of the USSR. Winner of the State Prize of the USSR. Painter of genre scenes, portraits, landscapes, still lifes; also stage designs. Studied at the Azim Azim-Zade Art Institute, Baku (1945–50). Began to exhibit in 1952. Graduated from the Surikov Art Institute, Moscow (studio of P. D. Pokarzhevsky), 1957. Attained professorial rank, 1973. Taught at the Aliev Institute of Arts, Azerbaijan. Beginning 1973, First Secretary to the board of the Union of Artists of the USSR.

SAMOKHVALOV, Aleksandr Nikolaevich
Born Bezhetsk 1894. Died Leningrad 1971.

Honored Art Worker of the RSFSR. Painter, graphic artist, stage designer: portraits, genre scenes, landscapes, book illustrations. Received initial art training from I. M. Kostenko at the Bezhetsk Institute of painting. Studied in St. Petersburg at the Higher Art Institute attached to the Academy of Arts, attending courses in the Architecture Department (1914–18), then at the Petrograd SVOMAS/Academy under D. N. Kardovsky, A. A. Rylov, V. E. Savinsky, graduating from the studio of K. S. Petrov-Vodkin (1920–33). In 1920 worked with Petrov-Vodkin in Turkestan as part of an expedition to study the art and architectural monuments of Samarkand. Lived in Leningrad. Member of the Circle of Artists and the October society.

SARIAN, Martiros Sergeevich
Born Nakhichevani-on-Don (now part of Rostov-on-Don) 1880. Died Erevan 1972.

Painter and graphic artist: landscapes, portraits, still lifes, stage designs, book illustrations. Hero of Socialist Labor. People's Artist of the USSR. Full Member of the Academy of Arts of the USSR and the Academy of Sciences of the Armenian SSR. Winner of the Lenin Prize and of the State Prize of the USSR. Studied at the Moscow Institute of Painting, Sculpture and Architecture under V. A. Serov and K. A. Korovin (1897–1904).

Visited Constantinople (1910), Egypt (1911), Transcaucasia (1912), Persia (1913). Lived in Moscow until 1921, then in Erevan (except for 1926–28 when he worked in Paris). Member of the Union of Russian Artists (beginning 1911), the Blue Rose (1907), the World of Art (1910–16), Four Arts (late 1920s), and many other art societies.

SAVRASOV, Aleksei Kondratievich
Born Moscow 1830. Died Moscow 1897.

One of the founders and most prominent representatives of Russian landscape painting of the second half of the 19th century; outstanding teacher. Studied at the Moscow Institute of Painting, Sculpture and Architecture under K. I. Rabus (1844–54). Received title of Academician, 1854. From 1857 until 1882 supervisor of the landscape class in the Moscow Institute of Painting, Sculpture and Architecture: among his students there were I. I. Levitan and K. A. Korovin. Founder-member of the Wanderers. Lived in Moscow. Visited London and Switzerland, 1862.

SEROV, Valentin Aleksandrovich
Born St. Petersburg 1865. Died Moscow 1911.

Painter, graphic artist: portraits, landscapes, genre and historical painting, book illustrations, stage designs. Son of the composer A. N. Serov. Studied under I. E. Repin and at the Academy of Arts, St. Petersburg, under P. P. Chistiakov (1880–85). Lived in St. Petersburg and Moscow. Traveled in Russia and western Europe. In Greece with Lev Bakst, 1907. Member of the Wanderers (beginning 1894) and of the World of Art. Contributed to exhibitions of the Society of Lovers of the Arts and the Union of Russian Artists. Received title of Academician, 1895. Taught at the Moscow Institute of Painting, Sculpture, and Architecture, 1897–1909.

SHISHKIN, Ivan Ivanovich
Born Elabuga, Viatsk Province, 1832. Died St. Petersburg 1898.

Painter, draughtsman, lithographer, and etcher: landscapes. Studied at the Moscow Institute of Painting, Sculpture and Architecture under A. N. Mokritsky (1852–56), then at the Academy of Arts, St. Petersburg, under S. M. Vorobiev (1856–60). As a *pensionnaire* of the Academy, worked in Munich, Prague, Zürich, and Düsseldorf (1862–65). Received title of Professor, 1872. Lived in St. Petersburg, Founder-member of the Wanderers (1870). Professor and supervisor of the

landscape studio at the Higher Art School attached to the Academy of Arts, St. Petersburg (1894-95).

SHTERENBERG, David Petrovich
Born Zhitomir in the Ukraine 1881. Died Moscow 1948.

Honored Art Worker of the USSR. Professor. Painter and graphic artist, stage designer: still lifes, portraits, book illustrations. Studied in Paris at the Ecole des Beaux-Arts and private studios (1907-17). Began to exhibit in 1912. Beginning in 1918 lived in Moscow. Headed the Department of Visual Arts of the People's Commissariat for Enlightenment (1918-20). Cofounder and president of OST. Taught at SVOMAS/VKhU-TEMAS/VKhUTEIN (1920-30).

SHURPIN, Fedor Savvich
Born Kiriakino in Smolensk Province 1904. Died Moscow 1972.

Honored Art Worker of the RSFSR. Winner of the State Prize of the USSR. Painter of genre scenes, landscapes. Studied at VKhUTEMAS/VKhUTEIN under R. R. Falk, A. D. Drevin and D. P. Shterenberg (1925-31). Member of AKhR (1932). Lived in Moscow.

SOMOV, Konstantin Andreevich
Born St. Petersburg 1869. Died 1939 Paris.

Painter and graphic artist: portraits, landscapes, book illustrations; favored stylized, 18th-century themes of the *fêtes galantes*. Studied at the Academy of Arts, St. Petersburg, 1888-97, in Repin's studio there, 1894-97, and in Paris in the studio of F. Colarossi. Lived in St. Petersburg, New York, Paris (which he made his permanent home in 1925). Traveled a great deal in western Europe. Cofounder of the World of Art group. Contributed to the exhibitions of the Society of Russian Watercolorists. Received title of Academician, 1913. Elected to professorship at the Academy of Arts, Petrograd, 1918.

SOROKA (VASILIEV), Grigorii Vasilievich
Born Pokrovskaia, Tver Province, 1823. Died Pokrovskaia 1864.

Painted landscapes, interiors, portraits. Son of a serf. At first taught himself drawing, then studied under A. G. Venetsianov, working as an apprentice with him. Copied paintings and painted icons, 1842-47. His master,

the landowner N. P. Miliukov, refused to release him from serfdom, wanting him to become a gardener. Lived as a house serf in the village of Ostrovki and then in Pokrovskaia. During the 1861 Reform was released from serfdom. Committed suicide. Soroka was a given name.

STOZHAROV, Vladimir Fedorovich
Born Moscow 1926. Died Moscow 1973.

Honored Artist of the RSFSR. Full Member of the Academy of Arts of the USSR. Painter of genre scenes, landscapes, still lifes. Studied at the Moscow Secondary Art School (1939-45) and the Surikov Art Institute, Moscow, under V. V. Pochitalov and K. M. Maksimov (1945-51). Lived in Moscow. Made long study trips throughout the Soviet Union (Siberia, the Volga, Kazakhstan, the Komi Autonomous SSR, the Archangel, Vologda, and Kostroma regions, the Crimea, and the Baltic States).

SURIKOV, Vasilii Ivanovich
Born Krasnoiarsk 1848. Died Moscow 1916.

Painter of historical subjects, portraits, and landscapes. One of the most important representatives of Russian realist art of the second half of the 19th century and beginning of the 20th. Born into the family of a Siberian Cossack. Studied at the Academy of Arts, St. Petersburg, under P. P. Chistiakov (1869-75). After 1877, lived in Moscow. Traveled several times to Siberia. Visited Germany, France, Italy, Austria (1883-84), Switzerland (1897), Italy (1900), Spain (1910). Member of the Wanderers (beginning 1881), and of the Union of Russian Artists (1908-15).

TATLIN, Vladimir Evgrafovich
Born Moscow 1885. Died Moscow 1953.

Honored Art Worker of the RSFSR. Painter, graphic artist, constructor, stage designer. Studied at the Moscow Institute of Painting, Sculpture and Architecture under V. A. Serov and K. A. Korovin (1902-03, 1909-10) and at the Penza Art Institute under A. F. Afanasievich (1904-09). Lived in Moscow and Petrograd. Member of art groups including the World of Art, the Knave of Diamonds (until 1913), the Union of Youth (beginning 1913). One of the founders of Constructivism. Taught at art schools in Moscow, at the Academy of Arts, Petrograd/Leningrad (1921-25), and the Kiev Art Institute (1925-27). Supervised the Scientific Re-

search Laboratory for the Plastic Arts (1931-33). One of the originators of the Soviet school of design.

TOIDZE, Georgii Vakhtangovich
Born Tbilisi 1932. Lives Tbilisi.

Painter of genre scenes, portraits, landscapes, still lifes. Studied at the Nikoladze Art Institute in Tbilisi under T. Bardadze and V. S. Sherpilov (1949-54) and at the Tbilisi Academy of Arts under Sh. Mamaladze, D. Gabashvili, S. Kobuladze, and V. P. Shukhaev (1954-60). Began to exhibit in 1957.

TROPININ, Vasilii Andreevich
Born Karpovo, Novgorod Province, 1776. Died Moscow 1857.

Painter, draughtsman, portraitist, his work including many genre motifs and images. A serf of Count A. S. Minin and then of Count I. I. Morkov. Attended classes at the Academy of Arts, St. Petersburg, as an "outside student" (auditor), 1798-1804. Count Morkov did not allow him to finish a complete tour of study and recalled him to his estate. Until 1821 lived sometimes in the Ukraine, in Podolsk Province, sometimes in Moscow. Painted many portraits and acquired wide recognition for them. Received title of Academician, 1824, and settled in Moscow. Close contact with the teachers and students of the Moscow Institute of Painting and Sculpture. Painted A. S. Pushkin's portrait, 1827.

UDALTSOVA, Nadezhda Andreevna
Born Orel 1886. Died Moscow 1961.

Painter of still lifes, landscapes, portraits genre scenes. Studied at K. F. Yuon's art school in Moscow (1905-08), at Kim's (?) studio (1909-10), and in Paris in the studio of Jean Metzinger and Henri Le Fauconnier (1911-12). Began to exhibit in 1914. Member of, and contributed to the exhibitions of, the World of Art (1921-22), Moscow Painters (1925), the Society of Moscow Artists (beginning in 1928), and 13 (1929-31). Professor of painting at VKhUTEMAS/VKhUTEIN (1921-34). With A. D. Drevin traveled a great deal throughout the Soviet Union: to Kazakhstan and the Altai region (1930), to Armenia (1933-34).

VASILIEV, Fedor Alekseevich
Born Gatchina, near St. Petersburg, 1850. Died Yalta 1873.

Painter and draughtsman: landscapes. Studied for a time in the School of Drawing attached to the Society for the Encouragement of Artists in St. Petersburg. Worked under I. I. Shishkin (1866-67). Was close to I. N. Kramskoi. Journeyed along the Volga with Repin, 1870. After contracting tuberculosis, moved from St. Petersburg to the Crimea, 1871. Died before his art education was completed, leaving a number of large finished oils and many studies and sketches from nature.

VASNETSOV, Apollinarii Mikhailovich
Born Viatsk Province 1856. Died Moscow 1933.

Painter, graphic artist: landscapes and historical scenes, also some stage designs. Received lessons from his brother, V. M. Vasnetsov. Lived in St. Petersburg 1880-90, then in Moscow. Visited France, Italy, Germany (1898-99). Member of the Wanderers, beginning 1899. Chairman of the Commission for the Study of Old Moscow, attached to the Moscow Archaeological Society, beginning 1918. Taught at the Moscow Institute of Painting, Sculpture and Architecture (1901-18). Member of the Union of Russian Artists.

VASNETSOV, Viktor Mikhailovich
Born Viatsk Province 1848. Died Moscow 1928.

Painter of historical pictures on themes from the ancient Russian folk poems (*byliny*) and folklore, also of genre scenes and portraits; stage designer, book illustrator. His democratic sentiment was reflected in his distinctive interpretation of the fairy tale and *bylina* theme glorifying the moral ideals of the people. Brother of the landscapist A. M. Vasnetsov. Studied at the School of Drawing attached to the Society for the Encouragement of Artists under I. N. Kramskoi (1867-68), and then at the Academy of Arts, St. Petersburg (1868-75, irregularly). Lived and worked in St. Petersburg and Moscow. Visited France (1876), Italy (1885). Beginning 1878, a member of the Wanderers. Full member of the Academy of Arts, 1893-1905.

VENETSIANOV, Aleksei Gavrilovich
Born Moscow 1780. Died Tver Province 1847.

One of the founders of the peasant genre and the national Russian landscape. Son of a poor merchant. Studied in a private boarding school, then worked as a civil servant. Studied painting on his own. Moved to St. Petersburg, 1802. Developed his skill in painting under the supervision of V. L. Borovikovsky. Made many copies from pictures in the Hermitage. Received title of Academician, 1811. Acquired a small estate in Tver

Province together with the villages of Safonkovo and Tronikha. In 1819 retired and lived in the country, although he kept his house in St. Petersburg. In Safonkovo organized a school where he taught painting, for the most part to serf children. The basis of his pedagogical method was to work from nature. Painted scenes of peasant life, portraits of serfs. His views were progressive for his time. In addition to his painting and teaching, he carried on social work.

VERESHCHAGIN, Vasilii Vasilievich
Born Cherepovets 1842. Died 1904.

Painter of battle scenes and ethnographical compositions. Studied at the School of Drawing attached to the Society for the Encouragement of the Arts, St. Petersburg (1858–60), at the Academy of Arts, St. Petersburg, under A. T. Markov and A. E. Beideman (1860–63), and in Jean-Léon Gérôme's studio in Paris (1864–65). Traveled a great deal in Russia and Europe, went twice to India (1874–76, 1882), visited Syria and Palestine, the USA, and Japan. As a war artist saw action in the Turkestan War (1867–70), the Russo-Turkish War (1877–78), and the Russo-Japanese War (1904). As a result of his travels and of his historical, ethnographical, and military observations, Vereshchagin generally painted extensive cycles of pictures. He exhibited them only in one-man exhibitions both in Russia and abroad—in Europe and the USA. Lived for the most part in St. Petersburg and Moscow, although he had studios in Munich (1871–73) and Paris (1876, 1878–79). Died when the battleship *Petropavlovsk* blew up at Port Arthur.

VIALOV, Konstantin Aleksandrovich
Born Moscow 1900. Died Moscow 1976.

Painter and graphic artist: genre scenes of modern subjects; also worked as a poster and book designer. Studied in Moscow at the Stroganov Institute (1914–17) and at SVOMAS/VKhUTEMAS under A. V. Lentulov and A. A. Morgunov. Began to exhibit in 1923. Member of OST (1925–31).

VRUBEL, Mikhail Andreevich
Born Omsk 1856. Died St. Petersburg 1910.

Painter and graphic artist: monumental paintings, easel paintings, stage designs; also book illustrations, decorative sculpture, and architecture. Studied at the School of Drawing attached to the Society for the Encouragement of the Arts, St. Petersburg (1863–64, 1869), at the

Academy of Arts under P. P. Chistiakov (1880–84). Took lessons from I. E. Repin. Lived in Kiev 1884–89, where he took part in the mural painting for the Church of St. Cyril and the Cathedral of St. Vladimir. Moved to Moscow, 1889. Associated with S. I. Mamontov's circle at the art colony of Abramtsevo. Worked at Abramtsevo on maiolica designs and stage designs, 1891–1900. From 1904 onward, lived and worked in St. Petersburg. Frequent visits to Italy, France; also traveled to Germany, Switzerland, and Greece. In 1906, already insane, went blind. Died in an asylum.

YAKOBI (YAKOBII), Valerii Ivanovich
Born Kudriakovo (now part of Tartar Autonomous SSR) 1834. Died Nice, France, 1902.

Painter of genre scenes and historical subjects, mostly from Russian history. Studied at the Academy of Arts, St. Petersburg, under A. T. Markov (1856–61). As a *pensionnaire* of the Academy, lived in Zürich, Paris, Naples, and Rome (1861–69). Lived in St. Petersburg. Founder-member of the Wanderers but did not exhibit with the association. Also helped to organize, and was active in, the Society of Exhibitions of Works of Art, 1874–85, an academic association of artists founded to compete with the Wanderers. Taught at the Academy of Arts, St. Petersburg, 1878–89.

YAROSHENKO, Nikolai Aleksandrovich
Born Poltava 1846. Died Kislovodsk 1898.

Painter, draughtsman: portraits, genre scenes, landscapes. Received a military education and was in military service until 1892. Studied painting at the School of Drawing attached to the Society for the Encouragement of Artists under I. N. Kramskoi and at the Academy of Arts, St. Petersburg (1867–74). Lived mainly in St. Petersburg, but spent his last years in Kislovodsk. Traveled a great deal to collect material for his art—in Europe, the Near East, Middle East, and throughout Russia (the Urals, the Volga, the Caucasus, and the Crimea). Member of the Wanderers, beginning 1876, and one of its leaders.

YUON, Konstantin Fedorovich
Born Moscow 1875. Died Moscow 1958.

People's Artist of the USSR. Full Member of the Academy of Arts of the USSR. Winner of the State Prize of the USSR. Painter of genre scenes, historical subjects, landscapes, portraits; stage designer. Graduated from the studio of V. A. Serov at the Moscow

Institute of Painting, Sculpture and Architecture. Began to exhibit in 1901. One of the organizers of the Union of Russian Artists (1903) and a contributor to its exhibitions. Member of AKhRR, beginning 1923. For Diaghilev's Ballets Russes in Paris, 1913, designed Mussorgsky's opera *Boris Godunov*. With I. O. Dudin headed his own art school in Moscow (1900-18). Worked as a designer for the Malyi Theater in Moscow (1919-43); chief designer for this theater (1944-47). Headed his own studio within the Academy of Arts, Leningrad (1938-39). Awarded degree of Doctor of Art History (1941), title of Professor (1952). Director of the Scientific Research Institute attached to the Academy of Arts of the USSR (1948-50). Professor at the Surikov Art Institute, Moscow (1952-55). First Secretary to the Board of the Union of Artists of the USSR (1957-58).

ZARIN, Indulis Avgustovich

Born Riga 1929. Lives Riga.

Corresponding Member of the Academy of Arts of the USSR. Honored Art Worker of the Latvian SSR. Painter and graphic artist: landscapes; also active in book design. Received initial art tuition at Ya. Rozental's art institute in Riga (1947-52). Began to exhibit in 1956. Graduated from E. Kalnynsh's studio at the Academy of Arts of the Latvian SSR (1958). Secretary to the Board of the Union of Artists of the USSR (1963-68). Since 1967 Pro-Rector at the Academy of Arts of the Latvian SSR.

Selective Bibliography

ABBREVIATIONS: L. = Leningrad, M. = Moscow

General Directories

Azarkovich, V., et al. (eds.): *Vystavki sovetskogo izobrazitelnogo iskusstva*, M., 1965-75. Vol. 1 (1917-32), Vol. 2 (1933-40), Vol. 3 (1941-47), Vol. 4 (1948-53).

Bowlt, J.: *Russian Art of the Avant-Garde: Theory and Criticism 1902-1934*, New York, Viking, 1976.

Imperatorskaia Sanktpeterburgskaia Akademiia khudozhestv 1764-1914: Yubileinyi spravochnik, St. Petersburg, 1914. Two vols.

Lebedev, P. (ed.): *Borba za realizm v izobrazitelnom iskusstve '20-kh godov: Materialy, dokumenty, vospominaniia*, M., 1962.

Markov, V.: *Russian Futurism: A History*, Berkeley, University of California, 1968.

Matsa, I., et al. (eds.): *Sovetskoe iskusstvo za 15 let*, M.-L., 1933.

Sovetskie khudozhniki: Avtobiografii, M., 1937. Two vols.

Sternin, G.: *Khudozhestvennaia zhizn Rossii na rubezhe XIX-XX vekov*, M., 1970. German translation, *Das Kunstleben Russlands an der Jahrhunderwende*, Dresden, VEB, 1976.

Sternin, G.: *Khudozhestvennaia zhizn Rossii nachala XX veka*, M., 1976.

General Histories

Ainalov, *Istoriia russkoi zhivopisi ot 16-go veka*, St. Petersburg, 1913.

Aleshina, L., et al.: *Pamiatniki mirovogo iskusstva: Russkoe iskusstvo XIX—nachala XX veka*, M., 1972.

Alpatov, M.: *Russian Impact on Art*. Edited and with a preface by Martin L. Wolf. New York, Philosophical Library, 1950.

Alpatov, M.: *Etiudy po istorii russkogo iskusstva*, M., 1967. Two vols.

Alpatov, M., et al: *Geschichte der russischen Kunst*, Dresden, VEB, 1975.

Benois, A.: *Istoriia zhivopisi v XIX veke: Russkaia zhivopis*, St. Petersburg, 1901-02.

Benois, A.: *The Russian School of Painting*, New York, Knopf, 1916.

Billington, J.: *The Icon and the Axe*, New York, Knopf, 1966.

Bunt, C.: *Russian Art: From Scyths to Soviets*, London and New York, Studio, 1946.

Chamot, M.: *Russian Painting and Sculpture*, London, Pergamon, 1969.

Eliasberg, A.: *Russische Kunst*, Munich, Piper, 1915.

Fiala, V.: *Russian Painting of the 18th and 19th Centuries*, Prague, Artia, 1955.

Froncek, T. (ed.): *The Horizon Book of the Arts of Russia*, New York, American Heritage, 1970. Introductory essay by James H. Billington.

Gibellino Krasceninnicowa, M.: *Storia dell'arte*, Rome, Maglione, 1935-37.

Gollerbakh, E., et al.: *Istoriia iskusstv vsekh vremen i narodov*, L., 1929.

Grabar, I., et al. (eds.): *Istoriia russkogo iskusstva*, M., 1953-69. Thirteen vols. The standard reference book on the history of Russian and Soviet art. It is based, in part, on Grabar's incomplete *Istoriia russkogo iskusstva*, M., 1910-15, six vols.

Hamilton, G. H.: *The Art and Architecture of Russia*, Baltimore, Penguin, 1954; second edition, 1977.

Hare, R.: *The Art and Artists of Russia*, London, Methuen, 1965.

Klimov, E.: *Russkie khudozhniki*, New York, Put zhizni, 1974.

Muther, R. (with A. Benois): "Russia," in Muther, R., *The History of Modern Painting*, London, Dent; New York, Dutton, 1907, vol. 4, pp. 236-85.

Nemitz, F.: *Die Kunst Russlands. Baukunst. Malerei. Plastik. Vom II bis 19 Jahrhundert*, Berlin, Hugo, 1940.

Newmarch, R.: *The Russian Arts*, London, Jenkins, 1916.

Réau, L.: *L'Art russe des origines à Pierre le Grand*. Paris, Laurens, 1921.

Réau, L.: *L'Art russe de Pierre le Grand à nos jours*, Paris, Laurens, 1922. Both the Réau volumes have been updated and reprinted as *L'Art russe*, Paris, Marabout Université, 1968. Three volumes.

Rubissow, H.: *The Art of Russia*, New York, Philosophical Library, 1946.

Talbot Rice, T.: *A Concise History of Russian Art*, London, Thames and Hudson; New York, Praeger, 1963.

Woinow, I.: *Meister der russischen Malerei*, Berlin, Diakow, 1924.

Wulff, O.: *Die neurussische Kunst im Rahmen der Kulturentwicklung Russlands von Peter dem Grossen bis zur Revolution*, Augsburg, Filser, 1932.

Zotov, A.: *Russkoe iskusstvo s drevnikh vremen do nachala XX veka*, M., 1971.

Ancient Art

Alpatov, M. (ed.): *Andrei Rublev i ego epokha*, M., 1971.

Alpatov, M.: *Treasures of Russian Art in the 11th-16th Centuries*, L., 1971 (in English).

Alpatov, M.: *Early Russian Icon-painting*, M., 1974 (in Russian and English).

Evdokimov, P.: *L'art de l'icône*, Bruges, Desclée de Brouwer, 1970.

Kondakov, N.: *Die russische Ikone*, Prague, 1928-33 (in Russian). English translation by E. Minns: *The Russian Icon*, Oxford, 1927.

Lazarev, V.: *Feofan Grek*, M., 1961.

Lazarev, V.: *Moscow School of Icon-painting*, M., 1971 (in Russian and English).

Lichatschow, D.: *Die Kultur Russlands während der osteuropäischen Frührenaissance vom 14. bis zum Beginn des 15. Jahrhunderts*, Dresden, VEB, 1962.

Maslenitsyn, S.: *Jaroslavian Icon-painting*, M., 1973.

Skrobucha, H.: *Meisterwerke der Ikonenmalerei*, Recklinghausen, Bongers, 1975.

Suslov, V.: *Monuments de l'art ancien russe*, St. Petersburg, 1908-12 (in Russian).

Talbot Rice, D., and T.: *Icons and Their History*, New York, Overlook, 1974.

Wulff, O., and Alpatov, M.: *Denkmäler der Ikonenmalerei in kunstgeschichtlicher Folge*, Dresden, Hellerau, 1925.

Late 17th to Early 19th Centuries

Alekseeva, T. (ed.): *Russkoe iskusstvo pervoi chetverti XVIII veka*, M., 1974.

Alekseeva, T. (ed.): *Russkoe iskusstvo XVIII veka*, M., 1968.

Alekseeva, T. (ed.): *Russkoe iskusstvo XVIII veka*, M., 1973.

Alekseeva, T. (ed.): *Russkoe iskusstvo XVIII—pervoi poloviny XIX veka*, M., 1971.

Alekseeva, T.: *Khudozhniki shkoly Venetsianova*, M., 1958.

Andronikova, M.: *Ob iskusstve portreta*, M., 1975.

Bird, A.: "Eighteenth-century Russian painters in Western collections," *The Connoisseur*, 1971, October, pp. 79-83.

Bowlt, J.: "Russian Portrait-Painting in the Late Eighteenth Century," *Apollo* Vol. 98, No. 137 n.s. (July, 1973), pp. 5-13.

Gollerbakh, E.: *Portretnaia Zhivopis V Rossii XVIII vek*, M.-Petrograd, 1923.

Kaganovich, A.: *Anton Losenko i russkoe iskusstvo serediny XVIII stoletiia*, M., 1963.

Kovalenskaia, N.: *Istoriia russkogo iskusstva XVIII veka*, M.-L., 1940.

Kovalenskaia, N.: *Istoriia russkogo iskusstva pervoi poloviny XIX veka*, M., 1951.

Krasnobaev, B.: *Ocherki istorii russkoi kultury XVIII veka*, M., 1972.

Kukolnik, N.: *Kartiny russkoi zhivopisi*, St. Petersburg, 1846.

Lebedev, G.: *Russkaia zhivopis pervoi poloviny XVIII veka*, L.-M., 1938.

Lebedeva, T.: *Ivan Nikitin*, M., 1975.

Lebediansky, M.: *Graver petrovskoi epokhi Aleksei Zubov*, M., 1973.

Liaskovskaia, O.: *Plener v russkoi zhivopisi XIX veka*, M., 1966.

Moleva, N.: *Moskovskaia mozaika*, M., 1971.

Moleva, N., and Beliutin, E.: *Russkaia khudozhestvennaia shkola pervoi poloviny XIX veka*, M., 1963.

Ovsiannikov, M., et al. (eds.): *Russkie esteticheskie traktaty pervoi treti XIX veka*, M., 1974. Two vols.

Ovchinnikova, E.: *Portret v russkom iskusstve XVII veka*, M., 1955.

La peinture russe à l'époque romantique, Paris, Grand Palais, 1976. Exhibition catalogue.

Portret petrovskogo vremeni, L., 1973. Exhibition catalogue.

Rakova, M.: *Russkoe iskusstvo pervoi poloviny XIX v.*, M., 1975.

Smirnov, G.: *Venetsianov and His School*, L., 1973 (in English, French, German, Russian).

Shmidt, I. (ed.): *Ocherki po istorii russkogo portreta pervoi poloviny XIX veka*, M., 1966.

Turchin, V.: *Orest Kiprensky*, M., 1975.

Yurova, T.: *Mikhail Lebedev*, M., 1971.

Mid- and Late 19th Century

Gomberg-Verzhbinskaia, E.: *Peredvizhniki*, L., 1970.

Iovleva, L.: *Tovarishchestvo peredvizhnykh khudozhestvennykh vystavok*, L., 1971.

Kovalenskaia, T.: *Iskusstvo vtoroi poloviny XIX—nachala XX veka*, M., 1970.

Lebedev, A.: *The Itinerants*, L., 1974 (in English, French, German, Russian).

Leonov, A. (ed.): *Russkoe iskusstvo serediny XIX v.*, M., 1958. Supplementary volume, *Russkoe iskusstvo vtoroi poloviny XIX v.*, M., 1971.

Mashkovtsev, N. (ed.): *Ocherki po istorii russkogo portreta vtoroi poloviny XIX veka*, M., 1963.

Minchenkov, Ya.: *Vospominaniia o peredvizhnikakh*, L., 1964.

Moleva, N., and Beliutin, E.: *Russkaia khudozhestvennaia shkola vtoroi poloviny XIX—nach. XX veka*, M., 1967.

Ogolevets, V. (compiler): *G. G. Miasoedov: Pisma, dokumenty, vospominaniia*, M., 1972.

Paramonov, A.: *Peredvizhniki*, M., 1971.

Sakharova, E.: *V. D. Polenov, E. D. Polenova: Khronika semii khudozhnikov*, M., 1964.

Sarabianov, D.: *Narodno-osvoboditelnye idei russkoi zhivopisi vtoroi poloviny XIX veka*, M., 1955.

Sarabianov, D.: "Russkaia realisticheskaia zhivopis vtoroi poloviny XIX veka sredi evropeiskikh shkol," *Vestnik Moskovskogo universiteta*, M. 1974, No. 1, pp. 54-73.

Valkenier, E.: *Russian Realist Art, the State and Society; the Peredvizhniki and Their Tradition*, Ann Arbor, Ardis, 1977.

The Fin-de-siècle and the Avant-Garde

Andersen, T.: *Moderne russisk kunst 1910-1930*, Copenhagen, Borgen, 1967.

Apollo n.s., vol. 98, no. 142 (December, 1973). Issue devoted to Russian art of the Silver Age.

Berninger, H., and Cartier, J.: *Jean Pougny (Ivan Puni). Catalogue de l'oeuvre.* Tübingen, Wasmuth, 1972. Vol. 1: *Les années d'avant-garde. Russie-Berlin 1910-1923.*

Bowlt, J.: *Russian Art 1870-1970. A Collection of Essays,* New York, MSS Information Corp., 1976.

Bowlt, J.: *Russian Art of the Avant-Garde: Theory and Criticism 1902-1934,* New York, Viking, 1976.

Bowlt, J.: "The Blue Rose: Russian Symbolism in Art," *The Burlington Magazine* Vol. 118, No. 881 (August, 1976), pp. 566-75.

Bush, M., and Zamoshkin, A.: *Put sovetskoi zhivopisi 1917-1932,* M., 1933.

Diakonitsyn, L.: *Ideinye protivorechiia v estetike russkoi zhivopisi kontsa 19—nach. 20 vv.,* Perm, 1966.

Fedorov-Davydov, A.: *Russkoe iskusstvo promyshlennogo kapitalizma,* M., 1929.

Fedorov-Davydov, A.: *Russkii peizazh kontsa XIX—nachala XX veka,* M., 1974.

Fülöp-Miller, R.: *The Mind and Face of Bolshevism: An Examination of Cultural Life in Soviet Russia,* London and New York, Putnam, 1928. Rev. ed.: New York, Harper, 1965.

Gray, C.: *The Great Experiment: Russian Art 1863-1922,* London, Thames and Hudson; New York, Abrams, 1962. Reissued as *The Russian Experiment in Art: 1863-1922,* London, Thames and Hudson; New York, Abrams, 1970.

Guercio, Antonio del: *Le Avanguardie russe e sovietiche,* Milan, Fabbri, 1970.

Karpfen, F.: *Gegenwartkunst: 1, Russland,* Vienna, Literaria, 1921.

Livshits, B.: *Polutoraglazyi strelets,* L., 1933. English translation and annotation by J. Bowlt: *The One and a Half-Eyed Archer,* Cambridge and Philadelphia, ORP, 1977. Memoirs of the avant-garde period.

Loukomski, G.: *History of Modern Russian Painting (1840-1940),* London, Hutchinson, 1945.

Lozowick, L.: *Modern Russian Art,* New York, Museum of Modern Art, 1925.

Makovsky, S.: *Siluety russkikh khudozhnikov,* Prague, 1922.

Makovsky, S.: *Poslednie itogi zhivopisi,* Berlin, 1922.

Petrov, V.: *Le Monde Artiste/Mir iskusstva,* M., 1975 (in Russian and French).

The Russian Art Exhibition. Introduction by Christian Brinton. New York, Grand Central Palace, 1924. Exhibition catalogue.

Russische Malerei 1890-1917. Frankfurt am Main, Städelsches Kunstinstitut, 1976. Exhibition catalogue.

Salmon, A.: *L'Art russe moderne,* Paris, Laville, 1928.

Sarabianov, D.: *Ocherki russkoi zhivopisi kontsa 1900-kh—nach. 1910-kh gg.,* M., 1971.

Schmidt, W.: *Russische Graphik des XIX und XX Jahrhunderts,* Leipzig, VEB Seemann, 1967.

Shcherbatov, S.: *Khudozhnik v ushedshei Rossii,* New York, 1955. Memoirs of an associate of the World of Art group.

Sidorov, A.: *Russkaia grafika nachala XX veka,* M., 1970.

Steneberg, E.: *Russische Kunst, Berlin 1919-1932,* Berlin, Mann, 1969.

Tugendkhold, Ya., et al.: *Iskusstvo oktiabrskoi epokhi,* L., 1930.

Umanski, K.: *Neue Kunst in Russland, 1914-1919,* Potsdam/Munich, Kiepenheuer/Goltz, 1920.

Výtvarné umêní (Prague), no. 8/9. 1967. Issue devoted to the Russian avant-garde (partial translation in Russian, English, German, French).

Soviet Art

Alpetin, M. (ed.): "Painting, Sculpture and Graphic Art in the USSR," *VOKS. Bulletin of the USSR Society for Cultural Relations with Foreign Countries,* Moscow, 1934, Vol. 9/10. Issue devoted to the subject.

Arsenieva, Yu.: *Sovetskaia zhivopis 1917-1973,* M., 1976.

Beskin, O.: *Formalizm v zhivopisi,* M., 1933.

Bowlt, J.: "Soviet Art in the 1970s," in B. Eissenstat (ed.): *The Soviet Union: The Seventies and Beyond,* Lexington Books, Mass., pp. 197-213.

Fedorov-Davydov, A.: *Russkoe i sovetskoe iskusstvo,* M., 1975.

Friche, V., et al.: *Iskusstvo v SSSR i zadachi khudozhnikov,* M., 1928.

Gronsky, I., and Perelman, V. (compilers): *Assotsiatsiia khudozhnikov revoliutsionnoi Rossii (AKhRR),* M., 1973.

Hiepe, R.: *Die Kunst der neuen Klasse,* Munich, Bertelsmann, 1973.

Holme, C. (ed.): *Art in the USSR,* London, Studio Special, 1935.

Johnson, P.: *Khrushchev and the Arts. The Politics of Soviet Culture, 1962-1964,* Cambridge, MIT Press, 1965.

Kamensky, A.: *Vernisazhi,* M., 1974.

Kaufman, R.: *Sovetskaia tematicheskaia kartina, 1917-1941,* M., 1951.

Kostin, V.: *OST,* M., 1976.

Kriukova, I., et al. (eds.): *Ocherki sovremennogo sovetskogo iskusstva,* M., 1975.

London, K.: *The Seven Soviet Arts,* London, Faber, 1937; New Haven, Yale, 1938.

Nikich, A., et al. (eds.): *Sovetskaia zhivopis '74,* M., 1976.

La peinture russe contemporaine, Paris, Palais des Congrès, 1976. Exhibition catalogue.

Shchekotov, N.: *Iskusstvo SSSR. Novaia Rossiia v iskusstve,* M., 1926.

Sopotsinsky, O., et al.: *Stanovlenie sotsialisticheskogo realizma v sovetskom izobrazitelnom iskusstve,* M., 1960.

Soviet Painting: 32 Reproductions of Paintings by Soviet Masters, M. and L., 1939.

Vanslov, V.: *Izobrazitelnoe iskusstvo i problemy estetiki,* L., 1975.

Vaughan James, C.: *Soviet Socialist Realism: Origins and Theory,* London, Macmillan, 1973.

Zhdanov, A., et al.: *Problems of Soviet Literature. Reports and Speeches at the First Soviet Writers' Congress.* Edited by H. G. Scott. New York, International Publishers, 1935. An abridgement of I. Luppol, et al. (eds.): *Pervyi Vsesoiuznyi sezd sovetskikh pisatelei 1934: Stenograficheskii otchet,* M., 1934. A stenographic account containing the main principles of the program of Socialist realism.

Monographs on Particular Artists

ALTMAN

Arvatov, B.: *Natan Altman*, Berlin, 1924 (in Russian).
Etkind, M.: *Natan Altman*, M., 1971.

BAKST

Spencer, C.: *Leon Bakst*, London, Academy Editions, 1973.
Pruzhan, I.: *Bakst*, L., 1975.

BENOIS

Benois, A.: *Memoirs*, London, Chatto & Windus, 1964.
Etkind, M.: *A.N. Benois*, L.-M., 1965.
Zilbershtein, I. and Savinov, A. (eds.): *Aleksandr Benois razmyshliaet . . .*, M., 1968.
Bernandt, G.: *A. Benois i muzyka*, M., 1969.

BORISOV-MUSATOV

Rusakova, A.: *Viktor Elpidiforovich Borisov-Musatov*, L.-M., 1966.
Rusakova, A.: *Borisov-Musatov*, M., 1974.
Rusakova, A.: *Borisov-Musatov*, L., 1975 (in English, French, German, Russian).

BOROVIKOVSKY

Alekseeva, T.: *Vladimir Lukich Borovikovsky i russkaia kultura na rubezhe 18go—19go vekov*, M., 1975.

BRIULLOV

Atsarkina, E.: *Briullov*, M., 1963.

BRODSKY

Brodsky, I. A.: *I. I. Brodsky*, M., 1973.

DEINEKA

Deineka, A.: *Zhizn, iskusstvo, vremia*, L., 1974.
Sysoev, V.: *Aleksandr Deineka*, M., 1973.

FALK

Sarabjanow, D.: *Robert Falk*, Dresden, VEB, 1974 (in German).

FEDOTOV

Sarabianov, D.: *Pavel Fedotov*, M., 1969.
Sarabianov, D.: *P. A. Fedotov i russkaia khudozhestvennaia kultura 40-kh godov XIX veka*, M., 1973.

FILONOV

Bowlt, J.: "Pavel Filonov: An Alternative Tradition?", *Art Journal* Vol. 34, No. 3 (Spring, 1975), pp. 208-216.
Kříž, J.: *Pavel Nikolajevič Filonov*, Prague, 1966.
Pavel Filonov: Pervaia personalnaia vystavka, Novosibirsk, 1967. Exhibition catalogue.

GERASIMOV

Denisov, L. (compiler): *Sergei Vasilievich Gerasimov*, M., 1972.

GONCHAROV

Nekhoroshev, Yu.: *Andrey Goncharov*, L., 1973 (in English and Russian).

GONCHAROVA

Loguine, T.: *Gontcharova et Larionov*, Paris, Klincksieck, 1971.
Chamot, M.: *Gontcharova*, Paris, La bibliothèque des arts, 1972.

Rétrospective Gontcharova, Maison de la culture de Bourges, 1973. Exhibition catalogue.
Orenstein, N.: "Natalia Goncharova: Profile of the Artist—Futurist Style," *The Feminist Art Journal*, Brooklyn, 1974, Vol. 3, No. 2, pp. 1-6.

GRABAR

Podobedova, O.: *Igor Emmanuilovich Grabar*, M., 1965(?)

GREKOV

Kucherenko, G.: *Estafeta traditsii: Grekovtsy*, M., 1975.

IVANOV

Alpatov, M.: *Aleksandr Andreevich Ivanov*, M., 1956. Two vols.
Zagianskaia, G.: *Peizazh A. Ivanova*, M., 1976.

KANDINSKY

Grohmann, W.: *Wassily Kandinsky: Life and Work*, New York, Abrams [1958].
Roethel, H.: *Kandinsky: Das graphische Werk*, Cologne, DuMont Schauberg, 1970.
Wassily Kandinsky 1866-1944. Munich, Haus der Kunst, 1976. Exhibition catalogue.

KONCHALOVSKY

Neiman, M.: *Petr Konchalovsky*, M., 1967.

KOROVIN

Kogan, D.: *Konstantin Korovin*, M., 1964.
Vlasova, R.: *Konstantin Korovin*, L., 1969.

KRAMSKOI

Goldshtein, S. (ed.): *I.I. Kramskoi: Pisma, stati*, M., 1965. Two vols.

KUINDZHI

Bowlt, J.: "A Russian Luminist School? Arkhip Kuindzhi's Red Sunset on the Dnepr," *Metropolitan Museum Journal 10*, 1975, pp. 119-129.

KUSTODIEV

Etkind, M. (ed.): *B.M. Kustodiev: Pisma: Stati, zametki, interviu . . .*, L., 1967.

KUZNETSOV

Budkova, L., and Sarabianov, D.: *Pavel Kuznetsov*, M., 1975.

LARIONOV

George, W.: *Larionov*, Paris, La Bibliothèque des arts, 1966.
Dabrowski, M.: "The Formation and Development of Rayonism," *Art Journal* Vol. 34, No. 3 (Spring, 1975), pp. 200-207.

LENTULOV

Lentulova, M.: *Khudozhnik Aristarkh Lentulov*, M., 1969.

LEVITAN

Fedorov-Davydov, A.: *Levitan*, M., 1966. Two vols.

LEVITSKY

Diaghilev, S. (compiler): *D. G. Levitsky 1735-1822*, St. Petersburg, 1902.
Gershenzon-Chegodaeva, N.: *Dmitrii Grigorievich Levitsky*, M., 1964.

MALEVICH
Andersen, T. (compiler): *Malevich*, Amsterdam, Stedelijk, 1970.
Andersen, T. (compiler and ed.): *Malevich: Essays on Art*, Copenhagan, Borgen, 1968, 1976. Three vols.
Karshan, D.: *Malevich: The Graphic Work*, Jerusalem, Israel Museum, 1975.

NESTEROV
Mikhailov, A.: *Mikhail Vasilievich Nesterov*, M., 1958.

NISSKY
Murina, E.: *Georgii Grigorievich Nissky*, M., 1952.

ORLOVSKY
Atsarkina, E.: *Aleksandr Orlovsky*, M., 1971.

PEROV
Sobko, N.: *Vasilii Grigorievich Perov: Ego zhizn i proizvedeniia*, St. Petersburg, 1892.

PETROV-VODKIN
Kostin, V.: *K. S. Petrov-Vodkin*, M., 1966.
Rusakov, Yu.: *Petrov-Vodkin*, M., 1975.

PIMENOV
Barabanova, N.: *Yury Pimenov*, L., 1972 (in English, French, German, Russian).

PLASTOV
Kostin, V.: *Arkadii Aleksandrovich Plastov*, M., 1956.

POPOVA
Rakitina, E.: "Liubov Popova: Iskusstvo i manifesty," in Rakitina, E. (compiler): *Khudozhnik, stsena, ekran*, M., 1975, pp. 152–165.

REPIN
Grabar, I.: *Repin*, M., 1937. Two vols. (and subsequent editions).
Nemirovskaia, M.: *Portrety I. E. Repina*, M., 1974.
Sarabyanov, D.: *Ilya Repin*, M., n.d. (in English).

ROKOTOV
Lapshina, N.: *Rokotov*, M., 1959.

ROZANOVA
Efros, A.: "Vo sled ukhodiashchim," *Moskva: Zhurnal literatury i iskusstva*, M., 1919, No. 3, pp. 4–6.
Betz, M.: "Graphics of the Russian Vanguard," *Art News* Vol. 75, No. 3 (March, 1976), pp. 52–54.

RYLOV
Mochalov, L.: *Arkadii Aleksandrovich Rylov*, M., 1966.

SALAKHOV
Zinger, E.: *T. Salakov: Ritmy novogo*, M., 1975.

SAMOKHVALOV
Samokhvalov, A.: *O svoei rabote*, M., 1974.

SARIN
Sarian, M.: *Iz moei zhizni*, M., 1970.
Matevosian, B.: *Martiros Sarian*, Erevan, 1975 (in Armenian, Russian, English).

SEROV
Zilbershtein, I., and Samkov, V. (compilers): *Valentin Serov v vospominaniiakh, dnevnikakh i perepiske sovremennikov*, L., 1971. Two vols.

SHTERENBERG
D. P. Shterenberg: Vystavka kartin, M., 1927. Exhibition catalogue.

SOMOV
Pruzhan, I.: *Konstantin Somov*, M., 1972.
Gusarova, A.: *Konstantin Andreevich Somov*, M., 1973.
Bowlt, J.: "Konstantin Somov," *Art Journal* Vol. 30, No. 1 (Fall, 1970), pp. 31–36.

SOROKA
Mikhailova, K.: *Grigorii Soroka*, L., 1974.
Grigorii Soroka. L., 1975. Exhibition catalogue.

SURIKOV
Mashkovtsev, N.: *V. I. Surikov*, M., 1948.

TATLIN
Vladimir Tatlin, Stockholm, Moderne Museet, 1968. Exhibition catalogue.
Strigalev, A.: "O proekte 'Pamiatnika III internatsionala khudozhnika V. Tatlina,'" *Voprosy sovetskogo izobrazitelonogo iskusstva i arkhitektury*, M., 1973, pp. 408–452.
Tatlin, Odense, Fyns Stifts Kunstmuseum, 1976. Exhibition catalogue.

TROPININ
Amshinskaia, A.: *Vasilii Andreevich Tropinin*, M., 1970.

VASNETSOV, A.
Bespalova, A.: *Apollinarii Vasnetsov*, M., 1956.

VASNETSOV, V.
Shanina, N.: *V. Vasnetsov*, M., 1975.

VENETSIANOV
Efros, A., and Miuller, A. (compilers): *Venetsianov v pismakh khudozhnika i vospominaniiakh sovremennikov*, M.-L., 1931.
Savinov, A.: *Venetsianov*, M., 1955.

VERESHCHAGIN
Lebedev, A.: *Vasilii Vasilievich Vereshchagin*, M., 1972.

VRUBEL
Tarabukin, N.: *M. A. Vrubel*, M., 1974.
Kaplanova, S.: *Vrubel*, L., 1975 (in English, French, German, Russian).
Reeder, R.: "Mikhail Vrubel: A Russian Interpretation of *fin de siècle* Art," *The Slavonic and East European Review* Vol. 54, No. 3 (July, 1976), pp. 323–334.